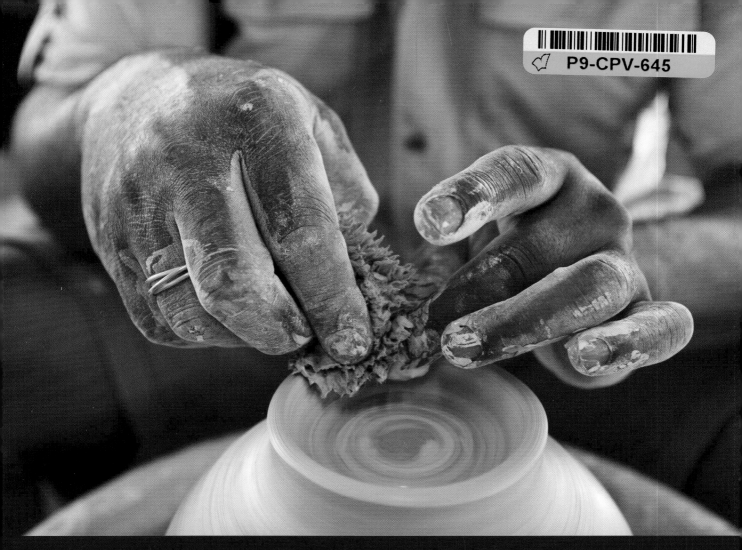

Storytellers

A Photographer's Guide to Developing
Themes and Creating Stories with Pictures

Storytellers:

A Photographer's Guide to Developing Themes and Creating Stories with Pictures

Jerod Foster

New Riders
1249 Eighth Street
Berkeley, CA 94710
510/524-2178
510/524-2221 (fax)

Find us on the Web at www.newriders.com
To report errors, please send a note to errata@peachpit.com
New Riders is an imprint of Peachpit, a division of Pearson Education

Acquisitions Editor: Ted Waitt
Project Editor: Susan Rimerman
Developmental/Copy Editor: Peggy Nauts
Proofer: Elaine Merrill
Indexer: James Minkin
Production Editor: Danielle Foster
Interior Design and Composition: Kim Scott, Bumpy Design
Cover Design: Aren Straiger

ISBN-13: 978-0-321-80356-6
ISBN-10: 0-321-80356-6

9 8 7 6 5 4 3 2 1

Printed and bound in the United States of America

To my daughter, Eva Korynn,
Your life is your story.
All my love.

Acknowledgments

I would like to offer deep thanks to everyone at Peachpit and New Riders. Thank you for providing the opportunity to share what I love to do day in and day out and for offering such strong resources for a large international photography community. Your contributions to the world of visual storytelling matter each time someone turns one of your books' pages.

Particularly, I'd like to acknowledge this book's production team. Books like this aren't put together solely by the author. Rather, a supportive and extremely knowledgeable group of individuals works together to make my words and images flow as smoothly as possible. I couldn't ask for a better team to work with for my first book.

Ted Waitt, Peachpit's acquisitions editor, is at the core of this project. I'm ever thankful that his interest in my blog posts prompted our conversations on photography, lighting, and ultimately, the topic of visual storytelling.

My editor, Susan Rimerman, has been at the helm of this project since the beginning, providing guidance every step of the way. From trans-Atlantic phone calls to our hundreds of e-mails since the book was in proposal stage, Susan has continuously offered her expertise in transforming ideas into an extended production.

Peggy Nauts, my developmental editor, worked extra hard to make sure my words made sense. She helped hold my sanity together while putting up with my jokes and Texasisms.

Danielle Foster, the book's production editor (and probably a distant cousin given how small this world is), kept the wheels greased, and proofreader Elaine Merrill finessed my copy and paid attention to the details.

Kim Scott, the book's interior designer, and Aren Straiger, the cover designer, presented my images and text in a way that dresses both up. Visual stories are often not told alone, and Kim and Aren did a great job putting this one together.

To each and every person and animal I've photographed and will continue to tell stories about, your generosity in allowing me to observe and capture parts of your lives and activities makes for a special experience each time I go on assignment or happen upon story. I won't forget the landscapes and places that have invited me in.

Among friends and colleagues around the world who pick up a camera every day to tell visual stories, particular thanks to Wyman Meinzer, who saw in my work something that could piece together a part of the larger narrative that surrounds a people and a place.

To all the readers of this book, thanks for not only your interest but ultimately your initiative to contribute to the stories that keep this world turning.

My appreciation goes to the College of Mass Communications at Texas Tech University for providing me the chance several years ago to share what I do professionally in an educational setting. I hope that teaching what I do encourages others to pursue opportunities in visual storytelling.

My family's support over the years has meant a great deal. Everyone from my parents, Jay and Marsha, to both sets of grandparents and beyond has taught me how to work hard and nurture my creative enterprise.

I thank my wife, Amanda Waters Foster, for her inspiration and loving support. Every day I understand more clearly why I call her my hero.

Last but certainly not least, I would like to thank God. Without him, the grand story of life wouldn't exist.

Contents

Introduction

A couple years ago, I started a new series on my blog called "Field Lighting." At the time, I thought it was simply a way for me to relay useful information for the next time readers were on a shoot. It also appealed to those who were interested in the behind-the-scenes production side of editorial and natural history shooting. I enjoyed writing this quasi-regular column (still do), and it even helped me pick up a few assignments along the way. I couldn't argue with that.

As it turned out, the "Field Lighting" series was not just a collection of posts about how to light a building or see the subtle variation in how composition affects how we light certain subject matter. The series was ultimately a collection of instructions and practical information on how to better tell *story*. I wasn't necessarily trying to emphasize how to light. Rather, I was more interested in showing how light contributes heavily to how photographers actually go about saying something—how using light can make us better storytellers. Story was the core of the posts.

When Peachpit expressed interest in my blog and I had the opportunity to write this book, I wanted it to complement the how-to books out there, explaining what it is that we really do when we pick up a camera, put it to our eyes, and trip the shutter. As a photography instructor, I teach about the technical handling of the tools of the trade. There's quite a bit of value in learning your gear to the point that it becomes almost second nature. However, as a professional photographer, I also understand that just knowing how to operate the shutter speed and aperture dials alone won't create images that truly speak to an audience beyond the photographer and the photography community. Making a living at it depends on how well those images speak to an outside audience.

No matter whether we're shooting a huge assignment for a national magazine or our family reunion, there's a story to be told. The notion of visual storytelling has a buzz these days, and for good reason. Story is the next stage in the conversation about how to develop your creative photographic vision.

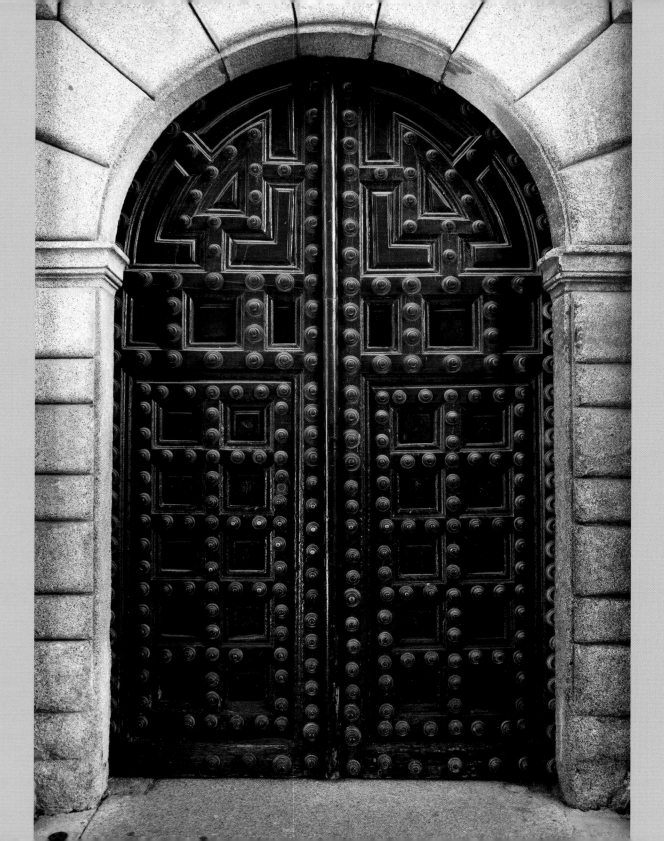

This book, *Storytellers*, delves into the value of visual storytelling and how to go about producing stories that reach out and say something powerful to others. I want this book to help you think about the narrative of your own work. Are your images telling the stories that you meant to tell?

This book is not a how-to manual. It's not a technical course in photojournalism, nor is it an in-depth dissection of documentary photography. *Storytellers* is a discussion about those components that we use day in and day out to create compelling images, as well as *why* we use them in certain ways for story's sake.

The book does cover subject matter such as composition, lighting, portraiture, and depth of field, as well as many other components of effective image making, but its main purpose is to help hone photographic practices and approaches that better our abilities to tell story.

When we practice our craft mindfully, it contributes to well-produced, nuanced storytelling images and photo essays. A large part of this book is devoted to producing different types of storytelling images and how they can work together to attract and engage a viewer. Additionally, I point out characteristics of visual stories that make them interesting to follow and create.

I also touch upon everyone's favorite topic, research. Some photographers view it as a dreadful activity, but it doesn't need to be, and it's an essential tool in successfully telling story. The book closes with a guide for developing an encompassing storytelling workflow, from selecting the right equipment and visualizing imagery to postshoot computer work.

Along the way, I serve up some personal experiences that have taught me important lessons about visual storytelling and offer quick tips to keep in that photographer's toolbox we all carry. You'll also have a chance to participate in some exercises that will reinforce the ideas in the text.

At the end of the first six chapters of the book (and in online bonus material found by registering your book at peachpit.com/storytellers), I'm honored to present conversations with some of the visual storytellers I admire. From *National Geographic* documentary and Pulitzer-winning photojournalism to conservation and commercial photography, their work covers an impressive range of experience. In these interviews, they provide insight into why they are drawn to story, their influences, and how they personally go about creating compelling,narrative images.

Ultimately, if I've done my job, this book will make you consider each and every part of your photographic process and the story you are trying to tell. Just pushing the buttons on your camera and snapping a photograph because you composed the shot according to the rule of thirds will not be an option. You'll know why you made the decision to set the image up the way you did and what your photograph is saying. The ultimate goal? Make images that both engage the viewer *and* impart story.

As you move through the book, I hope it helps increase the depth of the images you produce and gets you into the constant mind-set of seeking interesting story.

Writing a book on this subject invigorates me to go tell more stories, and I hope reading it does the same for you.

A medieval door in Toledo, Spain.
Oh, the stories this door could tell…
Canon 5D Mk II, 28mm, 1/60 sec., f/4, ISO 200

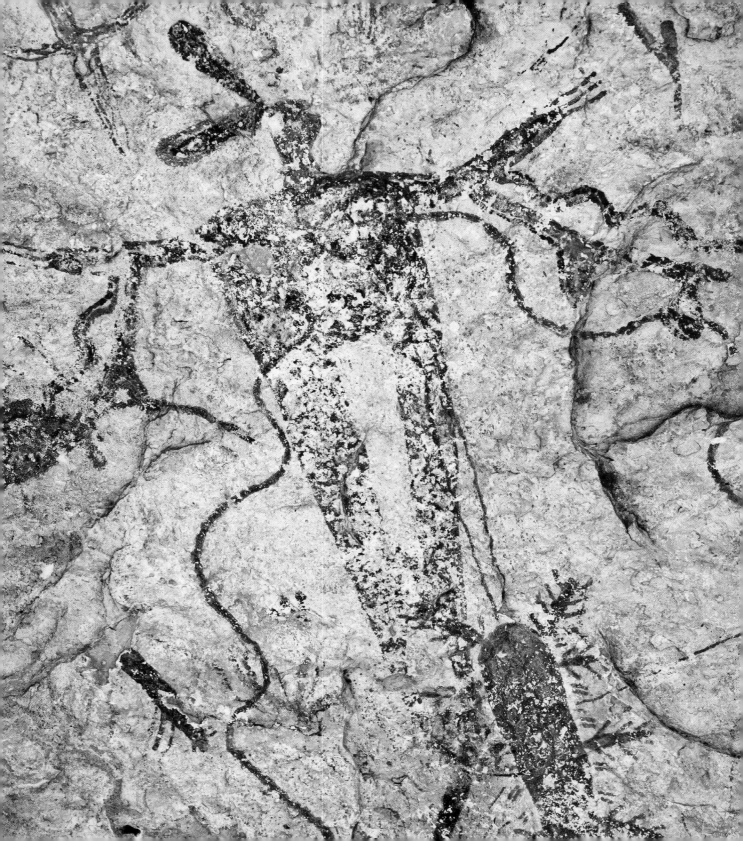

A Tradition in the Making

There is a swath of land in southwest Texas that opens up to the Rio Grande River named Rattlesnake Canyon. The canyon is a steep depression in the unforgiving desert country near Langtry, a sparsely populated ghost town that is known for the infamous Judge Roy Bean, a saloon owner turned justice of the peace, who referred to himself as "the Law West of the Pecos." The land surrounding Rattlesnake Canyon is hard and ragged, with dog cacti, thorny mesquite trees, and ocotillo, yucca, and daggerlike lechuguilla—the only things holding the soil together. The weather is hot, dry, and often windy. As for water, there's the river, but not much else.

One of many ancient shamans who exist in Rattlesnake Canyon.
The rock art tells the story of his journey to and from the spiritual realm.
Canon 5D, 50mm, 1/100 sec., f/5.6, ISO 100

If this sounds to you a bit like the backdrop for *No Country for Old Men* or an older Clint Eastwood western, you aren't too far off. This desolate expanse of Texas is eclipsed in size only by the legends about the people who call it home. Those stories, however, did not start off with the movie-making Coen brothers. Indeed, story has existed in this land for millennia, and to some extent, it's what keeps it alive.

Inside Rattlesnake Canyon is a series of long, concave limestone walls covered in pictographs that scholars determine to have existed for more than 4000 years. Colorful depictions of spiritual experiences and life activities characteristic of the Lower Pecos people come to life from ground level to several feet above your head. Shamans, a type of medicine men, are easily identified among the characters on the walls, as are the snakes that give the canyon its name.

To historians, archaeologists, and those just plain interested in what life was like thousands of years ago, these walls hold vast amounts of historic narrative captured in creative, visual form. Some are faded and washed by time and precipitation, others bleached by the sun and the light-colored limestone. Thanks to preservation advocacy and technology, though, what's not faded yet is the story placed upon these walls so many years ago.

The story that continues to say something, even though it's ancient history.

WHAT IS A STORYTELLER?

It wouldn't be very helpful to explain what a storyteller is without first talking about the story itself. We're exposed to story daily, yet it's not all that easy to describe. On the surface, a story contains a plot, a set of characters, and an environment, and it often involves conflict of some kind. It's usually contained along a timeline and explained through what we refer to as narrative. Story is simply the telling of events, whether fictitious or true. Ever since grade school, we've had the opportunity to create, consume, and critique story and all of its elements (there were some good *and* bad grades in there, I'm sure). We find it played out on our television screens, in our newspapers, on our radios, and online. It's all around us. However, it's not always as simple as a plot, a character, and a setting.

When we scratch the surface a bit, story is more complex. Story evokes in us attention and emotion, and if it is truly powerful, story inspires action. Of

course, story is but one component of a million other things that influence how we think, feel, and operate. However, it is a very important part of the process.

Stories inform us about the world we live in and how we should consider living in it. From when we were toddlers listening to bedtime stories to when we saw our first *National Geographic* magazine and began to watch the nightly news broadcast, we've heard stories that construct a reality with which we engage on a daily basis. In essence, the different stories that we encounter throughout life help build our way of seeing the world, even though it might not necessarily be through our own lens all the time.

Although they can be entertaining, stories have a purpose. They explain right from wrong and they help us understand the actions of others, as well as make us laugh, cry, gasp in awe, cringe in fear, feel disgusted, and experience just about any other visceral emotion we can conjure up. We might not all react the same way to similar stories, but the fact is, we do react.

And those responsible for making us react are the storytellers.

A Long Line of Storytellers

Storytellers are a unique lot. Before the means to produce and distribute written stories in large quantities was developed, story was passed down orally and visually, and included some famous ancient tales that are still being told in very similar ways. Greek thespians, tribal and spiritual leaders, painters, sculptors, and musicians have all helped to develop an aesthetic of storytelling that involves physical proximity to the storyteller and his work in order to fully appreciate seeing and hearing the unfolding narrative.

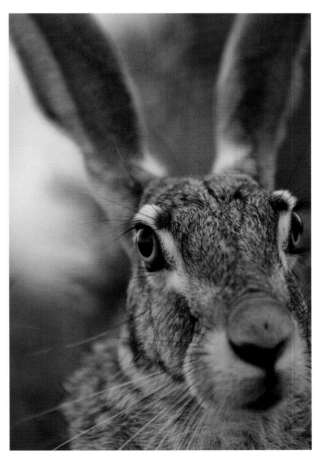

Stories permeate society to the degree that looking at a photograph of a jackrabbit might just trigger thoughts of folk tales, childhood bedtime stories, or even Saturday morning cartoons. Likewise, we might already have a particular perception of the rabbit in the image because of these stories.

Canon 20D, 200mm, 1/400 sec., f/2.8, ISO 100

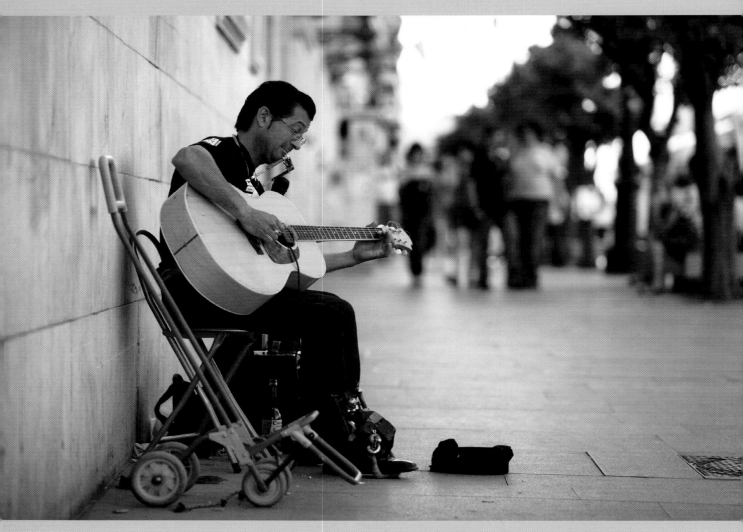

Thanks to continually advancing technology, story can travel the world in the blink of an eye. This street performer in Seville, Spain, is part of that process, singing classic American blues tunes to those passing by.

Canon 5D Mk II, 135mm, 1/320 sec., f/2.8, ISO 200

Later, the development of the printing press moved story into many more places than it had existed before. Religious stories the world over were forever changed when followers of many faiths could now read holy documents alongside listening to spiritual leaders and viewing iconic images in places of worship. Writers began to flourish, the novel was developed, and readers could get lost in fiction about secret gardens and flying children who fight pirates. At this point, the visual and written story could be combined, leading to the forerunner to the modern newspaper. Bringing sounds and oral storytelling to the mix was not too far behind.

With changes in technology, new storytellers have emerged or found different ways of doing their job. Photographers, videographers, cinematographers, and every other type of "ographers" out there have entered the storytelling fray throughout the past couple of centuries, and they've each made their own contribution to a society that revolves around story.

As it has always done, storytelling involves a level of training and insight. Just as ancient shamans painted spiritual experiences on tall limestone walls in the desert heat to convey and record story for their culture and social structure, contemporary storytellers are responsible for constructing the reality (and sometimes the nonreality) that we find in our newspapers, on our televisions, in our books, through our radios, on our computer screens, and around our dinner tables.

However, the list of storytellers does not stop with those who are formally trained in a related craft. Each one of us participates at some point in the practice of gaining someone's attention with our abilities to "spin a yarn" or capture the beauty of a landscape with the strokes of a charcoal pencil or our digital cameras. If story is all around us, permeating much of the information we bring in during the day, then it stands to reason that all of us are, in part, storytellers.

The greatest distinction among storytellers, though, and the one this book primarily deals with, is how well one individual tells his story compared to the rest. What really identifies an individual we would all call a storyteller?

Pencil artist, Gruene, Texas.
Canon 5D Mk II, 105mm, 1/400 sec., f/4, ISO 100

Certain moments strike us as memorable, occasions that warrant special attention with our cameras. You might be standing atop the highest peak in the state looking down on a blanket of early-morning clouds in the canyon below or photographing a high school football game for the first time, but either way, you know you're going to remember it. From time to time, these memorable occasions turn on the metaphorical light-bulb above our heads as well, and we suddenly become aware of what we're actually doing at that moment. Among many great memories I've had with a camera in hand, two that relate to becoming a visual storyteller will remain permanently fixed in my mind.

One concerns my first magazine cover from many moons ago. Before you get too excited, know that it was the cover of an agricultural college's student-produced magazine. Because of my unhealthy interest in photography, I was dubbed the photo editor. This might not sound like much, but to a new, self-proclaimed photographer, it was a great opportunity. I had previously interned with a couple of magazines as a writer, and now I was given the helm to shoot.

The cover art was supposed to be abstractly focused around the ideas of regional agricultural icons and technological progress. At the time, the majority of my photography occurred while "collecting stock." That's what I told myself as I drove all over the West Texas countryside, photographing the early-morning and late-evening colors, the bountiful cotton crops, and just about anything that caught my eye. I would submit the images to regional and national magazines without much knowledge about how the whole editorial review process worked, but I was learning.

To be honest, besides some really nice exposures and impactful one-offs, my image portfolio lacked consistency in style and storytelling direction. I was just getting initiated into making photographs as a way to pay the bills. However, with a cover shot deadline for the student magazine looming over my head all semester, I had a box to work within. Even though the box contained vague adjectives like "iconic" and "progressive," I still was given a bit of assignment-worthy structure with which to produce images. And this structure helped me realize one evening what I was doing with a camera—something beyond metering, composing, focusing, and pushing a button.

I came up with a few ideas for the cover, and one evening I saw the adjectives "iconic" and "progressive" come together in a shot that made the cut. I was photographing strippers (cotton strippers, that is) harvest the year's crop on a late autumn evening. I was out in the middle of thousands of acres of farmland, and the sun was setting behind an atmospheric haze thrown up by the harvesting activities. It was enough haze to produce a nice silhouette of the strippers and keep the sun in the sky. I probably shot three rolls of Fujichrome Velvia, making as many variations of the scene as I thought appropriate at the time.

During this process, I started to realize what made this shot a strong contender for a cover (besides its being a vertical frame). To the agriculture industry, the cotton stripper is an iconic implement, and putting it up against a visually stimulating background such as this sunset emphasized this status. Furthermore, the cotton stripper is one of the most advanced pieces of agricultural technology in production. The scene playing out in front of my 300mm lens met all the magazine's cover criteria. As a fledgling photographer, this moment in the field highlighted how two simple words could be pulled together to tell a story. It was a pinnacle moment for me. ■

A solo cotton stripper harvesting at dusk.
Canon 1N, 300mm, 1/1000 sec., f/5.6, ISO 100, Fujichrome Velvia

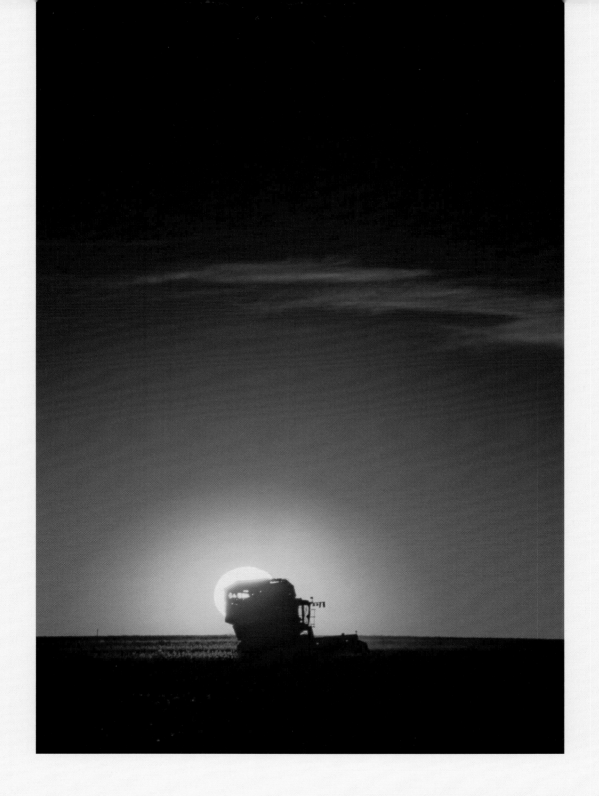

THE TIES THAT BIND US

If you think about the long line of storytellers throughout history, from Homer to Shakespeare, from Dorothea Lange to Joe McNally, all of them have certain things in common. First, they are connectors, establishing relationships with an audience that they intend to engage. Sometimes this audience might be a small, specific niche group of people interested in buying photographic prints for a certain humanitarian cause, or a large, more general audience that wants to read about the top ten travel destinations in the world. Regardless of audience size, the storyteller intends to create this link between the teller and the listener/reader/viewer.

Along the same lines, a storyteller is an involver. A storyteller is never satisfied with just establishing a connection. A storyteller's job is to bring you into a story, let you play there, and when the story is over, allow you to exit. You can probably still remember how you felt when you read your first gripping mystery novel, or when you viewed a single street photograph for any length of time only to find yourself imagining actually being in the photograph's environment. You became part of the story. This experience is probably more apparent now than it was, say, 50 years ago, due to the unlimited interaction between individuals across social media and networks. We're now able to communicate with the storyteller, leave comments on his blog posts or online news stories, provide plot suggestions over Twitter, or share a link to a compelling photo essay with our Facebook friends. Your involvement now, just as it has always been, is key to the storyteller's success.

Storytellers may not see the word *expert* thrown around much when they read reviews of their work, but to some degree, a good storyteller is an expert on the subject matter imparted. Wildlife photographers are great examples of holding both positions. Many of the most successful critter photographers in the industry know as much, if not more, about the species they are photographing than some biologists and natural resource managers. This expertise helps them shed light on aspects of the animal kingdom that many of us would otherwise never see or notice. Yet, the attention to detail that comes along with being an expert allows for nuanced components of the larger story to shine through in the telling.

It's presumptuous, however, to consider all storytellers experts in the same light. Feature writers, for example, may become temporary experts over the type of subject matter they are reporting and then move on to the next. However, the sense of expert authority still exists and aids the storytelling process.

BECOME AN EXPERT You don't need to go to school and study a certain subject in order to pass for an authority on the issue. Spending time visiting with the locals in a small Chinese village or, better yet, living there, might gain you more "expert" knowledge in a rural society and amiable access to tell their story visually. Taking university-level biology and wildlife courses can certainly help you become more knowledgeable about the natural history of foxes, but until you've actually spent time watching their movements and tendencies in the wild, you'll miss opportunities to create series of images that accurately and creatively highlight how they live and interact with others.

Research is another key component of becoming more expertlike in your photography, and we'll revisit the subject later in the book. In the meantime, consider what it means to really become an expert in the subjects or landscapes you're most interested in photographing. Read about your main area of interest, talk about it with other photographers, but more important, immerse yourself in the environment where you will most likely be working. Soak all the outside and inside information up, and you'll see what you learn come through in your images.

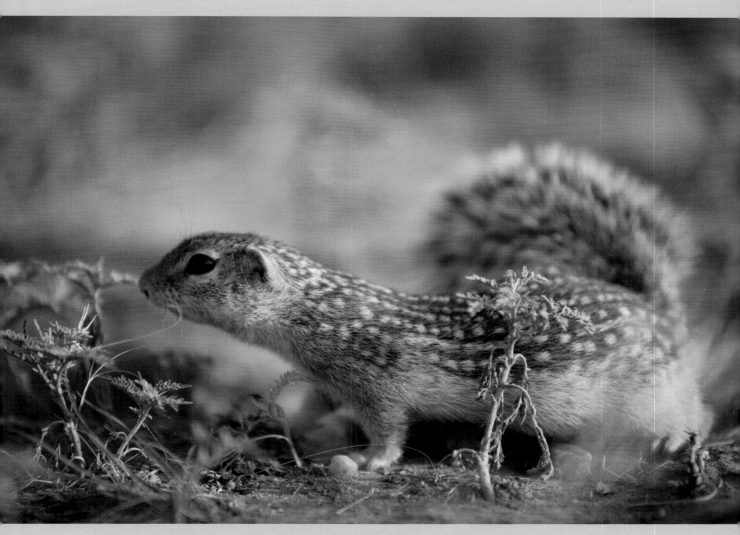

I became a temporary expert on Mexican ground squirrels. Aside from photographing him, a colleague and I took note of his tendencies and eased into his environment on an old Texas ranch. We were able to occupy his space enough to not interfere with his comings and goings.

Canon 5D, 195mm, 1/800 sec., f/2.8, ISO 100

After the cotton stripper, the second important memory I have related to storytelling occurred while I was on assignment for a medical school's alumni magazine a couple of years later. The story featured a local camp for autistic children and the efforts being made to improve treatment for camp attendees and other autistic children. I did not know much about autism, and even after some initial reading prior to the day's shoot, I didn't have a good grasp of how it affected social engagement. I was educated that day about both autism and the responsibilities I had as a photographer.

After arriving, I met with camp staff and was led to where the children were enjoying some playtime in a nearby courtyard. I soon started shooting. Amidst all the wagon pulling, ball throwing, sand castle building, and volleyball, I talked with staff members, learning how autism affects kids' ability to socially engage with others, and how even the play activities were used to tackle this issue. I shot for close to 45 minutes, and then I met a young boy who never played with anyone except one staff member. She let me know he didn't talk, let alone interact with others his age. I only made a few images of the two together since they were headed back to the classroom, but the Speedlite I had on top of my camera attracted a few smiles and pointing from the boy.

We all got up from the grass, I thanked the staff member holding the boy for letting me shoot their interaction, and I dropped the camera to my side. As they were walking away, the boy looked over the staffer's shoulder, smiled, waved at me, and said, "Bye!" Both the staff member and I were astonished and excited. The boy who had not spoken for days opened up to see me

on my way. That moment reinforced how important my work at that moment was for educating a larger public about autism and what is being done for our society's youth. I'll admit that I was in such a state of wonder that I didn't think to make another image of the young boy as he was leaving, but by the time I could have put the camera to my eye, he would have already turned around and headed away. It was that blink of a moment that was special.

The whole time shooting the interaction between autistic children was summed up in that last wave goodbye, and it signified what it means to be a visual storyteller. It was my job to make sure my images, at the very least, help convey the message of the text, if not tell the entire story by themselves. This is true of every assignment I get, no matter if it's a story on advances in children's health or one on Christmas quilt stitching. There's something to be told, and if I have a camera in hand, I'm going to do my best job to tell it visually. ■

Visionary Intent

Storytellers are also visionaries. Sounds pretty lofty, doesn't it? It's no exaggeration, though. If you're reading this book, there's a good chance you like to make photographs and you've been privy to the great, in-depth discussions surrounding the issue of vision in the photography community and industry. Successful storytellers take this concept and run with it. In fact, being a visionary prefaces developing that vision, and I believe it is what many storytellers use as constant encouragement to create better, more compelling and connecting story. Visionaries come in all shapes and sizes, and so do the stories that they tell. Some are motivated to be an integral part of a life-altering, world-changing organization, while others simply want to create an anecdote about life in the Midwest. Either way, the storyteller has visionary intent, and the development of vision is part of her growth and ability.

Visionaries come in all shapes and sizes, and so do the stories that they tell.

Tools of the Trade

Storytellers are knowledgeable not only about their subject matter and the direction they want to take the story, but also about how to make sure the story comes across to an audience in an effective manner. Storytelling involves using certain tools that help do the job.

It hasn't always been that way, if you don't count vocal cords, but the human race has been in search of new ways to tell story for quite some time. Improved paintbrushes, the development of the printing press, early chemical photographic processing, autofocus lenses, and the invention of electronic transmission of sound and the moving image are only a small part of the list of methods and tools used to tell a more compelling story to a larger audience. The digital devices we use day in and day out now, from computers to digital cameras to high-definition televisions, are the means of either creating or consuming contemporary storytelling, even if some weren't initially developed for such a purpose. However, no matter what tool is used, the storyteller is proficient in using the right one for the job. Part of the growth storytellers experience is with their means of doing so, and constant application of their tool of choice makes its use second nature.

The Human Connection

Last, and probably the most important characteristic of any storyteller in the history of humankind, is that the storyteller is simply another human being with an imagination. Until someone programs a robot to independently create story (something I hope never happens), we're left to ourselves and all the storytelling ability only the human imagination can manifest. How could anything *but* a human relate to us through story in a way that evokes fear, surprise, happiness, or sadness when we watch an award-winning movie or visit an art gallery populated with images made by well-known photojournalists of yesteryear? Storytellers experience many of the same things we all do, and because of that, they're able to connect with and involve an audience on a level that perpetuates story and the ever-growing narrative we often refer to as "life."

Some of the best stories are still told the same way that they originated: in person, over cervezas. Madrid, Spain.

Canon 5D Mk II, 50mm, 1/100 sec., f/2, ISO 800

STORYTELLING BEFORE AND AFTER THE CAMERA

I'll be honest. When storytelling comes to mind, I'm often not thinking of photography. Sure, I try to *see* the story and construct a photographic vision of it all, but if we were to have a conversation about great story-tellers right now over an iced tea (I'm from Texas, what can I say), I would have to mention at least a few writers in the mix. Writers like Mark Twain, Cormac McCarthy, and Garrison Keillor, who have the abil-ity to create such layered stories that I can actually *envision* them without ever viewing a single cartoon or photograph. They, and other writers, are champions of creating characters you can visualize, smell, hear, and almost touch. We become part of their stories, and I believe that's what we strive for even as storytellers with cameras in tow.

READ MORE **They say that if you want to become a better writer, read more. I think the same logic applies to photographers. I know quite a few photographers and students who really can't stand to write, but I've never known a successful photographic storyteller that did not like to read. Reading exercises your imagination and provides you an alternative way of seeing environ-ments, subject matter, characters, and conflict. It's also the inspiration for other stories, whether they are visual or not. Make time for it.**

Spend 30 minutes in the morning (wake up earlier if you have to) reading the news. At the end of the day, crack open that biography of Matthew Brady you've been meaning to read ever since you became inter-ested in 19th-century war photography. Read fiction, nonfiction, magazine features, documentary-style journalism, or whatever genre you lean toward. If you haven't noticed already, you might just be surprised at how much your own creative and storytelling abilities are energized by the practice. You'll improve both your written and visual vocabularies.

Think past photography for just a second, and imagine where else *you* constantly turn for stories. Is it the music you listen to? Perhaps you really enjoy listening to old-time radio show mysteries, or maybe it's your city newspaper's investigative reporter. I know quite a few people who really enjoy simply visit-ing their local coffee shop and listening to the older farmers tell stories about the way it used to be. The camera never enters the picture (don't mind the pun) in these scenarios, yet story is present and sometimes just as visual.

At the very core is story. It is our base, and a pretty solid one at that! There are many options as to how that story is told, and to say one is better than the other is to head down a very mean street. Photo-graphy is a great way to explore and convey the nar-rative surrounding certain activities in life, while a simple written essay will do the trick at other times with other stories. There's no getting around the fact that at the root is something that needs to get out: story! That's what the Lower Pecos people started with when they created the beautiful rock art that still resides 4,000 years later in Rattlesnake Canyon, and that's what we'll start with as we document and explain our lives moving into the future.

If you're like me, though, you'll have a camera in your hand.

Think back to your favorite songs, books, poems, paintings, and photographs (yours or others'), and you'll probably be able to recall what makes them attractive to you. For each of us, certain elements stick out more than others. Maybe it's the emotion conveyed in the voice of a stage actor, or perhaps the delicate colors and textures detailed in a painting of an East Coast sunset overlooking the Atlantic. We're drawn into story by whichever components attract or interest us initially, and those elements help in unfolding the story when we become engaged.

Personally, I'm interested in characters and settings. I'm engaged in story when the characters, be they human or animal, are described well and take on personalities that are both unique and relatable. If writers can describe characters to the point that I can see them vividly in my mind, there's a good chance I'll keep reading. If a painting or photograph conveys who a person is through showing that person's activity or environment,

I'm apt to spend more time diving into the visual. The same goes for settings; if they're unusual or something I can connect with, I'm interested.

I've always been a fan of environmental portraits, and my own personal work (which doesn't deviate too much from my professional work) focuses on creating "characters" in portraits of folks whose stories I want to document visually. I've also found myself creating contextual shots that highlight facets characteristic of the environments that I'm shooting, such as an urban cityscape emerging from a perceived wilderness.

Take a few moments to jot down on a piece of paper or using a computer what it is that initially intrigues you about story in general. Think about all types of media you consume story through, from your favorite singer to the photographer whose images stop you in your tracks. Make an outline of what components of story interest you using descriptive adjectives and nouns, such as "texture," "colorful," "reality," or "loud," to detail what

An urban environment growing out of the Texas hill country.

Canon 5D Mk II, 105mm, 1/500 sec., f/4, ISO 100

Carrying her wares, a character in a story—more importantly, a human being *with* a story.
Creel, Chihuahua, Mexico.

Canon 1N, 200mm, 1/500 sec., f/2.8, ISO 100

it is about certain storytelling components that draw you in.

After you are finished, look at the outline and compare your interests in story to your own photography work. See any similarities between the components of story that interest you and what you are creating as a photographer? Do you see where over time you've started to produce images that reflect your interests you had in story to begin with? Take note of these connections, or for that matter, any dissimilarity that you might come across as well. You might discover that

what you like to concentrate on photographically resembles what you enjoy in other kinds of stories.

We photographers tend to get wrapped up in the button-pushing parts of our work, often neglecting the story itself. Knowing what we're interested in helps us understand the stories we can stitch together and create with our own images. It's also useful to know where our storytelling strengths reside and what parts of the process we might need to think about or improve upon in future work. ◼

Jim Richardson has seen more of the world than most of us even dream of seeing. As a veteran National Geographic *photographer, he's told a visual story about areas and cultures across the globe, and he is a tireless advocate of the power visual stories hold for society in general.*

Growing up in rural Kansas, where he still lives, Richardson was introduced to photography early in his youth, and his interest in the craft stayed with him through college. Starting out professionally as a photojournalist, he quickly became interested in going beyond shooting the daily news and started delving into the facets of life around him in more detail. His work in Cuba, Kansas, is heralded as an important documentation of the rural Midwest, and his focus continues to return to this setting.

I first met Richardson at a conference during my college days, and I was inspired not only by his images and abilities as a photographer, but how he stitched together the parts of a narrative to which each of his photographs contributed. Richardson was a big influence on how I understood the visual story and how it was put together.

Q **Considering your career as a photographer, how important is storytelling to society?**

A Story and narrative are the ways that we understand the world. We seem to take all of the facts and experiences we have in life and build them into some sort of narrative in order to be able to make sense of our world. We do it imperfectly. We do it with many mistakes. But, if you want to see how we build our worldview, it comes down to how we have taken all the bare facts, experiences, times of our life, things that we know, things that we believe, and frankly, a whole lot of stuff that we're patently mistaken about, and melded them into some coherent narrative. Virtually everybody does it.

Once we have that narrative in place, it is how we filter what we understand and what we encounter. Once that narrative is fully developed in our minds, it is how we pick and choose among all the facts that come at us. It is both wonderful and productive on one hand, and it can be brutally murderous and destructive on the other

hand. It can be the story of the Mother Teresa view of the world, and it can be the story of the Hitlers of the world. We see our world through stories.

If you take groups of people living together and the melding of their different stories, voilà, you have the making of different cultures—as well as the conflicts between them. The truths that we come to understand and believe are somehow different than just a straight depiction of the facts, but they're equally important to us (even if they're wrong). They shape how we as individuals, as societies, feel on issues. Certainly today, the whole narrative of Western culture versus Islamic culture is riddled with truths, half-truths, un-truths, bad perceptions, and faulty logic. However, that whole narrative, that whole story, is what drives a huge piece of what is happening in our world. Similarly, you always have to assume that when people look at a photograph, they're going to take a story away from it—whether you intend for them to or not.

Q Who were your influences when you think about photographic storytelling?

A Early on it was folks like Henri Cartier-Bresson and W. Eugene Smith, and I was really drawn to anything that had to do with the wonders of everyday life and the interactions of people. Frankly, I didn't get fashion, and while I was always blown away by wildlife photography, I never really, deeply wanted to do that. I was a good enough sports photographer, but that wasn't a passion. My passion was to make real life, and particularly everyday life, meaningful.

My reading of the time was deep into people like John Steinbeck and the social ethos of the downtrodden, I suppose. I was also very much, and still am, taken by classical music. I'm probably pretty romantic in those kinds of things, idealistic and taken by emotional content. I kind of lament that the modern world, and even the postmodern world, has kind of shied away from that part of our humanity—of admitting and exploring emotional reactions to things.

Q Do you think growing up in a rural area of the Midwest had anything to do with that emotional connection?

A I think so. When you sit on a tractor and go around a field for about seven or eight hours, you have a lot of time to think. You can work out a whole lot of stuff about the world—at least to your own satisfaction. It is interesting that you find that trait in people who have that kind of time to think. They tend to build up a rich mindscape. It was sort of like Henry David Thoreau on the seat of a tractor instead of at Walden Pond.

Q Is there a particular moment that you can remember that truly emphasized the significant role you play as a storyteller?

A I think that happened in the 1970s when I was starting to photograph rural Kansas. I began taking some pictures that obviously made a statement. For instance, I remember several of the early black-and-white things I did, such as the water witcher, Ralph Fraser, and the picture of the great-grandmother and the great-granddaughter out on the porch. Not only did I react to them, but other people reacted to them in a fundamental way. These pictures were going well beyond just showing what happened, being dramatic, or just being pretty. They made statements.

That was when I really started having an inkling of what storytelling with still pictures was and how it differed from other forms of photography, in the same way that a poem is different from a novel—not just in the form, but in the intent and in the way things get said. Therefore, visual storytelling could be something other than literal, sequential events. That wasn't an easy hurdle for me to get over. I really didn't understand yet how that would work.

For instance, I started working on a story of everyday life in high school (which later culminated in the book *High School, U.S.A.*) I was using the heartfelt things that the students said to me as image captions. Essentially, I was discarding the concept of the purity of photographs and saying that the photographs weren't illustrating something, that they weren't subservient to the story, and that they weren't gallery pieces to be viewed from afar in abstraction. The images were integral parts of the story, as were the captions and the explanatory copy blocks that went with them, as well as the whole layout. Therefore, this whole thing together was the product, and the photographs were just raw material.

A pivotal moment came when we pubished that high school series in the *Topeka Capital-Journal*. We had just run a page about one of the girls who had dropped out of school to get married, and I photographed her wedding and her story. After work that night, I went down to one of my favorite watering holes and one of the waitresses came over and said, "You're doing that thing on the high school." I said, "Yeah." She said, "You know, I saw that story about the girl who dropped out of school and got married. I just wanted to shake her." I thought, "OK, we're getting through now." That convinced me that *story*, not just the pictures, was at the heart of what I was doing. The events of these people's lives were in fact the story, and the pictures and everything else were in service of making that story real.

It made me reconsider my way of thinking about the subjects I chose to photograph. And I withdrew from my idea of photographing all these strange events around Kansas—the rattlesnake hunt, the mule jumping contest—and instead go find one place to photograph and stick with it until the stories took over. That's when I started focusing on Cuba, Kansas, not knowing exactly where it would lead. That was a transformative time in my career.

Q Thinking about your extensive work in black and white, what are the advantages and disadvantages of this format in terms of storytelling?

A Black-and-white images can be complex in terms of storytelling. Black and white is powerful, because it is so abstract and such a distillation of the subject. You've stripped away the color, and you've made it into this thing that is both familiar and recognizable—but yet fresh and perhaps strange. However, it's also somewhat unreal. You talk about distorting things? If you take away the color and make something black and white, you've distorted it quite a bit. Black and white is a great paradox—so obviously different from what is being depicted, and yet so obviously true.

Q Was that a part of the conversation when there was only black and white?

A I don't think we saw it that way. I think we saw color as just too gaudy and that colors stripped away your ability to see the essence of things. You couldn't make statements in color. Everything came out looking like a Kodachrome calendar. We saw black and white as both purer and stronger. If you think about it, black and white gets its strength from that abstraction, stripping away pieces of reality until you're left with something that is a statement.

And then there is the simple reality of what equipment and tools we have to work with at any given time. The photographic necessities of any era, the types of cameras and films we have, come to define our visual thinking about that era. In the 60s, we thought the sort of grainy look we got when shooting available light with Tri-X film was more truthful. The further that you went into the dark netherworlds of everyday life, into the drug domains and the backstage world of the rock bands, and into the unknown hills of Appalachia, the further you went into the world of real life. And real life happened in dark places. Out of necessity your pictures became grainer and more contrasty, and that look became the hallmark of truth in that era.

Q You've worked with *National Geographic* for many years and photographed all over the world in a variety of settings and circumstances. When you think about your body of work, what consistencies do you find (abstract or not) in your approach to shooting story? Is there a particular Jim Richardson style to telling a visual story?

A Graphically, apparently so. People tell me they can recognize my pictures. I don't know what exactly any photographer does to accomplish that. I'm glad I've developed a style, but I don't know precisely what it is I do. Largely, the stories I have done for *National Geographic* are concept-driven. I'm really dedicated to the concept of the story, and I let that drive everything else. So, I can do nature photography and microphotography through microscopes, or nitty-gritty dirty documentary in bars. I simply let the concept drive the photography.

For instance, we have a story coming up in the December issue on the King James Bible. That was of course a tough one to do, because how many pictures of a book, even the Bible, can you take? This is where heavy research comes in to play. I absolutely believe that when the photographer is standing in front of the subject and pushing the button—that critical moment—it is really the product of a long train of events, research, cognitive exercise, and all kinds of things that bring the photographer to that one place, to that one moment.

Also, you can't separate the skill and craft of the photographer from what the photographer chooses to stand in front of, the subjects he chooses, and how he chooses to see them. You always hear of people looking at a picture and saying, "Well, I could have taken that if I was there!" And the answer is, "Yes, you probably could have. Why weren't you there?" Being there is the core of photography. The view that all of photography is happening with the twisting of knobs and the angle of the viewfinder ignores that whole chain of existential, causal processes that bring the photographer to stand in front of that thing and to be able to recognize it and it alone, out of all the things around her at that moment, choosing that particular angle, that particular moment, and that particular way of seeing something.

That's why I spend vast amounts of time on research.

Q **What is your thought process when generating or being assigned a new story to cover? Is there a particular workflow you follow?**

A Usually, the stories that I generate are some sort of happy confluence of experiences, background, thinking, invention, earnest seeking, and skullduggery. The process is total immersion. You just get in there and go looking for all the books, the Web sites, and everything else. Honestly, it's pretty fun, but you have to be willing to go at it ceaselessly. It makes you a really boring person for about a year and a half. You're just totally absorbed in your subject, and you can bring a cocktail party to a screeching halt. Technically speaking, when doing the actual work, I use a program called FileMaker in which I keep all my research. I have database for every story I've done. Each story includes up to 800 sources, and I put them into the database, sort them by the ones that are really prime, merely good, and those that aren't going to make it. I continually collect, sort, and winnow the information about possible picture subjects. When I go out in the field, I want to be loaded with "can't miss subjects"—things that are just visually on target and that I can make great visuals out of.

> Usually, the stories that I generate are some sort of happy confluence of experiences, background, thinking, invention, earnest seeking, and skullduggery.

Q This speaks to the value of previsualization.

A Of course, and the willingness to respond and react when events change, when your cherished perception turns out to be all wrong, when you get to some place and what you've been told is there just isn't there, and when you have to totally revamp what you think you should be saying.

But make no mistake. Storytellers make decisions about what they should be saying, whether they do it consciously or subconsciously. The idea of totally objective seeing without any decision making on the part of the photographer just doesn't stand up to scrutiny.

Q If you had to choose only one of your images to explain how effective storytelling can be achieved through photography, which one would it be, and why?

A There's a picture I did on the Great Plains of two guys in Nebraska putting up hay and watching a big storm come in. Their backs are turned to the camera, and you can see in the way they're standing and looking at the green storm that they're concerned. That image takes the viewer into both the physical nature of the place and time and the emotional and life experience of those guys in the moment. I think that's probably what I've always hoped for in my photographs—for the

Jim Richardson

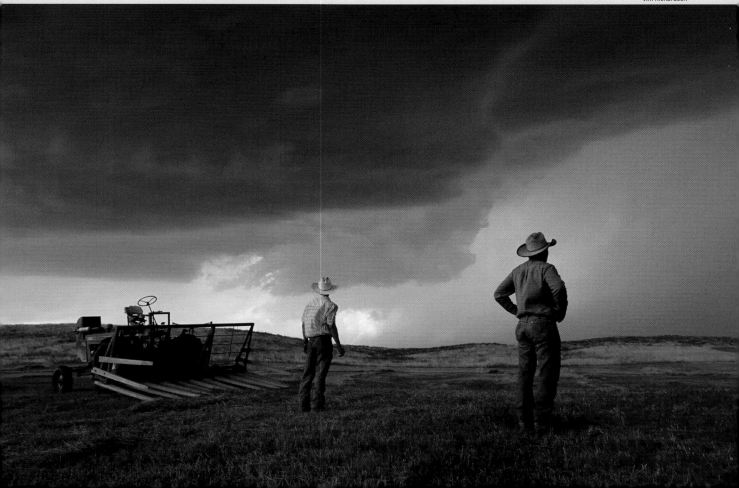

photograph to be transparent, in other words, so that the mechanics of the photograph don't get in the way of the essential experience. I always had the feeling that if people are noticing the cleverness of an image, it's probably not speaking to them directly, and it is saying something other than the essence of the subject.

There's some ambiguity of emotion in the image as well, and I'm glad to have been able to do that for some place out here in the Midwest. If I hadn't been photographing this area, I'm not sure who else would've been doing it. That's one of the things I admired about Cartier-Bresson. He took everyday life out in the countryside of France and made art out of it and brought respect to it.

Q **Besides camera gear, what is one thing you've found extremely useful in telling visual stories?**

A Reading lots of pictures. It's important to figure out how they say things and realize what an incredible, vast multiplicity of ways there are that pictures say things. Also, realizing that no one methodology has any lock on the truth when you're talking about making pictures that speak to reality.

The other thing that influences me, I suppose, is music. Music has been the way that I think about pace and rhythm. For me, it's been classical music and how it allows what is obviously a totally nonverbal narrative to take on shape and form. I've gotten a great deal out of music from that sense of it, and I know that there's a process by which when I listen to music, the kinds of stories that I try to tell take on a grander vision.

Q **If you could give one piece of advice to those starting out telling stories with photography, what would it be?**

A Read widely. In this case, that means read pictures and picture stories widely. By widely, I mean broadly as well as in depth, so that you reach out into areas beyond your comfort zone, you reach out into subject areas that you don't think you understand, and you reach out into methodologies that wouldn't normally fit into your worldview and your field of photography. Through this stretching exercise, you both become well rounded and able to adapt, because nothing else in this world is going to beat the adapting that keeps us alive. That goes for still photographers as well. ■

To see Jim Richardson's work, visit his Web site: jimrichardsonphotography.com.

CHAPTER 2

The Photographic Storyteller

So, who are we really? When you pick up your camera, strap it over your shoulder, and walk out the door, are you suddenly a different person than you were moments before? If you're like most folks who consider photography a profession or a hobby, you don't spend much time waxing philosophical about what it means to trip the shutter or compose an image. You'd rather get on with making images, thinking creatively, and deciding on what to eat later that evening. However, amid all the shutter actuations, lens changing, model posing, gear buying, and minutes spent in front of the computer screen, it's probably worth a second of your time to reflect on what it is we are actually doing when using all the equipment we collect in the name of photography.

A Texas windmill and vibrant sunset offer a sense of place.
Canon 5D Mk II, 400mm, 1/1000 sec., f/5.6, ISO 100

THE CAMERA IS OUR SOUNDING BOARD

If you're like me, you enjoy traveling. It's probably one of the reasons you picked up the camera in the first place, and since then, you've found more reasons to travel. When you are traveling on assignment or for leisure, you can't help but notice the abundance of other travelers with digital SLRs (dSLRs) slung around their necks, ready at a moment's notice to snap a frame of a street performer or a restaurant sign.

Now, before you pass any judgment about the tourist clutching his brand-new Canon, keep in mind that we've all been there in our photographic journey, and the tourist may see you in the exact same light. However, if you're reading this book, it stands to reason that you're seeking to be a bit more than the stereotypical tourist shutterbug.

What separates you from them? In the way of technology, not much, I'm afraid. Their camera does the same thing as yours: records images. You might have spent thousands of dollars on your rig, versus their $600 purchase, but often that won't cut it.

How about travel destination or location? If you're standing right next to them with camera in tow, you can't really make this distinction either, although you may be driven to find a more original vantage point. On the surface, you are another traveler with a camera. Sure, maybe your tripod is carbon fiber and you use a fancier strap, but theoretically, you're there to do the same thing: make images.

What separates you from the crowd is your ability to record images in a way that stitches together a narrative and a greater understanding of where you are and what you are seeing. We're not just experienced tourists walking around with cameras in our hands. We are storytellers, and we have a very specialized, creative way of carrying out our purpose!

The camera serves simply as our sounding board. Historically, that device was used to help project the sound of orators to crowds of listeners. Just as stories were told first vocally, then in writing, and then through various forms of art and communication technology, taking photographs is one of today's prime methods for visually describing what is in front of us at the moment.

At the risk of sounding awfully clichéd at this point, the camera is just a tool we use, much like the writer's pen, the singer's microphone, and even the ghost storyteller's campfire. We use the camera, its ancillary components, and all of our technical knowledge about it in an effort to record visual nuance,

> What separates you from the crowd is your ability to record images in a way that stitches together a narrative and a greater understanding of where you are and what you are seeing.

dynamics, and emotional context within an environment that throws a variety of contingencies at us in the process. Understanding how to use our equipment in any situation brings us closer to becoming better visual storytellers.

WE'RE NOT THE ONLY ONES INVOLVED

Each photographer goes through stages while becoming technically proficient with her gear, and more often than not, this facet of shooting overtakes the meaning created in the images we produce. I'm sure you can think of at least a handful of images that you are extremely happy with based on *how* you achieved them rather than what they are saying to a wider audience.

Students lean in tight to photograph a western diamondback rattlesnake. This isn't the environment or circumstances in which you see the typical tourist holding a camera.

Canon 5D, 24mm, 1/125 sec, f/8, ISO 100

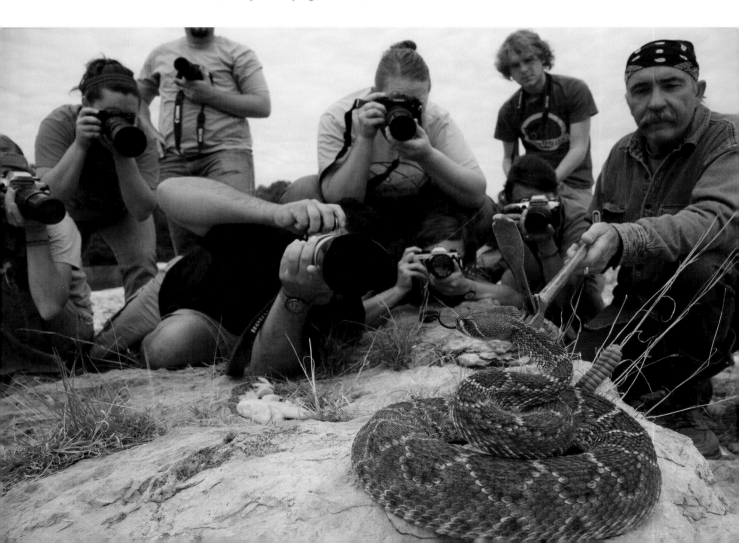

One of my more recent battles with the issue of making the method more important than the meaning occurred while on assignment for a state wildlife magazine. I was photographing a story on conservation efforts to protect a threatened lesser prairie chicken population in Texas. In addition to taking pictures of the animals, I was assigned to photograph several people involved in the story, including conservationists, researchers, state agency representatives, and energy lobbyists. One such person was Jeff Haley, a ranch owner in the Texas Panhandle, a cowboy, an intellect, and a great steward of the land he owns.

Jeff Haley shown here in the original image. The dark shadow splitting his face is the key element that takes away from his true personality and his role in the magazine story.

Canon 5D Mk II, 110mm, 1/200 sec, f/7.1, ISO 100

I drove several hours to meet with Jeff on our first visit, and the photo shoot was a three-hour ride across the ranch in his pickup, talking about the plains, his cattle operation, and his endearing connection with the prairie chickens that he no longer sees on his ranch. His portion of the story I was shooting related him to the land, so we would periodically stop the vehicle, and I would photograph the rolling prairie landscape and make portraits of Jeff along the way.

The whole time we were talking, and I was learning more and more about him and his family, their heritage with the land, and the reasons he considers himself a working conservationist. Toward the end of our shoot, when the light was sitting atop the western horizon, we drove down into a small dip in the land, an area that rolled with beautiful golden bluestem grass. I mentioned how well the area would serve for a portrait backdrop, and we set up about 100 yards from the pickup with just the breeze and the slight rustle of the grass.

I'm a field lighter, so I had what I call a quick bag of lighting equipment, and within minutes, I had an off-camera flash set up on a stand with a daylight reflector just below, forcing warm color back into Jeff, whose back was turned slightly to the setting sun. The resulting images were edgy and visually demanding. The hard light from the sun hitting his right side was gritty, and the light from the flash and reflector defined many of his facial features. The shadow created between the two, from my point of view, was the icing on the cake and gave the shot a signature Western feel.

At the time, I was really pleased with the shots, and still am, mostly because of the lighting. For the purpose of the story, however, this wasn't enough.

All things technical came together in Jeff Haley's portrait. What didn't come through was his role in the magazine story. I sought some feedback on this shot from the story's writer and a few colleagues after I made

it, and I remember one photographer's statement more than others. He enjoyed the shot for what it was but wondered if I was trying to make Jeff look like the bad guy. I looked deeper into the portrait, and I came to realize that the lighting and the contrasting shadow that I enjoyed were a bit intimidating and threatening. The black cowboy hat added to that feeling as well.

I came to know Jeff through the shoot and a few visits afterward, and he's every bit a gentleman and all-around nice guy, so threatening was not a word I wanted used to describe a portrait of him. After all, Jeff was the conservationist in the story, someone who yearned to see the prairie chickens flourish on his ranch again. Although the portrait is still one of my favorites, it does not exactly tell Jeff's story.

Essentially, I was wrapped up in making a shot that was technically impressive instead of creating the appropriate connection between subject and viewer. The image looks cool, but it says something completely different than what I meant to say. Just for good measure, I submitted this portrait to the magazine, along with others that weren't as "threatening," and the publication went with a more true, complimentary photograph than the one that I had thought was a sure thing. This issue crops up all the time when I'm on assignment, and because of this one incident, I'm more aware now of just whose story I'm telling. Thanks for the critique, Moose Peterson. ■

The portrait of Jeff Haley that was published alongside the conservation story depicted him in a less aggressive "light." McLean, Texas.

Canon 5D Mk II, 58mm, 1/200 sec, f/8, ISO 100

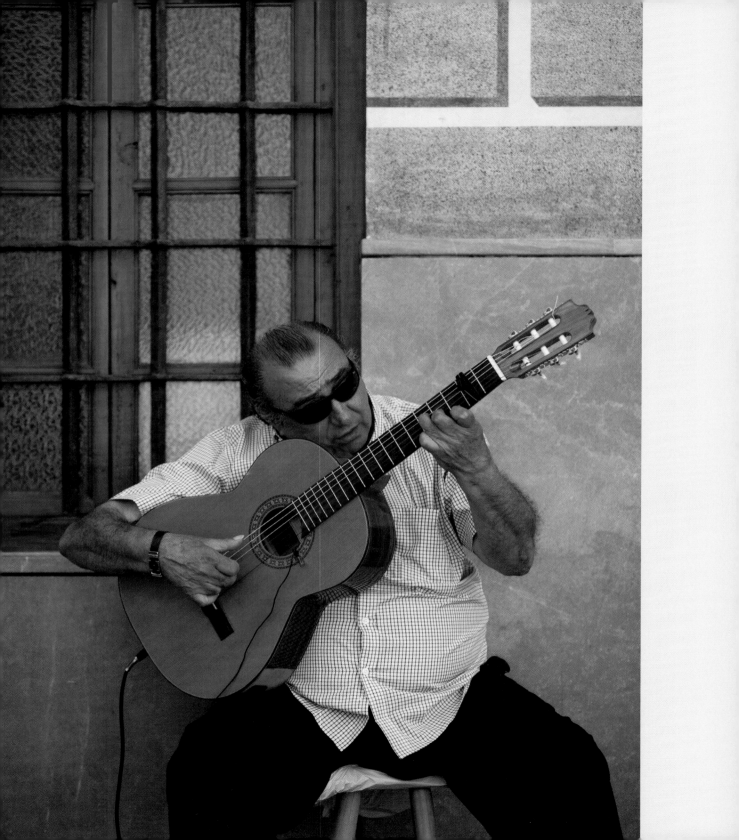

Just as we can express our own vision through images, we are also telling the story of who or what we are photographing, and the camera and our technical ability can sometimes get in the way of good storytelling. We'll always stumble over some of the technical details of making images, but the more we concentrate on creating story, the less stumbling we do along the way.

Creating visual stories is a two-way street, a relationship between the photographer and the subject. The subject may be static or live, but either way, the minute we publish an image in a magazine, newspaper, or image-sharing Web site, we're saying something about both actors. My villainous image of Jeff Haley says that I'm a photographer who knows how to use artificial light in a field context, but it doesn't exactly do his story justice. The image chosen for the story, however, fit his personality and role in the overall narrative while conveying my own photographic style.

DON'T GET DISTRACTED **Everything that glitters isn't necessarily gold. When you're taking a portrait, the subject's story is a significantly higher priority than your own ego. Cool effects may impress technicians, but they aren't telling the story you want to tell.**

Don't get me wrong—I'm not saying that the technical achievements are not important. Working on this aspect of your photography is infinitely valuable. I do believe, though, that our work as visual storytellers is most effective when the technical does not get in the way of the unfolding narrative. Sometimes, the technical aspects of images help advance the direction of the story, but that requires awareness. This is something I'll discuss in more detail in the following chapters.

A Spanish guitar player outside the city cathedral in Granada, Spain. Tourists pass by this gentleman daily and make similar images. What separates this one from theirs?
Canon 5D Mk II, 108mm, 1/500 sec, f/2.8, ISO 200

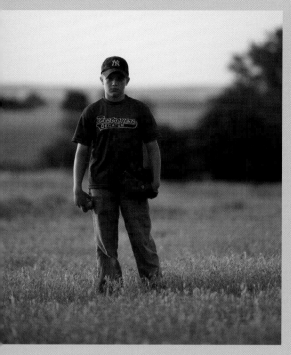

Field of Dreams. Sometimes your own family members help build your storytelling portfolio. Baseball is an important part of Dillon's life on the rural ranch where his family lives. Cottondale, Texas.

Canon 1D Mk III, 195mm, 1/250 sec, f/2.8, ISO 100

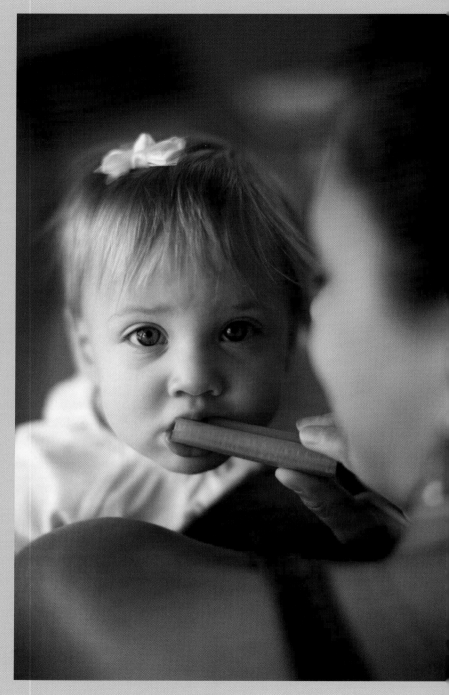

My youngest cousin, Addison, on her first birthday. Even if your heart's desire is to photograph extreme sports whilst hanging out of a helicopter window during a thunderstorm, don't shirk your role as the family photographer and visual storyteller.

Canon 5D Mk II, 50mm, 1/250 sec, f/1.4, ISO 100

STORY CAREGIVERS

We all start out by viewing photography as an involved hobby. Sometimes this leads to becoming a professional. Sometimes it means becoming a skilled weekend warrior. No matter which way you go, there's a good chance that the minute you pick up the camera is the minute you become the "family photographer."

This, my friend, is not a responsibility to shirk. Sure, you may not be a photojournalist in this setting (even though you might feel like you're in a war zone at times), but this is a big job. You are now the family documentarian. When little Max blows out his first birthday candle or your grandparents celebrate their 50th wedding anniversary, you're expected to be there, ready to make sure each highlight is given its due.

In years to come, your images will be regarded as family treasures. This is no joke. I've seen family members argue over who gets to keep historical photographs of ancestors after members of the family pass on. Images of family make up the story of the people within them, and you are now a big part of archiving and presenting that story. Congratulations!

Let's shift gears to outside the family environment. Think of those images that are considered iconic, such as Steve McCurry's *Afghan Girl*, Nick Ut's image of Kim Phuc running from a cloud of napalm in Vietnam in 1972, Dorothea Lange's *Migrant Mother*, and Ansel Adams's beautiful depiction of the Snake River winding its way through the Teton mountains. These are historical remnants of days gone by, yet the stories that are conveyed within their frames are timeless.

You might say that some of these were just "right time, right place" types of images, but that negates the fact that all of these photographers were set on telling story in the first place. Their skill set, their vision, and the way they saw the world, their technique and style, and their passion for photographing their subject matter played just as large a role, if not larger, as any geographic location and time.

Whereas at the beginning of their careers some of them might have been technically and emotionally ready to photograph their nephew's first track meet, at the time they took these iconic photos these photographers were in the hot seat, ready to do anything to document and create a visual story. They acknowledged their responsibilities as photo documentarians, just as we do each time we put the camera to our eye.

We are, in essence, story caregivers.

> We are, in essence, story caregivers.

Through photography, we become visual stewards of life's activities, places, individuals, and just about anything we can shoot. It's easy to fall into the mentality that some things are not as important to photograph as others, such as a family holiday gathering versus an assignment for a regional feature-based magazine.

Underneath the surface, though, there's still story, and that story is important to someone. To be honest, I'm not too sure how important a newspaper-run photograph of the stock exchange might be to a grandmother who has just picked up prints of her first granddaughter's junior high graduation (no offense to those of you who photograph the stock exchange). As the camera-wielding, shutter-happy people that we are, story is all around us, continuously unfolding, and we each have a role in telling a small piece of it.

If I may get on a soapbox, I believe we photographers actually have a responsibility to tell story. This is not an ethics statement about what kind of story you should tell, but rather a perspective on what it means to be a photographer, at any level of the game. We are provided the means to create, and with that ability, to say something with imagery. Each and every one of us—whether we're working in fashion, human rights, or photojournalism of other kinds, or whether we're the uncle who always has a camera around his neck at family reunions and baseball games—is a part of a tradition of storytellers. We stitch together life, in a

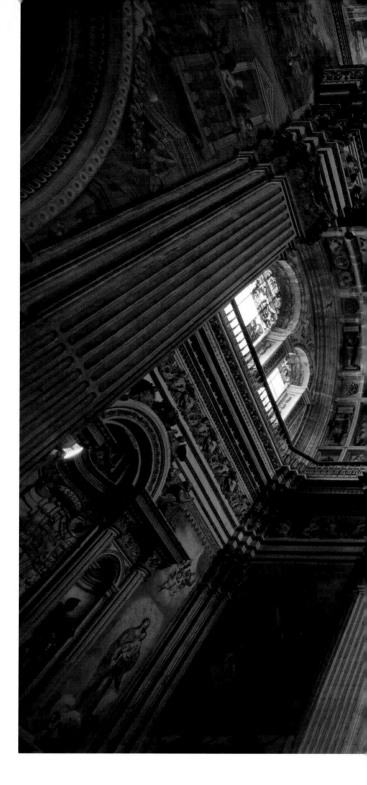

Places of worship in Spain are heavily populated with religious imagery, such as this ornate Jeronomite cathedral in Granada. This imagery was purposed in part to provide a visual depiction of the stories priests provided orally before the printing press and a more literate society emerged.

Canon 5D Mk II, 17mm, 1/30 sec, f/5, ISO 800

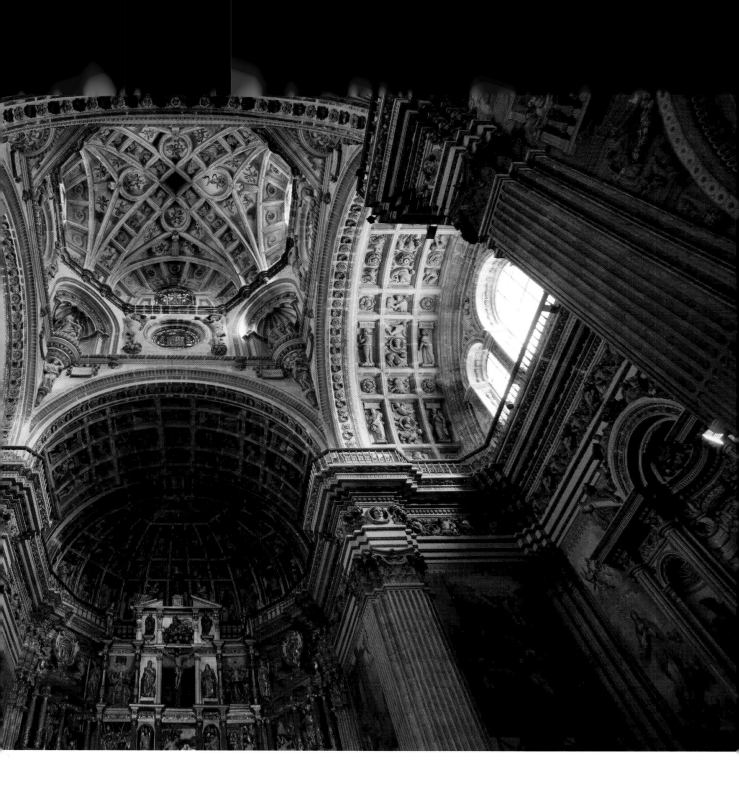

studio shoot for a new T-shirt line, on the front lines of a protest, or in the family backyard, for others to consume, appreciate, learn from, or enjoy.

To that extent, we have a responsibility as photographers. Those who embrace this responsibility ultimately become better storytellers. It sounds pretty heavy, but we're attracted to creating story; otherwise the camera is just an electronic tool that we fiddle with periodically.

Some folks are obviously more addicted to storytelling than others. Some approach it in a more roundabout way yet create equally compelling images. No matter what level of enthusiasm for and dedication to the craft a photographer has, his photographs provide a depiction of life in a way that other forms of visual description, such as paintings, can never do. Much like orators, some photographers tell stories in more interesting and captivating ways than others. They have learned their craft *and* combined it with finding, visualizing, and creating story.

This is a continuous learning process, and good storytellers, no matter how they choose to do it, are always striving to tell a better story. Each story is different and not meant to be told the same way. Sure, individual stylistic characteristics may occur across stories, but each story deserves a fresh approach and a varied telling. Good storytellers know this, which means the story is in good hands. Caring hands.

THE INTENTIONAL FALLACY: FRIEND OR FOE?

Have you ever heard the statement "It's all just so subjective?" Of course you have! We've all heard it and said it dozens of times before becoming photographers, and twice that much since. It's no secret anymore that most things produced through the creative process involve a variety of factors, such as inspiration, influence, personal experience and history, technique, gadgets, and good ol' know-how. You can thank postmodernism for that.

Personally, I can certainly appreciate and respect the subjectivity we consider as part of being creative. However, at times this statement can really get under your skin, especially when it is made in reference to your own work. I know, I know, it shouldn't really bother me (or us), but it does. It's at these times you get a bit defensive about your images and about the circumstances that brought you to trip the shutter at that particular time. You feel as if you have to explain what you ate for breakfast the morning you made the photograph, the tire you had to change as you were on your way to the shoot, as well as the puppy you lost when you were seven years old that inspired the emotion you were trying to emphasize, in order for the viewer to fully understand

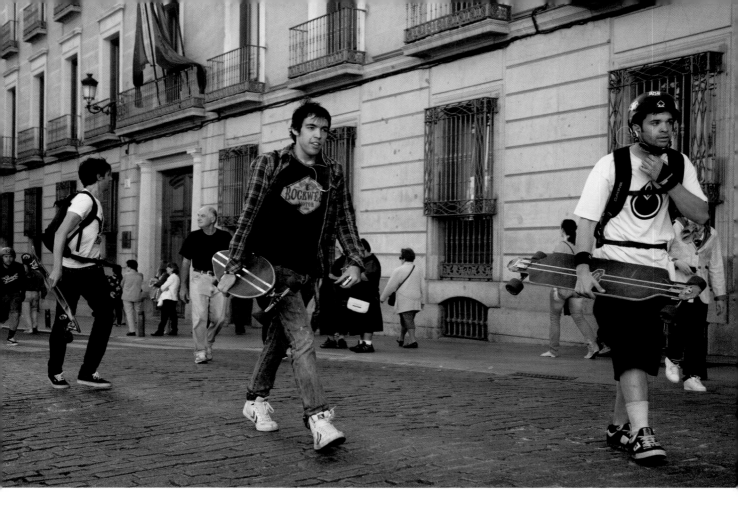

and finally "get" your work. And you thought you were just creating a colorful, well-composed image.

So, why does this comment, or situations where people are drawing different conclusions from our work than we are, get on our nerves? It has something to do with what folks much smarter than me call the intentional fallacy.

More of a literary term than anything, the intentional fallacy essentially refers to the difference between the creator's intended meaning in a piece of work and the meaning derived from the work by those who consume it. The fallacy, or mistaken idea, occurs when authors believe that their intended meaning is the only true meaning. I don't see why

it can't apply to photography. I'm not sure what the literary critics would say, but I'm willing to bet many would side with me on this.

When you make an image (or a series of images) and then release it to the world via a physical or online medium, you are letting it trot away into the wild. The wild is where people who did not create the image exist, where interpretation of and connection to the image are arbitrary at best sometimes. You might be able to explain your image to a small group in that wilderness, but for the most part, your image has to do the talking.

On top of that, it will speak differently to different people. The message an image sends to viewers is

Perspective has quite a bit to do with what the photographer intends to say and what the viewer interprets. The lines of this image are pleasing. However, I've always thought the lines in the clouds made the sky look a bit, shall we say, nuclear.

Canon 1D Mk III, 200mm, 1/200 sec, f/4.5, ISO 100

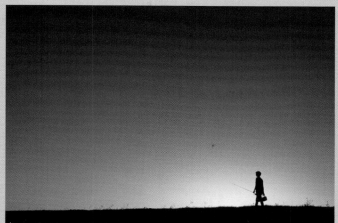

An image of a young boy walking across a lake dam after a pleasant evening spent fishing can mean so much more. Cottondale, Texas.

Canon 1N, 24mm, 1/400 sec, f/5.6, ISO 100, Fujichrome Velvia

Meaning is variable when you release an image out into the world. This oil pump jack set against a ferocious West Texas thunderstorm might mean one thing, while the rainbow peeking through the clouds might change a viewer's interpretation altogether.

Canon 5D Mk II, 17mm, 1/50sec, f/5.6, ISO 200

Just like abstract art, natural occurrences, such as this vivid sunset in McAdoo, Texas, are open for interpretation, appreciation, and criticism.

Canon 5D Mk II, 200mm, 1/320 sec, f/2.8, ISO 100

interpreted not only with the photographer's intention, but also with the viewer's history and place in the wilderness, as well as the contextual matter surrounding the work, such as text, other art, and maybe even the inappropriately placed advertisement on a social media Web site. All of these things, plus many more, come to play a role in how an image, *your* image, is viewed, consumed, and experienced by any number of people.

The wilderness that is the audience is vast, but it is not an unfortunate place for our work as photographers to reside. Remember my story about Jeff Haley's portrait? I had a completely different perception of my own photograph than did some other photographers and visual communicators. A little constructive criticism doesn't hurt now and then—in that case it ended up being helpful. It also helped me understand why the magazine picked a different shot to feature. You don't always have the chance to receive feedback on your images before they're officially "out there," but it can be valuable when you do.

So, if the intentional fallacy is an issue we confront continuously, and it doesn't *seem* like we can do anything about it, why even bring it up in regard to storytelling? Well, why not? Part of creating story is being able to effectively communicate a message. Stories are told to other people, and there's no way around that important part of the process. If you, the creator, the author, the *photographer*, want to tell stories, it's worth considering that there will always be different ways of seeing and consuming the same story that you produce.

I don't believe the intentional fallacy should drive you to change your visual style should it prove successful for you, but keeping the audience's interpretation in mind might just help you seek out those images that really do tell the story you want out there—you know, in the wilderness.

SEEK GENUINE FEEDBACK **Constructive criticism is extremely valuable. If you are ever concerned about whether or not the images you create are really telling the story you want to show, get other opinions of your work. After producing a series of images, edit them enough to create a small selection (approximately five images), and ask for thoughts regarding your storytelling direction from others you know will provide you with an honest thought or two about what the images are saying to them. Remember, this type of critique is not meant to be harmful, nor is it the polemical truth. Its sole purpose is to help you determine whether the story you are attempting to tell is coming through. Use this information to grow as a photographer and to continually improve your storytelling abilities.**

Another answer would be to use the intentional fallacy while in the field as a way to see the images you create. Photographers and other artists alike have stared this issue in the face for eons, and the more we come to recognize our work as being prone to different interpretations, the more we're able to use that knowledge in how we compose, what we emphasize in our images, where our focus is placed, and even the color temperature we use on certain shoots.

Intentionally giving viewers the ability to interpret beyond the overt story in your images might just provide you with the depth of storytelling you and your images need. Instead of just photographing a waterfall as you've seen it before, or under environmental and technical conditions you are likely to shoot others under, approach it from an angle that perhaps emphasizes the fragility of the environment around it and underexpose the scene by two-thirds of a stop to

A gloomy Gorman Falls, Bend, Texas.
Canon 5D Mk II, 35mm, 0.5 sec, f/22, ISO 50

Robert Frank is a well-known name in American photography history, although during the 1950s, his name would more than likely have been given a chilly reception in photographic circles. A Swiss photographer, he immigrated to the United States shortly after World War II. Like most shooters, he found the industry to be a hard compromise between creative vision and editorial administration, but after several years he was freelancing for some of the biggest names in New York.

In 1955, Frank received a Guggenheim grant to photograph life across the United States. After two years of traveling across the nation, sometimes with his family in tow, he pulled together one of the most seminal volumes of photojournalism and art history: *The Americans*. The book showcased Frank's interest in the people who made up the nation, but more importantly, it was a deviation from traditional photojournalism and art photography, which highlighted the ideal America.

Among other themes, the 83 images used for the book touched on class struggle, distrust, segregation, and poverty. His images were often out of focus and extremely grainy, and his work was criticized for lack of technique and "quality." Today, however, the book is considered one of the most iconic collections of American photography, in part due to the rise of the beat culture and Frank's relationship with folks like Jack Kerouac and Allen Ginsberg. Regardless of how *The Americans* first gained attention, though, the fact still remains that individual viewers of his work also saw meaning in his images, meaning derived from documenting American life.

Kent Lowry, a good friend of mine and an outstanding media educator, and I often have conversations about *The Americans*, and I've invited him to lecture a few classes about its prominence in photography. Kent highlights one of the key elements of why the book makes an impression: the intentional fallacy. Although Frank suggested meaning in his images, he allowed the audience to interpret them in a personal way.

Kent makes a good point in noting how Frank's images were interpreted by others: differently and with varied meaning. Unless we can talk to Frank himself, we can't know exactly what he was trying to say with his images, but we all can infer meaning ourselves about the stories contained within the frames. Robert Frank and *The Americans* made viewers think about the story of their fellow human beings. The collection gave insight into different areas of life, and it begged viewers to question what was happening and who was in the photographs.

Every time I consider how an audience might receive an image I produce, I think about Robert Frank, photographer and visual educator. ■

Faith and religion, as well as death, are strong universal themes upon which story is often constructed. Shafter, Texas.

Canon 5D, 24mm tilt-shift, 1/400 sec., f/3.5, ISO 50

subtly help the viewer interpret the image on a different emotional plane.

This sounds a bit like directing your viewer in experiencing the image, and it is. You are the creator, and although the intentional fallacy is not going away no matter what you do, you can use that knowledge as a tool in your belt that helps you find and breathe more life into images below the surface of the story you primarily want to exhibit to an audience.

VISUAL THEMES

Stories contain messages—messages that might convey a mood, perspective, or moral. Stories make us feel a certain way, give us another way to look at things, and inform, educate, and entertain us. More importantly, though, stories are *about* something. Whether spoken, broadcast, shown through photography or film, stories revolve around thematic narrative structures.

Remember when you first heard the phrase, "The moral of the story is…?" The moral happened to be part of the theme: right and wrong, the strong versus the weak, good against evil. Such themes, among many more, are what story is constructed around.

While it seems elementary to think of these ideas in terms of *Little Red Riding Hood*, certain themes persist through time. Themes are as old as story itself; in essence, they are what story is really about. Love, beauty, faith, conflict, peace and unification, destruction, religion, progression, conservative and liberal, happy and sad—these are all themes upon which stories are built. Likewise, as many photographers and writers before me have emphasized, the more universal the themes—the more relative these thematic foundations are to the global population—the stronger the story.

If this all seems a bit too philosophical to you, consider the different types of photographers in the industry, who focus on sports, family, war, travel, lifestyle, and more. All of these photographers find themselves shooting in accordance to broad themes that identify their genre at the moment. These themes can be narrowed to several less abstract but just as encompassing ones. Travel photographers build upon themes related to the journey and adventure of life, where life will take you, and the excitement it might provide along the way. Humanitarian photographers thematically create images that inspire assistance and justice, hope and peace, as well as a unified global population. The wedding photographer is focused on shooting love, family, and the perpetuation of those two into the future.

These are fairly broad generalizations, and each genre has its own more specific thematic possibilities. But the point is, it is to our advantage when telling story, whether it's through a photojournalism piece on the famine in Somalia or a wedding in Kalamazoo, Michigan, to determine or identify themes that will aid us in the storytelling process.

> Themes are as old as story itself; in essence, they are what story is really about.

Travel photography touches upon thematic topics such as culture, journey, and adventure. The blurred movement of the people and the car lights near the Giralda Tower in Seville, Spain, abstractly relate to these themes.

Canon 5D Mk II, 24mm, 2 sec., f/22, ISO 400

A great way to start developing and shooting with storytelling themes in mind is to find them among the images you have already made. I believe that each individual, knowingly or not, is drawn to certain universal themes over others.

PART I: DISCOVER THEME

There's a reason you became a photographer, and it's likely to be apparent in your images. If you started out taking shots while you traveled, then you more than likely see themes related to culture, adventure, food, and other global narratives. For those of you who picked up the camera the moment you became a father or a mother, looking through your archive of images devoted to your children might result in identifying themes closer to purity, youth, joy, love, and possibly tradition. Consider these reasons for initially learning how to shoot as strengths. You've started to develop images along certain universal themes because you are in tune with them.

Determine what constitutes the bulk of your work. Are you a landscape shooter? A lifestyle photographer? Perhaps you use your camera as a tool to shape people's attitudes about the less fortunate and how they should be treated. Comb your archives, if you must, to make this determination.

After you have a hold on the type of photography you lean toward, start looking at the images you have produced. What do they represent? Be philosophical for a moment, and write the answer to this question down. Answering it will point you toward a universal theme or themes that your images embrace and relate to other viewers. This part of the exercise may seem somewhat useless or vague, but it puts you in the mindset of looking for and identifying themes, not only among your existing archive but also among the images you are yet to produce.

PART II: SHOOTING THEME

Assign yourself a weekend of shooting toward a universal theme. For the sake of the exercise, choose a rather abstract one, such as good and evil, prosperity, youth and age, power, or even life and death.

Once you've selected a theme, develop a list of at least 15 potential images that will highlight said theme. This will invigorate your creative juices, and even though you've already made a list of images, you will now be more likely to see others that showcase the theme you're shooting. While flowers or street signs are relatively specific, *images* of flowers or street signs might actually contribute to storytelling themes that reach a broader audience.

Once the weekend is finished, edit your images down to the top ten that highlight your theme, noting why they are the strongest of the bunch. The "why" should relate to the theme you chose to cover. If it suits your liking, write down the reasons these images are strong representations of the theme. A more practical way of putting words to this facet of the exercise is to caption the images with your theme in mind.

Although it may seem impractical to repeat these exercises in a formal way each time you shoot, keeping them in mind will strengthen how you find and make storytelling images. The more you are open to finding and developing images that touch upon universal and regionalized themes, the stronger you become at saying something with your images.

The themes you discover among your images or what you continue to shoot may change over time. You might have started out because of your kiddos, but you might eventually find yourself shooting diptychs that illuminate a theme focused on justice and the lack thereof. Regardless, knowing how important themes are to storytelling will push you to be persistent in identifying the possibilities for producing stronger images. ■

From abstract, theoretical meaning to detailed specificity, stories are developed across thematic structure. Themes give stories breath, keep them on track, and invite broad and niche audiences to consume and interpret our images. Remember what I said about the intentional fallacy? A photograph is a document, but it is a subjective document. Likewise, beyond what is simply in the frame, this document will *mean* something to someone. A rainbow appearing at the end of a torrential thunderstorm means something different to a variety of people. Photographers might look at a photograph of a rainbow and think, "Nice photograph." Others might read hope, unity, strength, or a promise in the same image.

Take a deeper look into your own images. When we start thinking about story from a thematic point of view, we begin to notice what we are saying with our images. Photographers can shoot under a fairly specific theme and develop images that also say something more universal. For example, developing images thematically around city color might excite the notion of global culture in viewers. Good versus evil might be emphasized in images that were developed around the more pragmatic theme: venomous creatures of North America. You quickly become versed in the versatility of the images you have made, and you start to see where developing a theme for a particular shoot can provide you creative guidance and a new vision for what or whom is in front of your lens.

Fortunately, photographers are able to do more than devote ourselves to the sense of sight; we can capitalize on themes that contribute an additional dynamic to a story. The ability to tell visual stories that revolve around universal themes is significant. It puts the phrase "a picture's worth a 1,000 words" into perspective, doesn't it?

After a storm, a rainbow is a sign to many. The implied meaning can fall under several thematic structures, religion being one. Christians believe that a rainbow represents a promise between God and the world's population to never destroy the earth again with water.

Canon 5D Mk II, 17mm , 1/60 sec., f/3.2, ISO 400

Bright, exuberant colors complement the signature white of Cordoba, Spain's historic town center—an abstract way to suggest the excitement of travel.

Canon 5D Mk II, 50mm, 1/400 sec., f/8, ISO 100

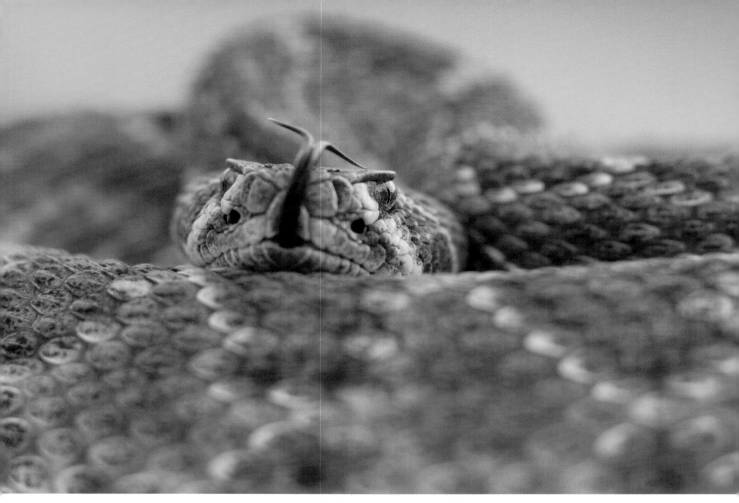

A poisonous snake, such as this western diamondback rattlesnake, symbolically suggests "evil" in some cultures.

Canon 1D Mk II N, 115mm with extension tubes, 1/160 sec., f/4, ISO 50

Themes are always the foundation of stories. A magazine publication guided by a mission in wildlife conservation contains a variety of specific articles, and each speaks to its audience under a more broad theme: preservation of life and well-being. You might see this theme also addressed through stories and images in other publications dealing with human lifestyle, health, or even politics. Themes are theoretical, yet attractive. Stories, visual stories included, are tangible and representative. Without one, it's hard to find the other.

ARE YOU TELLING A STORY? CHECK AGAIN.

By now we can agree that the point for many of us in slinging a camera around our shoulders is to tell a story with our images. Everyone who attempts this part of the craft does so at varying levels of aptitude, interest, and quality. Some of us may notice two older men having a chat on a park bench and decide that would simply make a nice picture, while others may spend a month researching and photographing a series of images on what occurs inside a denim manufacturing facility. Intentionally or not, we're saying something with our images. The question at the end of the day is, *what* are we trying to say?

To experience growth as a photographic storyteller requires one to be a bit reflective. This may come on as many levels as you would like, but it ultimately resides in looking back on how you achieve telling a story each time you trip the shutter and where you go from there. There is no ten-step process to learning how to tell a story, but I would wager that many folks with a hankering for photography have already benefited from examining their own work.

Remember the time you were shooting a pristine farm landscape and, after making several images at standing height, you lowered your perspective to emphasize not only the vastness of the land but the dense barley crop that flowed like green ocean waves? That was literally being reflective in the field. How about the time you were driving away from your first paying assignment from the local newspaper featuring a local barber and you thought to yourself, "Why didn't I get a shot of him sitting in his own chair with a shoot-through umbrella feathered past him to the right?!" That is also being reflective. And you can't forget the blog post you wrote about one of your all-time favorite images, what it felt like the day you made it, why it was important to shoot, the image's backstory, and why you still consider it a keeper. Yep, you guessed it: reflection.

Reflection is only part of a culmination of photographic insight, processes, and lived experiences that make us better visual storytellers. However, it's one that we can continually employ, whether we're deciding on an f-stop during a shoot or editing our images later on the computer. The more we do it, the more it becomes second nature, just like figuring exposure equivalencies and focusing for maximum depth of field. Reflection need not be a time-consuming task added on to each shoot's editing process, and there are no rules about keeping a diary (although I know several successful photographers who do in an effort to detail a shoot or inspirational experience). Reflection, though, is a valuable component to improving your storytelling ability, both technically and conceptually.

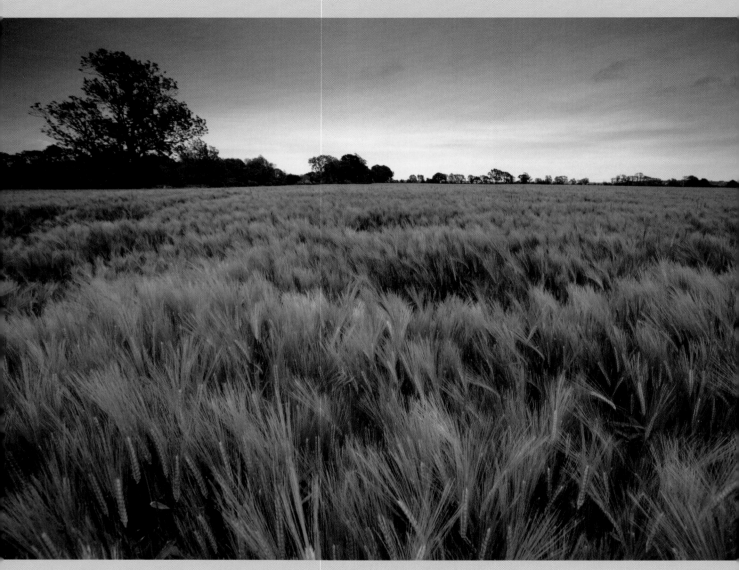

Lowering a wide angle lens into the barley crop helped emphasize the immensity of the field, while a graduated neutral density filter brought back the detail in a rain-heavy Scottish sky. Near Montrose, Scotland.

Canon 5D Mk II, 17mm, 1/160 sec, f/8, ISO 200

A FEW BASIC QUESTIONS

Reflecting on your work essentially begs you to ask yourself questions about the images you create. These questions are not set in stone, and no exhaustive list exists. Here, however, are a few abstract questions I routinely ponder, consciously or subconsciously, along the way:

- Am I telling a story with this image?
- Is it the story I want to tell?
- What elements in the image(s) might distract or intervene in the successful telling of this story?
- Is there anything else I could use that would strengthen my ability to tell the story I'm photographing?

Throughout the rest of the book, we'll concentrate on those areas of creating story that benefit from constant reflection. Consider this encouragement to always know why you are making certain technical, aesthetic, and stylistic decisions. The following pages detail ways to consider storytelling on the spot and later as part of your growth as a photographer. I would be presumptuous if I said the following information is prescriptive. Rather, it is an effort to charge you with considering why we make decisions with the camera that aid or counter our knack for telling a good story. At the end of the day, this is our goal, right? After all, we have this hefty responsibility of being the story's caregivers.

Robb Kendrick

I unabashedly call Wyman Meinzer my foundational mentor in photography. We've known each other for a number of years now, and I've had the opportunity to ride along on more than a few adventures with the official state photographer of Texas. We met at Texas Tech University when I was a student, and I took one of his well-regarded field courses, which I now co-teach with him every summer. Ever since I took his class, I've been fortunate enough to call him my friend and colleague. We've photographed and taught together all over the state of Texas and northern Mexico, and several years ago, along with his wife, Sylinda, we started a coffee-table-book publishing house.

Some say, "Those that can't do, teach," and vice versa. Wyman is not one of the folks to whom they refer. His abilities to both shoot and effectively teach and inspire his students have inspired me as well. For nearly a third of a century, he's documented the nation's wildlife and the natural history of Texas, and told the story of countless individuals along his travels for magazine and book publications around the world. His work and his teachings have helped influence many photographers to learn to tell the visual story.

Q Tell us a little about yourself and your photography.

A I first developed an interest in photography at the age of about 12. My mother gave me an old Kodalux 120 roll film camera that I carried in my saddlebag and I shot photos while out exploring in canyonlands. After two or three years, I became less interested and shot fewer and fewer images due to the fact that I could not close-focus the little Kodalux. Even at that early age, I had an interest in moving in close for a more intimate view of the subject.

After enrolling at Texas Tech University, I was awarded a research grant to study the dietary habits of coyotes on the Texas Rolling Plains, and I borrowed a 35mm camera to document the research methods. That's when I developed a more serious interest in photography.

After graduation in 1974, I continued to work on the technical aspects of the art and delved seriously into black-and-white photography and darkroom work, all the while studying the work of Fred Picker and other shooters of the time. By the late 70s, I had pretty well gone over to color and was inspired by the work of Ernst Haas and Eliot Porter. Shooting primarily wildlife, I had already published in *National Wildlife* and *Texas Parks and Wildlife* magazine, but I had my eye on the larger national publications in New York. By 1985, I had shot several cover and inside images for *Sports Afield*, *Field & Stream*, and *Outdoor Life*.

I had my first book published in 1993, titled *Roadrunner*, and I've published 22 large-format coffee-table books since that time. My work as a wildlife and natural history photographer has taken me all over the state of Texas, into the rough wilderness of northern Mexico, and through the big game states of the U.S. and into the Yukon.

Q Who were your influences in how the camera allows you to tell story?

A As mentioned, I initially studied the work of a few of the black-and-white icons of the time, although it primarily influenced my technical knowledge of the camera and film. The color work of Ernst Hass and Eliot Porter in their documentation of the West was a great influence on my future photographic endeavors. Both Haas's and Porter's collections of images reflected a personality of the West beyond the typical "poster" photograph; they effectively used light to maximize the dynamics of color and form that define this fabulous region of our America. Much like photographing the natural history of a wildlife species, rendering the landscape in such energetic form requires knowledge of the geology and the effective angles that render the land correctly. These two men were absolute masters.

Q Is there one instance that truly emphasized the role you play as a photographic storyteller? When you realized that what you were doing with the camera went beyond just you and reached others?

A I well recall the very instance when I realized that my work could be an influence on others. It was in 1981, when I took several weeks to document the nesting behavior of the Texas roadrunner. I became so involved in the natural history process of this species that it was evident my work just might enlighten the readership about the life of this bird that heretofore had been largely understood as the cartoon character seen on TV. As it turned out, I was correct, and I eventually went on to publish photo essays virtually all over the world about the roadrunner.

Q Your work as a wildlife photographer has evolved over the years to take on more feature-based assignments. What is the one most consistent aspect of your imagery that helps you tell the story that you see?

A I think the consistency in my imagery that makes a difference is an interest in offering the natural history aspects of my subjects, whether it is the natural fauna or the land itself; all have a story to tell.

Q Some would describe you as a historian as well as a photographer. How does this characteristic help you as a visual storyteller?

A I believe that being a historian can enhance the overall interest in a photographic essay. Meshing the natural history of fauna, people, weather, and landscape with actual historical accounts connects with the readership in a way far beyond the typical "one shot" approach. It is a more conclusive approach and, I believe, one that stimulates the interest of the audience.

A good example of this would be one of my recent works that highlights a large ranch here in Texas. The expected approach for a ranch publication is, of course, the general ranch activities with cows. In this case, however, I augmented that approach with interesting historical events that occurred within the ranch boundaries, such as 19th-century military actions against hostile bands of Comanche, 19th-century cemeteries established by early settlers, and stone etchings from long-forgotten cowboys of the early 20th century. It is a great approach in telling the entire story and adding yet another dimension to the marketability of the product.

Wyman Meinzer

Q If you had to point to only one of your images to explain how effective storytelling can be achieved through photography, which one would it be, and why?

A The image that I think might present a good example of powerful storytelling would be one I made many years ago of a burrowing owl in the snow. The photo accentuates the huge eyes that seem to define a creature that could be bold and aggressive, but whose actions describe its true self as a small bird of the plains with a timid and retiring personality.

Like so many great photos, this one came to me almost by accident one cold day after I decided to leave the office and take a chance on getting an image during a winter storm. Going out to a prairie dog town with the intention of photographing the mammals under adverse conditions, I found them to all be in their burrows. However, the little owls were out in the snow. Lying on my stomach and pushing forward with my Canon F1N and Canon 500mm f4.5L lens in hand, I approached one of the birds standing on a snow-covered burrow. It began to sink deeper in the burrow with every foot of advancement I made toward it. Finally, with my elbows burrowed deep in the snow, I could see only the owl's large eyes staring balefully at me above the snow-covered dirt mound. It was a classic shot that resonates with viewers whenever it is shown.

Q You've largely been working on book projects for the past several years. How does this affect the way you work as a storyteller?

A Book projects are wonderful forums by which the photographer can convey the story in its entirety simply because they allow the shooter a greater time investment to create more insightful images. Many of my magazine assignments are short-lived—perhaps three days to a week—and make for a difficult time frame in

Become not only a master of the photographic medium but also possess a curiosity about the history of the intended subject.

which to completely tell the visual story. For the most part, book projects can be planned far in advance, thus giving me wider latitude to seasonal preferences. Magazine stories are often assigned on the spur of the moment, sometimes at an adverse time of the season to fully convey the intended photographic goal.

Q Besides camera gear, what is one thing you've found extremely useful in telling visual stories?

A Telling the visual story can be enhanced beyond the camera by using the Internet as a means of distributing the visual message. A Web site, social media outlets such as Facebook, blogs, and email are wonderful forums by which the story can reach an audience beyond the traditional editorial readership. In today's changing technological climate, with the rise of the Internet and the decrease in print publication readership, it's beneficial for a photographer to engage such outlets in order to not only tell the story, but also to further promote their own work to a vast audience.

Q You're the state photographer of Texas. What inspires you to tell the state's story visually? How do you find story amid such an expanse?

A The state of Texas is a story of variety in the context of land, people, sky, weather, history, and natural fauna. The source of intrigue for me is combining all of these aspects over a period of years to finally define the personality that is our great state. This has been an undertaking that has required 25 years of continuous,

dedicated work and hundreds of thousands of miles in traversing this great land to cultivate the story of our Lone Star State. This endeavor has also been one of great educational value in regards to an awakening to the rich cultural diversity that so defines the pride that is our Texas heritage.

Q If you could give one piece of advice to those starting out telling stories with photography, what would it be?

A Become not only a master of the photographic medium but also possess a curiosity about the history of the intended subject. Combining the application of great light, careful composition, and other elements needed in fine photography with a knowledge of history is essential in producing truly great photographic essays. Photographers who are not students of history or natural history often shoot their images in a more one-dimensional manner, because they do not know enough about the intended subject to photographically define the more intimate aspects of its life or the landscape. ■

To see Wyman Meinzer's work, visit his Web site at wymanmeinzer.com.

Shooting Story

Although true, it's almost becoming clichéd to identify the camera as only a tool in the photographic process. Of course it is only a tool, but it's an essential one. We're photographers— we use cameras. We've chosen the camera as our means to express story, and if we want to continually grow as visual storytellers, it's to our advantage to learn not only how to use it but why we use it in certain ways under certain circumstances. Skilled photographers employ this tool much like a master wood craftsman uses a hammer or a lathe.

A great way to exhibit color variation and attractive light, layering silhouetted mountain ridges is also an effective way of highlighting the immensity of the land. Big Bend National Park, Texas.

Canon 5D, 200mm, 1/1000 sec., f/4, ISO 100

The name of the game is to use your camera instead of letting the camera use you. We all go through this arm-wrestling match with our cameras, lenses, flashes, tripods, and whatever else we throw in the bag. However, it does make sense that the more time you spend working with your gear, the more images you produce, and the more time you spend with your images, the more comfortable you will get with your gear. Unfortunately, it's not just the amount of time you spend shooting that determines how your photographs turn out. Your time needs to be focused on why you're telling the story in the first place.

Camera technology is fascinatingly complex, and at the same time, it works on the most basic of photographic principles. Despite some amazing technological advancements throughout history, not much has changed in the way of what allows the contraption to work and produce images. For that reason, I don't believe trade "secrets" and technical components of the gear should intimidate emerging storytellers. Understanding why images work—or don't work—gets easier the longer you spend viewing photographs and using the gear. We just have to push a few buttons along the way to telling the story.

This chapter does not tell you how to push those buttons (plenty of other useful books out there will do that). What it does do, though, is prompt you to think about those principles of photography that we push the buttons for. Adding the "why" to the "how-to" is essential for storytelling. It's how we *see* to shoot story.

TECHNICAL APTITUDE, TECHNIQUE, STYLE, AND STORYTELLING ABILITY

Photographers continually grow with their craft. I'm willing to bet there's not one photographer out there who says he's finished learning how to make images. If you do happen to run across such an individual, I don't know how much stock I would put in what he's saying. As in other areas of life, we're constant students of photography. This enables us to improve and develop in four different areas. Let's consider why we need all four of them.

As mentioned, the more time we spend with our gear, shooting, and reviewing images, the more technically competent we become. The concept of exposure, for instance, can be learned without ever tripping the shutter, but unless you do it, you'll never really understand it. There's no doubt that what the camera (and everything else in the bag) does can be learned; remember, the camera is basically a machine with an operator's manual. Once you've learned most of what a certain camera model can do, it's more about what you do with it.

Not only do we continually learn how to make images, all photographers learn differently. Let's say that you learned how to make exposures for concerts from a music photographer's blog. You probably picked this technique up in a different manner than the shooter standing next to you in the pit the night you photographed an up-and-coming rock 'n' roll band. Maybe the other photographer learned how to expose from another photographer or through much trial and error. She might even be using a different exposure mode, aperture priority instead of manual. Each photographer has her own slightly different way of getting the job done, and this is called technique.

If you ever spend any time walking around a football field during game time, you'll hear more about how shots were made than you might ever hear in a classroom. It's like listening to guitar players talk about their vibrato or painters explain their brushstrokes. Technique is important to creating consistently successful images, and the number one factor affecting technique is, you guessed it, experience with the camera.

Over time, that technique leads to style. I say "over time" rather abstractly, because style is not something that happens automatically after years behind the camera. It could happen the second day you've owned a camera, on a walk around your vegetable garden photographing the dew built up on the okra leaves. Or, you could develop style over years of hauling light stands on and off outdoor locations where few photographers dare venture for portraits. Nevertheless, style is a noticeable characteristic of your images that evolves from your own vision.

You can own your style, even though you might not be able to own the story you're photographing. Just think about certain images you see periodically that tell you immediately that a certain photographer made them. That's style, and it becomes more pronounced

There's a good chance that everyone standing in the photography pit at this concert learned how to make an image like this one just slightly differently than the others.

Canon 20D, 33mm, 1/640 sec., f/2.8, ISO 800

the more in tune you become with, among other things, your gear and your technique.

As a photographer, your storytelling ability improves after combining technical aptitude, technique, and style. It would be nice to see those areas succeed one another chronologically, and often they do; however, it's not about whether one follows the other. Ultimately, it's about how they all work together, or rather, how you, the photographer, put them to work.

Madrid's Palacio Real, lit by the sunrise, is framed by the shadowed activities and structure where light has yet to touch.

Canon 5D Mk II, 55mm, 1/15 sec., f/11, ISO 200

If you're the type of photographer who is compelled to create images that say something to others, then taking into consideration your technical aptitude, technique, and resulting style is essential in gauging how effective you are as a storyteller. Everyone can tell some sort of story with a camera. Just Google *photovoice research*, the practice of photographing your own life, and you'll get an interesting and varied take on visual storytelling. But those of us trying to communicate most effectively with our images need to really *use* our gear, continually improve our technique, and involve our photographic style in ways that help us speak the visual language eloquently.

Keeping these general things in mind, let's discuss certain components of producing images. The remainder of the chapter may seem to pose many "what ifs" in regard to producing storytelling images. But if you're continually working on using your camera, technique, style, and overall ability to tell story, then these are the kinds of questions you consider all the time in your work as a photographer.

LIGHT: A POWERFUL, NUANCED STORYTELLING TOOL

No good discussion about photography is complete without touching upon light. Why? It is the modus operandi for everything technically photographic. That's not all, though. Photographers since Nicéphore Niépce and Louis Daguerre realized the power light wields aesthetically and emotionally. Like painters before them, photographers are at a great advantage when they concentrate on how light plays out in any given environment.

Light creates colors and shadow, both of which help set the tone for visual storytelling. The light you use to make images establishes an emotional foundation from which story emerges. For example, noir imagery is often dark and sinister, with hard shadows and large areas of the frame going completely black in exposure. On the other hand, wedding engagement photographs are often bright and joyful, with diffused shadows and the occasional warm-tinted hair light. Both examples oversimplify specific genres of the industry, but they give an idea of how something as basic and powerful as light affects our initial perception and interest in these types of images.

The light reflecting from the ridges of the Scottish forest moss makes for an earthy, dark mood within the frame.

Canon 5D Mk II, 17mm, 4 sec., f/22, ISO 100

I once shot an assignment that focused on a university's forensic anthropology program and the people who made it possible to study such things. When I got the assignment, I was told to think of the program as the *real* crime scene investigator's lab, not the world created on network television. Creativity was stressed, though, and one cannot help being influenced a little by Jerry Bruckheimer's visual sense of telling a story.

I was assigned to photograph three professors, one of whom was Dr. Payne (yes, that is his name, and his beard rocks). I usually go into these types of environmental portrait shoots with a few ideas, and I normally

start with the standard office shot. The majority of university professors' offices leave much to be desired in terms of decor, but Dr. Payne had life-size skulls on his desk, and they were a huge factor in the composition of the office shot. The lighting was, like the shot, fairly standard. A large shoot-through umbrella was used to bathe him and his skulls in fairly broad, even lighting. The images produced at this point of the shoot were comfortable and nonthreatening. They were safe images for the publication if all else failed, but I hadn't yet made the image that I thought needed to be out there telling the rest of the world what Dr. Payne represented. I wanted the light to say more than "safe."

After shooting in the office, we moved to a large classroom where Dr. Payne keeps some instructional tools, such as more skulls and a replica skeleton he stowed in a side closet (I know, bad joke). I told him I wanted the mood for the next set of images to be darker and edgier, yet fairly simple. Sitting him down in a chair holding a two decades-old cast of a homicide victim's skull, I wanted only three things to do the talking in the image: the person, the skull, and the light.

I set up a half-CTO gelled studio strobe in a medium-size octabox to camera left and slightly behind the subject, and I clamped a Speedlite to a nearby table to camera right. The Speedlite was gelled blue, and it was also slightly behind Dr. Payne. The soft box provided enough wrapping light to cross over Dr. Payne's face and head, as well as the skull he held, yet not so much that it filled in the deep shadows on the opposite side of the light. The Speedlite was zoomed in tight on his neck and

A safe shot of Dr. Robert Payne, forensic anthropologist.
Canon 5D Mk II, 70mm, 1/60 sec., f/4, ISO 400

head, leaving a stark, focused edge light that helped separate him from the background and inject the type of dynamic appeal I originally envisioned for the portrait. I switched off the lights in the room, and the shutter speed was fast enough to make sure no ambient light crept into the background, letting Dr. Payne's surrounding environment go completely black in the frame.

The resulting images were exactly what I wanted to say about the interesting and little-known type of work Dr. Payne does for a living and teaches about in the university's forensic anthropology program. The dark, almost macabre feeling to the image is intriguing, and one of my charges as a storyteller is to get people to listen to (or see, in this case) the story being told. Primarily through the lighting, this second image did a much better job at that than did the first safe, standard office shot. ■

A more intriguing and revealing take on Dr. Payne.
Canon 5D Mk II, 95mm, 1/60 sec., f/18, ISO 400

Beyond setting the emotional tone for the image, two other significant aspects of light promote photographic storytelling. The first is its tangibility. There's a reason many large-landscape photographers shoot at the very edges of the day. During these golden hours, the light is at its most extreme, almost-parallel angle to the natural horizon. As a result, the light is warmer due to the atmospheric debris it passes through, and it casts long shadows off even the smallest objects. Light, in a sense, becomes a tangible, physical component of the frame. Visually, the attractive coloration and the shadows pull us in to the frame, into the story being written within the image itself.

As the sun moves across the sky, shadows lessen in length and detail, and colors start to pale and blend together, removing quite a bit of what drew a viewer into the frame in the first place, away from the story contained within. It's not only the color of the light (we'll talk more about color in the next chapter), it's the direction of it that helps us create texture and tangibility in our images. Shadows help us determine the direction of light, and being able to see them brings the photographer and viewer a visual step closer to three-dimensional attraction. We can relate to shadows in a frame; they give us orientation, draw us in, and provide an image personality. If we do not use light in a way that casts shadows that we can see in a frame, we run the risk of losing a seemingly tiny, yet powerfully visceral connection for our viewers to make.

Early-morning light bathes the low desert landscape leading to the Chisos Mountains in Big Bend National Park.
Canon 1N, 17mm, 1 sec., f/22, ISO 100, Fujichrome Velvia

Light creates shadow, which in turn creates visual texture. Even the slightest dips of the grain in this skull-and-crossbones sculpture have a lit side and a shadowed side that provide a sense of tangibility.

Canon 5D Mk II, 50mm, 1/80 sec., f/2, ISO 400

Live music performances are perfect situations to use light to direct viewers' attention. Spotlights help focus your viewer's gaze on the most important subject matter in the frame.

Canon 1D Mk III, 200mm, 1/200 sec., f/2.8, ISO 1600

Another storytelling characteristic of light is its ability to highlight valuable areas of the frame. Seeing and using light in a way that gives the viewer visual guidance through the story being played out can provide your images substantiation that they might have otherwise lacked. Light engages the image's "readers," and when you're able to create an image with light that helps lead viewers through the frame, you're adding value to your storytelling.

You might find this light in a portrait of a coffee shop barista as it reflects off of a countertop and leads the eye to the espresso machine in the background, or it may appear as the light from neon lamps along a nighttime street scene, backlighting a group of people huddled together on the sidewalk. It even might appear as the light that you artificially push through a window to illuminate a scene or a person. Not only does this light help lead an eye through the frame, it helps reveal components of the frame that stitch together the narrative contained within.

BE A LIGHT SEEKER When you walk into a room, notice how the lamp in the corner lights up the wall and begins to fall off, pick up how light comes in through windows and reflects off surfaces of different colors, and even how shadows form on the faces of folks underneath kitchen lights. The same applies to the outdoors. Not every landscape requires golden hour light, but start picking up on which type of light is aesthetically appropriate for the story you want to convey. You're a photographer, and in order to tell story, you need to be able to see light. Make it a practice to notice the type of light in all environments you walk, ride, or drive through. Before too long, seeing light will be second nature.

The setting sun backlights people as they walk into Plaza Mayor in Madrid.

Canon 5D Mk II, 105mm, 1/160 sec., f/8, ISO 100

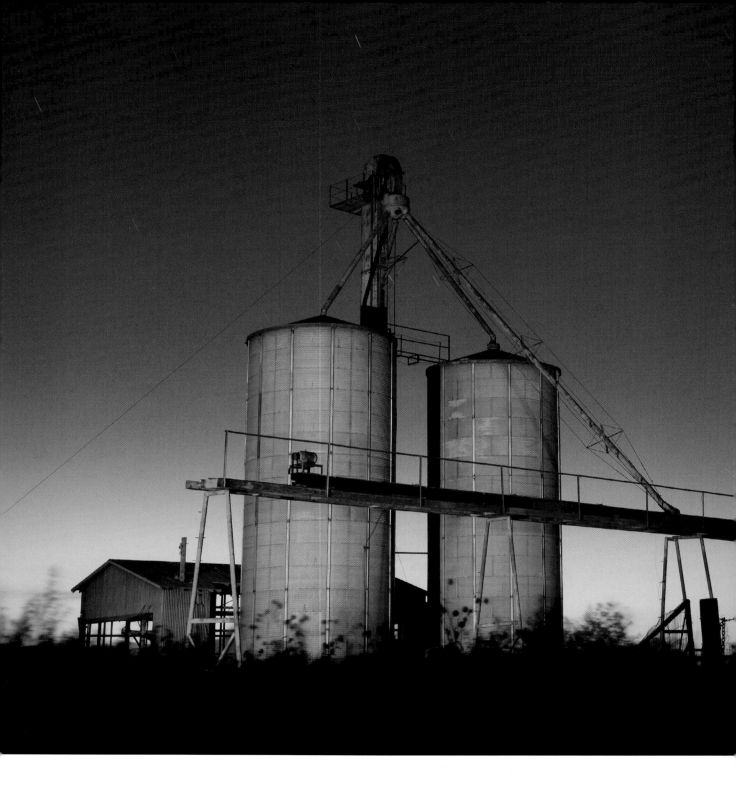

The application of light is infinite, and I'm not just talking about using strobes and flash units. As photographers, we use light in order to create a foundation to the stories we tell in our images. In order to use it, though, we must *know* the light. I know, it sounds rather mystical to go on about being one with the light, but as a foundational element to what we do as photographers, it's only right that we spend time getting to know how light works, its qualities, and how those qualities can be used to convey a message.

WARNING You might not be able to turn it off. However, I'm pretty sure no one really minds it when, as you drive down the road during the last rays of the day, you point out how nice the light is that's hitting the telephone poles along the road (yes, we all do that).

If there's one thing I can stress about light in a storytelling sense, it is the need for photographers to simply be in tune with how it aids emotional appeal and how its subtleties can be used to create nuance in the visual narrative.

Light is important. Combining dusk with a light-painted grain elevator attracts viewers' attention directly to the structure as well as the aesthetics of the colors.
Canon 5D, 45mm, 2 min., f/6.3, ISO 50

COMPOSITION: CREATING STORY WITH LIMITED SPACE

Composition is crucial to an image's ability to tell story. I don't know if I can emphasize enough how effective composition is in appealing to the viewing eye as well as taking control of that eye once it's in the frame. If light establishes the emotional dynamic you're trying to convey, composition is there to build the journey through that experience. An image's story relies on how well it can be revealed through its observable structure, and composition provides that structure.

The Rule of Thirds:
Providing Guidance Since the 18th Century

There are plenty of "rules" to photography, some of which are bound by the laws of physics more than aesthetics. However, there's not one that trumps the popularity and the controversy surrounding the rule of thirds. Quite possibly the first thing many of us learn when starting out in photography, the rule of thirds has long been a part of how visual creatives produce work. The so-called rule has been around since painters documented its use in the 18th century, although I would argue that it was in use for centuries prior to someone's writing it down. It has played an important role in everything visual since. Along the way, it has picked up its fair share of critics denouncing its authority as a rule to be adhered to at all times.

I can't say I totally disagree with the criticism the rule of thirds receives, particularly when one of the other "rules" of photography is to break the rules. Successful, compelling images are made with and without observance of the rule of thirds. However, if we consider for a moment how the rule of thirds works in regard to storytelling, we might be able to manipulate it more successfully when the camera is in our hands.

Simply put, by breaking the image's frame into a 3 x 3 grid, the rule of thirds allows the photographer to organize the space for story creation. For example, if you place the main subject of your image in the left third of the frame, you're left with two more thirds for content that may help convey story related to the subject. You might choose to place the end of a grapevine in the remaining two-thirds of the frame to highlight your subject's role as a winemaker, or you might leave the remaining two-thirds of an image completely blank, forcing the viewer's eye to concentrate primarily on the detail of a lit flower's vibrant and glistening petals.

If we consider how the rule of thirds works in regard to storytelling, we might be able to manipulate it more successfully when the camera is in our hands.

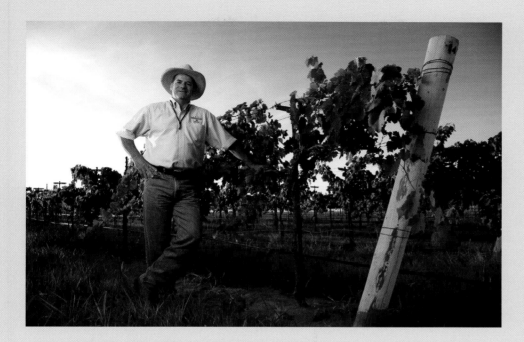

The compositional line created by the grapevine connects the winemaker and the crop aesthetically as well as suggesting his deep connection to his work.

Canon 5D Mk II, 24mm, 1/80 sec., f/8, ISO 200

Placing this flower in the left-hand third of the frame allows for the dark, contrasting background to serve as space for interpretation.

Canon 5D Mk II, 180mm, 1/8000 sec., f/3.5, ISO 50

Placing the horizon through the middle of the frame can force both the photographer and viewer to split their attention among the upper and lower halves of the image. Placing the horizon in the lower or upper third of the frame gives the eye a direction to travel in and leaves room for other subject matter that may aid in telling a bit of the story.

Canon 5D Mk II, 200mm, 1/500 sec., f/4, ISO 100

Pushing the horizon close to the edge of the frame indicates the significance of the West Texas sunset while still providing perspective between sky and land. Doing this also avoids including too much void black space below the colors (opposite).

Canon 5D Mk II, 24mm, 1/30 sec., f/5.6, ISO 100

Placing horizon lines on or near thirds in the frame gains the photographer space in which to emphasize what is important for the viewer to concentrate on. This need not only apply to the actual line where sky meets the earth, but to all distinguishing lines of separation. An image where a strong line splits the frame completely in half divides the viewer's attention between equally competing halves. When this is done, it is difficult to signify where the story is to be found. It's not that there is none, it just becomes harder to uncover. Horizon lines placed in accordance to the rule of thirds are useful in distinguishing where the viewer should focus, and they are awfully helpful in minimizing distraction from other areas.

Layers and Pathways

I love using leading lines and visual stepping-stones to create pathways through a frame, almost as if I'm holding the viewer's hand the entire way. I've often thought it's my job as a photographer to first invite a viewer into the scene, help him get around, and then provide a fairly comfortable exit.

This facet of composition is not uncommon, and it still eats at me when I see strong leading lines or layers of context just ready to be photographed. However, as with my occasional dalliances with artificial light and its technical cool factor, I'll shoot compositionally strong images without anything interesting to say along the lines I use. I would never say to not shoot these shots, because they certainly offer a nice practice in seeing composition. But when story is involved, it's our job as shooters to use those lines with purpose.

Canon 5D Mk II, 200mm, 1/500 sec., f/4, ISO 100

Canon 5D Mk II, 115mm, 1/500 sec., f/4, ISO 100

All lines lead to or help frame the tiny house at the base of El Capitan in Guadalupe Mountains National Park.

Canon 1D Mk III, 200mm, 1/200 sec., f/5.6, ISO 100

When working with elements as compositionally attractive as strong leading lines, diagonals, and layers, photographic storytellers are at an advantage. Is there something along these lines that helps the image speak on more than just a compositional level? How about the lone house at the base of a desert mountain that contains the entire history of the surrounding area, or perhaps the writer standing along an iron fence, taking notes in the thick dust as nearby cowboys vaccinate cattle? Leading lines offer an appealing way to not only add visual interest to a frame but to guide the viewing eye exactly where you want it to go: to parts of the story you're telling.

Creating compositional layers within a frame is also an effective way of both highlighting story and pulling several elements of it together. The most visible and recognizable layers come in the form of vast landscapes, such as mountain ridges in the early morning or dusk, or, for those of you more interested in urban scenes, sides of colorful buildings together in a single frame. These types of layers are enticing, and they involve so much content compressed together that seeing each image is like peeling an onion (without the crying), revealing more and more when you enter into the photograph. Layering also includes using points of interest to reveal pathways throughout a frame, much like leading lines do.

Not all images have to include multiple points of interest, but when the opportunity to include several key aspects of story together in one frame presents itself, compositionally positioning them to lead you through the frame allows components of the story to unfold rather than be aimlessly searched out.

A magazine writer standing in the dusty heat becomes a destination point for the eye as it follows the blurred lines of the cattle-working pens. Beyond the writer, the lines continue to direct attention through the saddled horses (opposite).

Canon 5D Mk II, 200mm, 1/2000 sec., f/4, ISO 100

Strong leading lines, like these rows of West Texas cotton, pull a viewer into the frame. Sometimes, placing a destination at the end of the lines, such as a barn on the horizon, gives the lines additional attraction.

Canon 1D Mk III, 17mm, 1/30 sec., f/16, ISO 200

Leading lines, such as fences or roads, are abundant, powerful elements for storytelling. In this shot of rural Scotland, they compositionally provide direction and destination.

Canon 5D Mk II, 35mm, .4 sec., f/16, ISO 200

Layers of color abound compositionally in Madrid.

Canon 5D Mk II, 105mm, 1/160 sec., f/16, ISO 100

When a photographer searches for outstanding composition, it's fairly easy for her to get wrapped up in seeking the image that combines leading lines with colorful layers all converging to frame up the subject matter at hand. However, looking too hard may result in a relatively busy, sometimes chaotic and frustrating image that amounts to nothing more than a visual headache. We're all guilty of this, and there's no going back. We can only learn from the experience.

Reducing an image to simple, clean composition is often just as powerful, if not more so, than more structured approaches to building a storytelling image. Simplicity leaves room for story to seep through, for visual appreciation, and for interpretation. Simplicity can tell a complete story with hardly anything but a hint, engaging a viewer for further meaning making.

Several years ago, I photographed a dormant oak tree on a foggy winter morning while I was driving south on the Llano Estacado, a flat escarpment that covers a great deal of northwestern Texas and eastern New Mexico. It was one of those shots that you see out of your window as you drive by and makes you feel compelled to turn around. My first impression of the subject was that of a mysterious icon of the plains appearing like a mirage in the fog. I took a few frames, following the rule of thirds, placing the tree off to the right third of the image and the almost indistinguishable horizon line in the bottom third. The middle and the left third of the image were left completely open. I placed the tree on the right third line of the frame simply because the branches leaned and pointed toward the left side, providing a direction for viewers to visually fall when inside the photograph. Beyond that, the image is as two-dimensional as it gets.

Yet, the simplicity of the image's composition implies a story all its own, and it frees the viewer to engage the image where he sees fit. The openness provides a space

A sole tree wrapped in winter fog sits on the open West Texas plains.
Canon 5D, 200mm, 1/1000 sec., f/2.8, ISO 100

for interpretation, where the soupy feeling of the fog enshrouds the ghost-like fragility of the enduring tree isolated in the winter desert. Just think of the emotional connection one could make with an image that provides such interpretive freedom to not only the photographer but also to everyone who sees it. In a way, this type of simplicity more effectively brings story to the forefront, because it lets the audience tell part of a variety of narratives centered on this one lonesome tree in a sparse winter landscape.

The power of simple composition may be rooted in the power that is given to those being told a story with the image. ■

Framing: Pointing a Finger

It's not difficult to see the usefulness of framing when it comes to storytelling. Compositionally, framing lets the photographer point a finger directly at what he is trying to show off in an image. Framing is often the most intentionally used compositional element available, while at the same time frequently absent due to either the environment's not offering a framing mechanism or the photographer's lacking thought toward using a frame when one is available. Regardless, framing is a powerful tool to have in your cache of storytelling techniques.

Framing does not always have to occur completely around the main subject, either. Some of the most successful frames are relatively subtle and incorporate themselves naturally into the flow of the image. A leaning tree or the legs of parade walkers can be just as useful as framing mechanisms as, say, mirrors or doorways. Sometimes, frames can be overt and large within an image, or they might be as minimal as the change of a color in the background. Either way, they subconsciously direct the image's viewer to where you want them to go.

A good frame is not to be wasted.

Storm clouds provide an ominous frame for a centuries-old tower in Madrid's Plaza Mayor.

Canon 5D Mk II, 50mm, 1/5000 sec., f/2, ISO 100

DEPTH OF FIELD: SETTING THE STAGE

There's no tool like it. From razor-sharp expanses of mountains and rolling hills to soft-feeling abstract images of Moorish doors and isolating portraits, the aperture is perhaps the most used and quite possibly the most taken-for-granted tool our cameras have to offer. Controlling the amount of focus into a frame is a powerful way of saying what is important, to emphasize composition and to create aesthetic interest and attraction for an audience. In terms of storytelling, it holds quite a bit of sway over what features are actually, ahem, brought into focus (don't mind the pun). Along this same line, it's appropriate to look at depth

of field as the tool that allows photographers the ability to contextualize or decontextualize a frame and its corresponding subjects.

Images with varying amounts of depth of field each say something different, and when first jumping into photography, we often learn the typical instances in which we employ specific amounts. The most depth of field for wide landscape shots and the exact opposite for portraits and other images involving people is the go-to train of thought for many (if not the majority) of photographers, including me.

If this extreme principle is followed each time, though, we may be robbing ourselves of images that

say something more than what f-stop was used. Instead of thinking about depth of field in a landscape or portrait mentality, we're at more of an advantage if we simplify this line of thought to what depth of field value will allow us to best exhibit the important subject matter in the frame. Considering shots of all kinds in this manner prevents us from missing out on images that we would otherwise not see or else just walk by.

Large amounts of depth of field (f/16 to f/45) can result in very busy images if you just want to emphasize a particular aspect of an environment, such as the dewdrops on the leaves of a plant in the middle of a forest. At the same time, portraits made at f/1.2 to f/2.8 can be extremely decontextualized, enough so that an environment that could help further tell the story surrounding a particular person cannot be discerned. Perhaps lessening the depth of

Parade band marchers' bodies frame an enthusiastic boy and his attentive mother in Madrid.

Canon 5D Mk II, 105mm, 1/100 sec., f/4, ISO 400

Although the depth of field is not infinite in this frame of the Rio Grande National Forest, it offers enough detail to provide the viewer a context to enter at the same time it drives initial focus to the dew-covered skunk cabbage (above).

Canon 5D Mk II, 24mm, 1/60 sec., f/8, ISO 200

Intricate Islamic engraving decorates a door of a cathedral in Seville, Spain (right).

Canon 5D Mk II, 50mm, 1/250 sec., f/2, ISO 400

Head shots are great images to make for any story. At times, though, the lack of depth of field used can decontextualize the environment. This is often an intentional stylistic choice (far right).

Canon 5D Mk II, 200mm, 1/800 sec., f/2.8, ISO 200

field in the forest shot will allow those drops to be more noticeable at the same time you hint at the environment surrounding the plant. Increasing the depth of field from f/2.8 to f/5.6 for the portrait may bring in just enough of the surrounding context to help tell story without interfering with the significant amount of focus given your portrait subject.

There is no universal "correct" amount of depth of field for any type of shot. There's only the photographer's choice to add or take away depth of field in order to say something more distinct with her images. Depth of field is, like other elements of photography, intentionally used to draw attention to or away from a subject or many subjects. Considering why you are using a certain amount of depth of field is a healthy way of building storytelling images. If what you are envisioning requires that the background be thrown out of focus with an aperture value of f/1.2, then by all means, go for it. Knowing why is the best reason to make these types of decisions.

At 35mm, f/2.8 still offers enough depth of field to showcase the storytelling environment, framing metal artist Charise Adams without making it a distraction.

Canon 5D Mk II, 35mm, 1/100 sec., f/2.8, ISO 400

Depth of field is something we photographers often take for granted. We frequently float on the extremes of aperture ranges, either shooting wide open or stopped down all the way. At the same time, it's one of the most useful tools residing in our camera gear. It helps us focus attention directly toward significant subject matter, it takes care of busy, distracting backgrounds, and it increases our ability to see every bit of detail in a shot and all variations in between. As storytellers, our familiarity with the means to complete this task is akin to a master carpenter knowing how to use his tools and technique, and the aperture is our set of drill bits. It's beneficial to know when to use which bit.

Here's a quick exercise that will help you become more familiar with how depth of field can make a story surface (or get in the way):

1. Create an environmental portrait of a friend, neighbor, or family member using only a standard lens at 35mm and an aperture value of f/16 or higher. Make a full body shot, a waist-up (or medium) shot, and a bust portrait, all in the intent of telling that person's story with his surroundings. Beware of extremely busy backgrounds at the large amount of depth of field you'll achieve at such aperture values even when you move in tight.

2. Shoot the same three environmental portraits with the same lens, only this time you're only allowed to use an aperture value of f/5.6 or lower. The busy background that you noticed in the first round of portraits will begin to diminish in distraction as you move tighter, perhaps to the point of nonrecognition—potentially a faulty choice when creating an environmental portrait.

3. After you're finished with steps one and two, put a telephoto lens on and shoot at 200mm (if you have the one standard lens, then just shoot at the longest focal length available). Repeat everything you just did for steps one and two with the new focal length.

4. Put all the images you shoot in this exercise on your computer after you are finished and select the 12 images that best represent the different aperture values and lens combinations used. Study these images to determine which level of depth of field strongly conveyed the story you wanted to tell in the portrait. There might be two or three that you feel do a great job, but you're likely to have more that don't speak as well as those two or three. Not taking into account composition, one of the reasons these images may not work well for storytelling is either the distractedness or ambiguousness of the environment created by certain depths of field.

This is not an exercise that will help you identify the ultimate aperture to use with every lens in every situation. The purpose is to help you begin to see which depth of field might be more helpful than others in developing a story for a particular frame. Depending on your choice of lens and your distance from the subject, one aperture value may seem better than any other to say something that might provide clarity to the story you are trying to tell. That doesn't mean, however, that there is only one depth of field value for each photographic instance. Indeed, you can tell story with the same subject and a slew of aperture values. Your job is to determine the best one for your way of telling story at that moment. ■

EXPOSURE: IS 18 PERCENT GRAY REALLY THE POINT?

This is where I get to be the curmudgeon for a bit. I started out shooting film. My real passion for film was color (not that there's anything wrong with black and white), and like many photographers, I just couldn't get enough of Fuji-chrome Velvia. The colors were vibrant, and the contrast was perfect for those early-morning or late-evening shoots. The inkiness of the shadows and the blacks were probably my favorite part of the film.

I digress, though. To me, the most intimidating part of starting out shooting film was making good exposures. You know, the types of exposures you initially approached with a gray card, taking scrupulous notes about the shutter speed, aperture, and ISO used for each shot. You continually stressed over how much you compensated when there were no neutral gray tones available, knowing that the film's latitude would just eat you up if you missed your exposure.

Sunlight shining through large cloud structures in central Scotland spotlights a small tree on the rolling hillside, throwing certain parts of the frame into deep shadow.

Canon 5D Mk II, 200mm, 1/250 sec., f/5.6, ISO 100

A stop-action frame of this enduro racer and the rooster tail of dust behind him freezes a slice of time in a way that helps the viewer imagine what the sport is like.

Canon 5D, 70mm, 1/5000 sec., f/2.8, ISO 200

Fast-forward to now, the digital age. Not all that much has changed, if you think about it. Camera meters still operate basically the way they used to, albeit with some improvements in accuracy. We're still shooting with a fairly limited range of tonal values, now called dynamic range instead of latitude, that the camera's sensor can handle before extreme under- or overexposure occurs, and despite the fact that we can take a peek at the LCD display and histogram for each shot, we still fret over making good exposures.

Knowing how to expose "properly" is a good thing, even when we can more easily compensate for error in the digital darkroom. What's better, though, is taking in a given environment and knowing how it's going to expose. This goes beyond just looking for 18 percent gray to meter on. This speaks to your knowledge of how the camera will technically see the image laid out in front of you, as well as your drive to see your image exposed the way you want; in a way that helps instead of hinders its meaning.

Knowing how a photographic situation may expose will help you make decisions in the storytelling process. It might suggest modifying the scene with artificial lighting to bring out detail in certain areas of the frame, or even returning to a scene at a different time of the day, month, season, or year to work with more appealing or telling light. It might mean you work in tight for portraits instead of wide where large areas of the frame will overexpose or deep shadows take on unattractive bulk. It all depends on what you are trying to say with your images. Becoming familiar with how a frame will expose will give you much more freedom in interpreting those exposures for storytelling. We're only given a few stops' worth of dynamic range in any shot, and seeing where and how that dynamic range may be compromised might just help you augment your approach to a particular scene.

MOTION: AN APPEALING SYNERGY

Even though it's called a still camera, we're able to imply so much more than subjects being static parts of a frame. Sometimes, of course, the static quality of subject matter is all you need. Other times, though, implying the movement of subject matter is an engaging way of both telling a piece of a larger story and powerfully attracting eyes to that image. Both photographers and viewers are drawn to images that convey movement. Think for a moment of the type of subject you're interested in photographing. Now, think how showing that subject in motion might help flesh out a more complete story about the subject.

Stop-action shots showing motorcycles frozen in midair, for instance, nudge the viewer to contemplate the excitement and risk involved in an activity that normally happens within seconds. A pan of a triathlete cycling up a long hill more abstractly implies movement, as well as conveys a hectic feeling of place and sense of the speed at which the athlete is moving.

Slow exposures of running water say something artistically similar, bringing to life the stream or river in the frame. We're provided the technical ability to achieve either type of shot and all those in between. We just need to know how they will help us in detailing the bits and pieces of story that make up the entire narrative.

Motion is also a good storytelling theme to develop a portfolio of images around. Life is relatively dynamic, even if your subject matter is a rock (just think about the sliding rocks of Racetrack Playa in California's Death Valley National Park). The natural world and human life have always been on the move. We've seen this in wildlife activity, ecological shifts from dry to wet environments, all the way to the growth of our world's cities and the athletic and recreational activities in which we participate. If anything, the universality of motion stresses the importance of at least considering creating images that imply movement for each subject that you shoot.

Visual engagement in shots that imply movement is often achieved with a pan. Slowing the shutter speed and following the action creates an image full of energy and an abstract sense of motion.

Canon 5D Mk II, 50mm, 1/25 sec., f/5, ISO 100

The golden tinge of light at the end of the flow of the rapids at the Hermitage in Dunkeld, Scotland, provides the viewer a direction to follow, as well as a feeling that there is something more to be seen.

Canon 5D Mk II, 17mm, 4 sec., f/22, ISO 50

Tossing large tortillas in the oven. Sometimes showing activity as out-of-focus movement is a powerful way of getting the point across.

Canon 5D Mk II, 24mm, 1/60 sec., f/4, ISO 1000

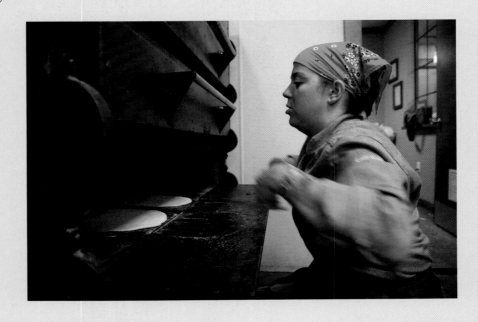

PERSPECTIVE: THE CAT'S-EYE VIEW

Technically speaking, perspective is the perfect balance between how you use your lenses and your position in relation to your subject. The physical perspective a photographer uses for a particular image has just as much to say as the composition does. In fact, we use perspective and composition in conjunction quite a bit to emphasize some subject matter over the other, or to bring content together in a way that only two-dimensional media can.

Using a wide angle focal length (24mm and wider) lets us not only depict the vastness in a landscape or an urban environment, but when pushed closer to one component of an image, it emphasizes the connected relationship between that particular component and all other elements in the frame. One nice thing about pushing a wide angle focal length in tight on a particular subject is that the environment in which it's contained is not lost on the viewer. The photographer is able to emphasize what is important in the image while also providing a sense of place. As you increase the focal length, these visual characteristics begin to morph. Expansive distances start to diminish, and subject matter in a frame start to compress. This becomes extremely useful when you want to show a strong connection between foreground and background elements in a frame. It's also useful when you want to meld together colors and form for an abstractly emotional image.

As opposed to with wider focal lengths, the closer you move toward subject matter with medium to telephoto focal lengths, the less depth of field you inherently can obtain at any given aperture value. What does this mean for storytelling? If you truly want to isolate a subject, using a longer focal length will do the job. The narrow angle of view combined with significant drops in depth of field at very open apertures allows the photographer an effective way of creating images that drive focus only to the subject.

Pushing in tight with a wide focal length emphasizes these flowers in Fredericksburg, Texas, without diminishing a sense of the place.

Canon 5D Mk II, 24mm, 1/30 sec., f/8, ISO 100

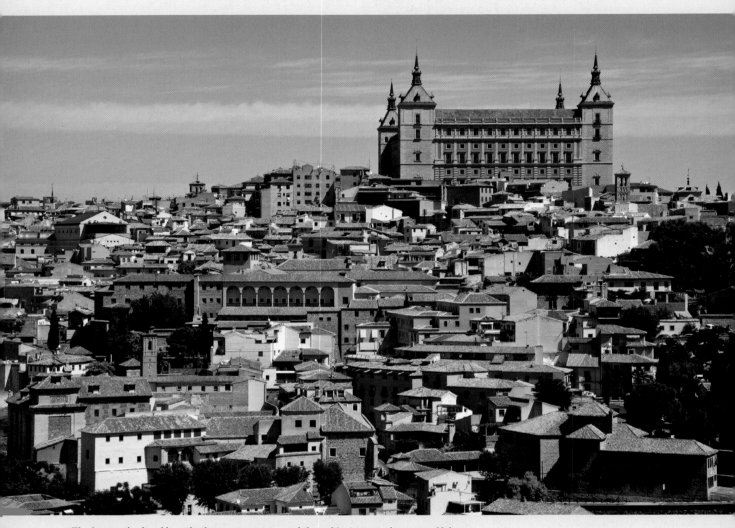

The longer the focal length, the more compressed the subject matter becomes. Using focal lengths that reach telephoto status is useful in visually explaining city density, such as these buildings, which seem built on top of each other in Toledo, Spain.

Canon 5D Mk II, 105mm, 1/400 sec., f/8, ISO 100

WARPING WIDE ANGLES Wide angle lenses are usefully addictive. When I purchased my first ultra-wide lens, I was stuck at 17mm for at least four months. I was able to jump into a world I never saw before that purchase, and I made hay with it!

However, wide angle lenses have their drawbacks, the most observable being their propensity to warp everything that comes close to them. Moving in tight with wider focal lengths may help emphasize some subject matter over others, but be careful when moving in too close. The perfectly symmetrical stone you just placed in the foreground of your landscape shot will quickly turn in to an oblong form unlike what you saw originally.

The same warping occurs with people. The closer you push a wide angle lens toward a person, the more elongated her facial and structural features become. Beware of noses stretching, cheeks bulging, and if you place a person to one side or the other, an entire half of her body reaching toward the edge of the frame! Wide angle lenses are extremely useful when photographing people; just always be aware of what they can do when worked in tight.

A strongly lit pivot irrigation system with a powerful sky as a background might make for a nice contribution to an agriculture story. However, the size-warping perspective of a wide angle focal length might deter some editors from choosing this particular image.

Canon 5D, 17mm, 1/50 sec., f/11, ISO 100

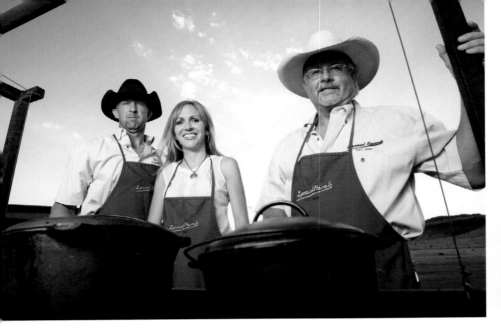

Photographing the owners and manager of a resort ranch in Fort Davis, Texas, from slightly below them visually indicates their authority.

Canon 1D Mk III, 17mm, 1/60 sec., f/5, ISO 100

The slash of light and upward perspective on El Monasterio de la Encarnación in Madrid can be interpreted as mysterious, foreboding, or authoritative.

Canon 5D Mk II, 24mm, 1/1250 sec., f/4, ISO 400

The photographer's position in relation to the subject is another key way to speak a visual language that signifies story.

Lens perspective is only one type; the photographer's position in relation to the subject is another key way to speak a visual language that signifies story. Arguably, photographers and viewers read into camera position as much as they do lighting, and rightly so.

The two positions receiving the most interpretation are shooting from below and shooting from above the subject. No matter if the subject is a human or a plain ol' sedentary boulder, power is delivered to the subject when a frame is made from an angle that forces the camera to look up. This often implies authority, superiority, intimidation, and sometimes menace.

Just the opposite, shooting at a downward angle on a subject, particularly another human, can be interpreted as diminishing or viewing the subject as an inferior. Of course, this is not always the case, and the interpretation involves much more than just another human, such as location, surrounding contextual environment, dress, facial expression, and much more. However, it's to the visual storyteller's advantage to consider how his position in relationship to the subject factors into what an image says beyond observable composition.

Here's a short exercise that can easily be incorporated into everything that you do with a camera in hand. Whether due to photographer laziness or not, it's not uncommon to settle for only one perspective when shooting, especially when you're crunched for time. However, we owe it to ourselves as storytellers to take at least one more look at the subject we just shot.

Think of yourself as a cat. Go on, just think about what a cat is able to see, considering that it can pretty much get under and above anything. If your model for the environmental portrait we discussed in the aperture priority exercise earlier in this chapter is not tired of your snapping away yet, consider another round of portraits. This time, though, you have the freedom to move around the subject and use whatever aperture value you deem appropriate. Move in tight, back away, shoot up on your subject from ground level and at a downward angle from atop a ladder. Tilt the horizon, even.

If you're not into portraiture, or your earlier model ran away, consider shooting an object, such as a phone booth or a small flower. Find a way to visually excite these two relatively docile subjects through perspective. Get down low and place the flower in the foreground of a wide angle lens to pronounce its size over surrounding greenery. Shoot from outside *and* inside the phone booth in order to find a unique and visually intriguing angle to position the frame's story.

Employ what many refer to as the cat's-eye view of things. Move around and find angles that speak to the story *and* appease visual aesthetics. And most important, don't stop at just one shot. Undeniably, on occasion all the time you have allows you but just one shot. However, the more you implement this exercise into the bulk of your shooting, your choice of perspective will be based on experience and being able to see the storytelling image. ∎

Even though cats tend to avoid water, having a cat's-eye view of the rapids on this section of the Llano River near Junction, Texas, places the viewer at water level (and the photographer in the river).

Canon 5D, 17mm, 0.6 sec., f/22, ISO 100

BREAKING RULES AS NEEDED

On occasion, accidents turn into gems. This portrait of Baron Batch was the first shot out of the box while I was testing the light. I didn't even realize the aperture was set to f/22. The closed aperture helped mute the artificial light on camera left, creating a reverent feeling on his face juxtaposed with the loud colors of the setting sun.

Canon 5D Mk II, 300mm, 1/125 sec., f/22, ISO 100

Remember what I said earlier about rules? They're great guides. They give us structure with which to visually make sense of the story playing out before our eyes and lenses. Despite what has been said in the past, I think this perceivable rigidity is comforting for creatives, providing photographers and other visual communicators boundaries within which they can nurture their creativity and storytelling ability. But these so-called "rules" we keep in the back of our minds are not the gospel truth, either. Sometimes, the rules must be broken.

If we were robots programmed to simply push a shutter release, always following the rules would be a cinch. The last time I checked, though, we're not robots. We all see differently, visually interpret differently, and even use different techniques in order to tell a similar story. These creative characteristics are what make it difficult to follow rules. If I told you to never make another image

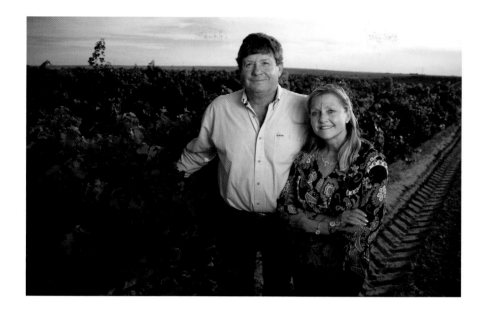

Although there's no getting around the overexposed values in the sky, secluding them to the upper right corner of the frame helps keep the distraction subdued, especially with the frame's subject matter maintaining a strong foreground presence.

Canon 5D Mk II, 24mm, 1/320 sec., f/4, ISO 50

without following the rule of thirds or without using only the first and last hour of light in a day, you could do it. For the majority of the time we're shooting, I'm willing to bet we have no problem with these boundaries. It's not all that uncommon, though, that bending the rules is necessary. Not just for stylistically breaking a stale run of images but to make good on what we've been talking about this entire book: storytelling.

Take, for example, overexposure. The rules state this is a bad thing. What about compositionally centering subject matter? Another no-no. And shooting at a downward angle on your human subject? You're not supposed to do that, right? Regardless of the critics, at some point in our tenure as photographers, we will bypass these rules in order to ensure that what we want to say in an image is actually conveyed.

We break these rules a couple of ways: intentionally, because it's impossible never to break photographic "rules," and by accident. The first one is worth talking about and the last one is worth learning

from. Accidents happen, and we learn by experiencing them. Even though a happy accident occasionally produces one of the best images ever seen by humankind, it may occur with little knowledge of how or why. Accidents can be learning tools. Just in case, don't disqualify accidental images right off the bat. Get them on the screen first to see whether or not they're helping you tell story.

Breaking rules intentionally and because there's just no way around breaking them are similar. When you break a rule either way, you're saying as a photographer that you acknowledge this supposed infringement, but it is necessary in order to visually showcase a stronger story. One example of breaking a rule intentionally is on the cover of this book. The ceramic artist's hands are smack-dab in the center of the frame, but putting them there drove home the significance of those hands to his art and his livelihood more effectively than any other way I could envision. Shooting tight at f/2.8 and at 35mm helped to diminish the

Placing ceramic artist James Watkins's hands dominantly in the middle of the frame emphasizes how important they are to his work.

Canon 1D Mk III, 31mm, 1/60 sec., f/3.2, ISO 400

Intentional over- or underexposure is sometimes key to the story. High-key frames of children often push the exposure toward overexposure to convey a sense of innocence and softness. This is also a lovely way to photograph older subjects.

Canon 5D Mk II, 105mm, 1/50 sec., f/4.5, ISO 800

busy background, allowing his hands to stand out in the frame, along with the top of his next piece of art.

Knowingly breaking a rule also denotes a willingness to budge on rigidity in order to strengthen a story. This says more about the content in the photograph than the technical aptitude it takes to make it. A good example is shooting a feature story for a magazine under conditions where parts of the background and most of the sky are going to violate your camera's dynamic range. You can overcome overexposure in a number of ways, and some will slow you down as a photographer who may need to move quickly with the story. Your job is to tell that story, and sometimes doing so disallows you some of the tools you might ordinarily use in order to avoid breaking a rule.

The best piece of advice I've ever been given and put to use in my own work when this issue comes along (and it does frequently) is to minimize the "rule-breaking" with the power of the content you're charged with photographing. Use the story you are trying to tell as a photographer, and make sure it stands out more than the burned-out sky or the horizon placed in the middle of the frame.

BUILDING THE STORYTELLING EYE

All of the learning we do in the way of technique and technical competence is for naught without also developing our eye if we're to tell stories with our craft. All of the bits and pieces we've discussed so far in this chapter synergistically work together in order to "compose" photographs that inform, intrigue, attract, and compel. Being able to see all of these elements gel is also how we as *storytellers* react as *photographers*. Subsequently, we must continuously build an eye for photographic story.

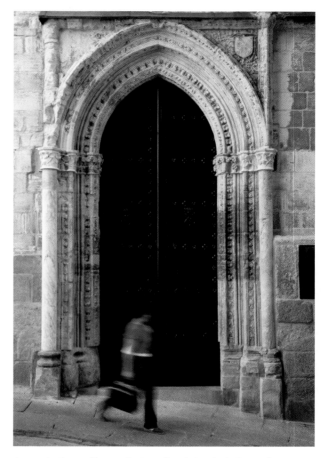

A popular type of image for travel and street photographers, people in blurred motion combined with relatively static backgrounds showcase life taking place around the structures, such as this medieval cathedral in Toledo, Spain.

Canon 5D Mk II, 50mm, 1/13 sec., f/9, ISO 200

Look Persistently

No matter if you have been shooting for less than a month or more than 25 years, the part of you that calls itself a photographer notices good light. You probably notice layered composition in the strangest of places as well. What about when you visit with an older gentleman at the bus stop, and at some point in the conversation you think to yourself that he has the face for an interesting portrait? Light, composition, form, and activity are constantly around us. Even more, all of these elements often come packaged together.

Even without the camera, story is played out in front of us. In order to build a storytelling eye, photographers constantly assess what is before them technically *and* for meaning. You technically notice the beautiful, warm, tangible light early in the morning, but you might also notice the aesthetic and emotional aspects of it as you come upon a backlit, dew-covered cactus in the

Although the Bridge of Craigisla, near Alyth, Scotland, is the main attraction in the image, it also serves as a framing mechanism for other important layers of the surrounding environment.

Canon 5D Mk II, 80mm, 1/125 sec., f/16, ISO 400

field where you're standing. The layers of composition you note might come as you walk through the neighborhood streets lined with building after building of colorful residential life. And the older gentleman you're visiting with might be in the middle of a story about his past occupation as a miner when you suddenly think you could wrap up all the information he's providing in an environmental portrait.

Story is definitely in front of you at all times. Sure, some of what is there is more interesting than other elements, and that's another part of storytelling, which we haven't come to yet. Still, having a persistent eye is essential to both growing your abilities as a photographer and using those abilities as a storyteller. This is a never-ending activity, and those closest to you might even jokingly think you have a condition. Do not stress over their remarks, though. Noticing photographs all the time is not a bad thing. It keeps you on your toes when it's go time.

The Small Things Count

While developing a storytelling eye early on, students of photography generally gloss over the finer things. Quite honestly, we're all shooting for the "big" picture, but often, the overlooked items are the most important in keeping story on track. As we'll discuss in the next chapter, looking for details amid the larger story is essential in pulling it all together in a visual sense. Take the time to notice those small dewdrops on the cactus, or the intricacy of stonework in historical buildings, or even the wrinkles on a farmer's hands. Look just as actively for the small things that tie even the larger images together. Take a look at any *National Geographic* magazine feature or Mediastorm slideshow, and you'll understand the phrase "the sum of the parts is greater than the whole."

Staying aware of lighting conditions will help you produce strong images. Window lighting on this set of hands is attractive, but it is the tinges of light on the coat and the transition to deep shadows that give this image a more interesting noir persona.

Canon 5D Mk II, 50mm, 1/400 sec., f/2, ISO 200

Paying Attention to Gesture

Along with paying attention to the smaller things, keep an eye out for gesture as well. Gesture is not one of those easily explained, black-and-white types of story characteristics, yet when you're looking for it, you know it's there. Gesture is a unique component of an image that can at times be, if you will, the cherry on top.

Think about some of the most iconic images in history. Many that come to mind are journalistic images

Revealing light on an intricately carved door in Madrid.
Canon 5D Mk II, 32mm, 1/60 sec., f/4, ISO 100

and those that involve a type of conflict, such as war. The famous Nick Ut image of a young and burned Kim Phuc running from a napalmed Vietnamese village in 1972 strongly enforces the idea of gesture. The story, or at least part of it, is evident in the image. Yet, one of the primary reasons we're hauntingly drawn to this image is the gesture on Phuc's face, the silent cry, and the frozen motion of her body and limbs. This gesture helps shove the story at you, powerfully.

Not all gesture is this in-your-face, but the right ones all help convey story more effectively than images that lack this special mark. Look for gesture and have your camera ready when it appears. Remember the discussion about becoming an expert? Doing so allows you to really notice when gesture that is both unique and telling of a subject is present. You don't have to be photographing people to pick up on unique "gestures," either. They're in the blazing sunsets that we shoot, all the way to the natural history of domestic and wild animals.

Forecasting

Last, continuously building a storytelling eye helps you forecast *when* certain images can be produced with more effective results. Landscape photographers use forecasting all the time. I remember it blowing my mind when I talked with landscape photographers about where exactly in the sky the sun was setting, and how the direction of that light was just not adequate for shooting a certain area. It was going to have to wait until six months later, when the sun was setting more to the northwest than to the southwest. Being able to forecast like this not only strengthens the images you produce, it is a way to develop an eye for photographic interest and attractive narrative.

As I stated earlier, the components discussed throughout the chapter work in harmony for story to pervade the images. There's no doubt that at times certain elements override the value of others. However, not one component stands 100 percent alone all the time.

Thinking about putting these elements together can be intimidating, especially when we have to consider the technical, the aesthetic, and the story side of photography in one swipe. With time spent looking through the viewfinder and at other images, many of the issues discussed above come to fruition in the blink of an eye, though, and many of the decisions regarding producing images a certain way are made in a flash.

Even though there is no definitive good or bad way of creating images with the elements outlined here, it's beneficial to consider how using the "rules and tools" will allow you to ultimately tell better, stronger stories with your images. We learn these principles because they've seen successful use for hundreds of years in piecing together visual elements that aid storytelling. The fact of the matter is that they're still valuable after all these years. Becoming more familiar with their applicability and when and where overriding them can be beneficial, and continuously seeing them play themselves out in everyday instances puts you in a position to create stronger storytelling images.

Forecasting when King Ranch bluestem goes to seed during the summer and early fall helps produce images like this one, where the low light in the evening illuminates the pinker tones across the field.

Canon 1D Mk III, 200mm, 1/125 sec., f/2.8, ISO 200

This man has a job that's literally as big as the state of Texas. He's been the chief photographer for the Texas Parks and Wildlife Department for 15 years, and he's been telling the state's conservation story for even longer if you include his many years of freelance work. Even though he holds a bachelor's degree in photography and a master photographer ranking from the Professional Photographers of America, he often states his Ph.D. is from the school of hard knocks. There's no doubt his years of racking up the miles on his rig have provided him hard-won, keen insight into being a visual storyteller.

I first met Earl many years ago while shooting for the primary magazine of the state agency. Along the way, our paths have crossed many times, and I've often attended his workshop and classroom appearances. With an eager, creative imagination and a whole lot more story to tell about the state's wildlife and natural resource conservation efforts, he's rarely behind the podium, though. He's simply one of the busiest photographers I know. And for good reason—he can tell a story.

Q **Who were your influences in how the camera allows you to tell story?**

A I think what we are as photographers, this thing that's considered our "style," is simply a homogenous mixture of all the exposure and interactions that we've had with other photographers and visual influences in the past. All of these things are mixed up in the Cuisinart in our head, and what comes out is us.

Ansel Adams was an influence, primarily for the technical aspect of his photography and his ability to quantify the science of it. I enjoyed his way of transferring the image that you previsualise in your mind to physical form using various exposure and development processes. Of course, that was all wet darkroom work, but the same concepts translate to the new digital world. I studied everything about him I could, just to be able to get the image I wanted.

A lot of photographers stop their photographic growth when they've mastered the technical side of photography. They get so concerned about the mechanics—the cameras, the lenses, and the shutter speeds—and are satisfied at that point. But at some point, that other side, the artistic component, comes in, and you reach that "Aha!" point of the marriage of art and the science. It's only then that photography starts to really come together.

So, I think I was more influenced by the old master painters than other photographers. As a senior in high school, I went on a student tour of Europe, and one of the places we visited was the Louvre in Paris. One of the things that really hit me was the power in the old masters' work. I can remember it just as clear as the day I saw it. We were looking at these old paintings and people were just standing there in silence, with their mouths open. I thought, "What's the deal? These are just a bunch of old pictures by a bunch of old dead guys from hundreds of years ago. But they still captivate people. Why is that? What is it, what's so magical about these things that hold people's attention and evoke a powerful response?" And from that point on, it became a journey for me—to break down and quantify art. What is it that causes that impact, the ability to arrest somebody's attention?

One of the classes I took in college was art history. I hated it at the time, because I thought, "I'm a photographer, not a painter." However, it quickly started to sink in. This is why those paintings are so great! I really made a point, and still do, to study a lot of the old masters and ask, "What are the elements of those paintings that I can apply to photography?" Those elements are the basics we know about—color balance, composition, leading lines. They're recognizable in those paintings, and we can easily apply them to photography.

One of the influential photographers who jumps out at me is Henri Cartier-Bresson—the decisive moment. Now we're going from a painting to what a lot of people call a snapshot, just a split second. What was it about that split second and how was he able to get that whole feeling in a split second, as opposed to the painter who has years to do one painting? He had to do it in 1/60th or thereabouts of a second.

I enjoy learning from his work and how quickly he incorporated many of the elements usually found in a painting into just one passing moment. I was impressed by his use of geometry. His pictures weren't just about people doing things—they were about the geometrics and the juxtaposition of objects and how he composed them, whether it was with classical or unbalanced and asymmetrical composition.

In the 1980s, I was really into Eliot Porter's nature photography. It was very simple stuff, like looking down at a bunch of flowers, I remember visiting one of his exhibitions and being in awe of the color in his images. He was using dye transfer at the time and what impressed me about his work, in addition to the artistry, was the technical mastery of color via the dye transfer print. It was a good example of science and art working hand in hand to achieve an image that captivates the attention.

Q Is there a particular moment that emphasized the significant role you play as a photographic storyteller? When you realized that what you were doing with the camera went beyond just you and reached others?

A Not one instance in particular; rather, it was a gradual progression, especially in the late 1980s and 1990s when I was shooting more travel work. The feedback I would get from people, like, "Oh, that's such a pretty picture," was starting to include how much a particular shot would move them or brought back certain memories. One shot in particular was of an old barn near Dubina, Texas.

I was shooting a story for *Texas Highways* on the painted churches near La Grange. I had finished shooting one of the churches, and I drove down this little dirt road that went across a creek that a little bridge made out of planks crossed. I noticed on the other side of the bridge a little barn. I was there early in the morning, and a big old oak tree reached over the barn, and the wildflowers were coming out during that time of year. The light was perfect, and I started shooting.

An old farmer came across the bridge in a truck, and you could hear the planks rumble as he went across. He stopped and asked me what I was doing, and I told him I was shooting the barn. He told me he was raised right next to the old barn, and he actually started tearing up talking about growing up there. It was at that point that I realized that the photograph is more than just a pretty picture; it is a visual summation of objects and

At some point the artistic component comes in, and you reach that "Aha!" point of the marriage of art and the science.

emotions—it was the fact that I was at a place where somebody's life had existed, as well as their story.

It hit me that a lot of these places I had traveled to, and a lot of the places I would subsequently go, included such stories. Many times we just go to take a pretty picture. We want to get the f-stop and the shutter speed right and take it back home and look at it. There is some satisfaction in that. In that sense, though, we're always looking for the perfect shot. It's kind of like a drug—you've got to keep getting another fix. You're waiting to get that right one. However, in waiting for that right one, we're missing a lot of the neat experiences in the stories, especially the stories of the people who we run across along the way.

It's one thing for people to look at your photograph and *see* something. It's something else for them look at your photograph and *feel* something. If that happens you've truly accomplished something.

Q **I've heard you talk about creating storytelling images in regard to using layers of interest. Discuss this approach to building compelling, informational imagery.**

A It's as though you're standing in front of those old masters' paintings and asking, "Can we quantify art?" So, you start by breaking down the elements, all the layers of interest (not to be confused with layers in Photoshop), in the paintings. It's important to remember that as photographers, a blank canvas is what we're given. It's our task to put something on there that will arrest somebody's attention, just like those old masters'

paintings—something that will contain their eye and move it where you want it to move.

Also, just as in a painting, we're working with a two-dimensional medium, and we're trying to make it as three-dimensional as possible. When somebody looks at an image, we want them to say, "I could almost reach out and touch it."

When I talk to students about interesting images, I use an analogy of having them envision a single dip of ice cream as the subject. Homemade vanilla is pretty good, and I could eat an entire gallon of it by myself. Unfortunately, many photographers are happy with that single dip of ice cream. We call that a snapshot.

The subject is good; however, it's only our base, and we have to build up from there, with an ice-cream sundae as our ultimate goal. We start adding things to the mix to improve the product, as if they were layers of visual interest. We're taking something ordinary, the dip of vanilla ice cream, and we're doing extraordinary things with it.

The most important layer to add is the quality of light we use to illuminate our subject. A great photograph is nothing but an ordinary subject in extraordinary lighting, whether that light is natural or modified by the photographer.

The next layer you add may be composition. In an old master's painting, you may have a lady sitting under a tree with pretty light, but it's important to pay attention to how the painter used composition, how the artist has posed her leaning up against the tree, how it follows the rule of thirds and how the roots and upper tree branches of the tree create leading lines toward and frame the lady.

It's one thing for people to look at your photograph and *see* something. It's something else for them look at your photograph and *feel* something.

After composition, you add a layer addressing color. The lady's beautiful blue dress against a warm, yellowish background—two complementary colors that when combined create visual vibrancy. You may have texture in the dress created by the light, and combined with the colors, the image becomes more tactile, so you can almost feel the fabric itself. Texture, form, and color are all layers used to create this image, and there may be other layers present such as unique body language or behavior. She could be posed wistfully—a svelte, wistful lady whose every body movement is fluid. Before you know it you have a Thomas Gainsborough portrait.

As with a very good ice-cream sundae, you have a cherry on top. Photographically, the cherry on top is the thing you can never plan for. You can plan your shoot, pick the time of the day, get the lighting right, get the location and the pose, but regardless of what your subject is, something's going to show up that you didn't count on that could make the photograph even better! The chance of having a cherry on top increases the more you're ready for it, putting yourself in the right place at the right time—just like wildlife photographers knowing where and when to be day in and day out.

It's that split second nuance you can't plan. It's just there. It may or may not happen. You could sit there every day for a year and have nothing happen, but then one little thing does that makes your shot. You could be shooting a landscape with pretty storm clouds, and then right before sunset, you're given a five-second window of streaming sunlight coming underneath the deck of clouds that you weren't expecting. There's your cherry on top.

There's a difference between pictures you *take* and pictures you *make*. What we're after as professional photographers are pictures that we *make*. Taking pictures is the dip of ice cream—the picture we make is the sundae. So, to make a picture implies an element of craftsmanship, of planning, and more than anything else, sensitivity to the nuances of the story itself.

Q You've really increased your efforts on the video and multimedia approach to telling a story for Texas Parks and Wildlife. How has this changed the way you *produce* story?

A You have to change mental modes when you go from still to video and audio. For me, you have to do either one or the other at a time. I have to go out to shoot still photographs, or I have to go out to do video. You can't do both. I can multitask to a point, but you've got to get into a mind-set and once you're in that mind-set, you're able to produce better work than you would if you came into the story with intentions of shooting both video and stills.

Luckily, I do have a little background in cinema from college, and I can call upon that when shooting and editing video for story. The transition from photography to video is like going from checkers to chess and at the moment, I'm really enjoying the added dimensions of the moving image.

Q What does combining stills, audio and video, do for the person actually consuming the story?

A It's all about synergy. It's taking a few things and creating something greater than their sum. You're adding a dimension—a sense of place and realism. We gain additional synergy by using current social networking sites as well as our own Web site to distribute our content. For the agency, it gives people a sense of participation so they can connect better with whatever we're telling a story about. I've even had our editor add my email address to the bottom of the online and printed versions of my stories, which gives people the option of discussing the story with me and sharing their stories.

Q If you had to choose only one of your images to explain how effective storytelling can be achieved through photography, which one would it be, and why?

A I don't know if I've taken that one yet, but hopefully everything I do tells a story. You shouldn't have to have a bunch of photographs to tell a story—you can do it with one image.

We did a magazine story on the Texas-Mexico border fence. Before I shot it, I read the manuscript, and I had a good idea of what I needed to cover visually. I did the research and just tried to get a feel for it. The story was about how the border fence will affect wildlife. We did not approach it from a political aspect, and we stayed strictly objective about the fence and wildlife.

Before I even took the camera out of the bag, I wanted to spend some time trying to get a feel for the subject. I was overwhelmed by the fence—it has a personality. You walk up to it, and it's about 20 feet tall. It's an imposing dark brown, iron fence. I was in the rural areas on the border, so it's just you and that fence out there.

Photographically, you just try to let it come to you. What hit me was its strong, dynamic architectural qualities. And as a photographer, you start to look at it in regard to perspective, visualizing how it might look with a wide angle or with a telephoto. With a wide angle, the geometry of its form is phenomenal. And it's imposing, it's dark. You have to be careful about your exposure, because the structure could go black. Although it is meant to be a barrier, you notice that it will run for a distance, and then in order for the farmer to be able to access his land on the other side (since in places it's a quarter mile away from the actual border), there is a 30-foot gap in the fence that begs the question, "What's the point of a fence?"

Earl Nottingham

To a lot of photographers, a camera is a defense mechanism or an insulator from real life. It can act as a fence between us saying, "I'm an artist, you're a subject."

So, one of my favorite shots—one of the simplest shots from the story—is just a long horizontal image of this very rigid, structured, stoic-looking structure with a simple gravel road going right through it, winding down off in the distance with the fields in the sides of the frame. Components of that image convey a particular feeling that contributes to the ongoing issues, not solely political or about wildlife, that surround this fascinating structure.

Q **What is your thought process when generating a new story to cover?**

A If there is a story already written, I'll look at the manuscript and get a feel for the message, because my photography is supposed to work *with* the written word. This goes back to what I was saying about trying to achieve a three-dimensional feel. If the images work in concert with the words, it creates a degree of perceived realism.

Once I get on location, I have pretty much carte blanche on the look that I give the story, just as in a movie, the director of photography would get his own personal treatment of how the film looks. I get to a location, I get a feel for it, and I think visually. What photograph could I make that would most effectively tell this story? Going back to the bag of tricks—the layers—what can be added? Should I come back in an hour when the light is a little bit different?

Then, the only thing left is that cherry on top, and that's what makes the images. For example, in the case of the border fence, if all I have is this big, monotone fence and there's nothing else—then all of a sudden, there's a horse casting a shadow on the side of the fence, I've found a cherry and get more interesting photographs. In a way, I'm always dancing with the many visual possibilities that each story affords.

Q **What about the stories that you actually originate?**

A I do several photo essays each year for the agency's magazine, and it is kind of open-ended. I just need to come up with an interesting idea. For example, one thing I'm working on right now is a story about injured and rehabilitated animals. People who find orphaned or injured animals often take them to a rehabber. And I don't think anybody else gives a thought to what the animals that go to these places actually look like. So, I'm doing a photo essay I'm calling "Little Lives" about mangled animals that are still holding on.

I wanted the story to be hard-hitting, in black and white, and I want the viewer to be impacted when they see these little creatures. I want it to be very stylized—portrait-esque if you will. I want to give them the dignity of a portrait, even though the animals are deformed or mangled.

I wanted the look to be as consistent as possible as a unified body of work. However, I have to be flexible

with my plan. In most shooting situations I don't exactly know what I'm going to shoot until I get there. I previsualised the shoots with some type of solid backdrop, but I found the animals were already in some very interesting settings that I could never have planned. As it turned out, these areas worked well for the story—the cherries on top.

Q **After you're done shooting, then, does your story further evolve during the editing phase?**

A It's always evolving. It will never end up exactly like I'd originally envisioned it. If you go into something with blinders on, thinking you're going to tell your story, then you're not being receptive to that other bigger story coming to you, hitting you in the face. Everything I do preliminarily is just a general road map to where I actually end up visually. It took several years for me to be receptive to this way of thinking. Again, as a photographer, you want to go out and *take* that picture. It's not an easy thing to let up and be sensitive to the things that are coming in to you and then to capitalize on them.

Q **Besides camera gear, what is one thing you've found extremely useful in telling visual stories?**

A Camera gear is just nuts and bolts. It's a lens, it's the f-stop, it's the shutter speed. It's like giving two workmen the same hammer from Sears. One workman is going to barely make a shack with it, and the other is going to make a mansion with it. What does the other workman have? I'm not saying I can build a mansion, but my biggest tool other than the camera is being able to research the subject and being sensitive to all the possibilities for that subject and its surroundings.

Q **If you could give one piece of advice to those starting out telling stories with photography, what would it be?**

A One of my mentors, Will Thompson, was an older photographer who lived in Temple, Texas. I met him when he was close to 80 years old. He had become a photographer back in World War II, and I still have some of his 4 x 5 Kodachromes.

He introduced me to Big Bend. He was a member of the local pack and paddle clubs, and he was always inviting me to go to the Rio Grande River. Finally, I went with him one year. We went across to Boquillas, and I noticed he took a sack of oranges across the river with him. All of the little village's kids would come up to you, wanting to sell you rocks, but Will would give them oranges. They just loved the orange, because it was something they never or rarely had. I asked him, "How come you do that?" He said, "You know, the people over here have a hard life." Then he said something that really stuck with me: "Even the poorest guy or little kid over here has their dignity."

That kind of hit me, because I realized everybody I deal with, every subject, and for that matter, almost every inanimate object, the land, the animals—has its own type of dignity. When I approach my subjects now, that's always in the back of my mind. It boils down to having a respect for every person or thing I photograph.

To a lot of photographers, a camera is a defense mechanism or an insulator from real life. It can act as a fence between us saying, "I'm an artist, you're a subject." But when you let that fence drop, it allows you to be a participant in the wonderful and infinite stories all around us. ◼

To see Earl Nottingham's work, visit his Web site: www.earlnottingham.com.

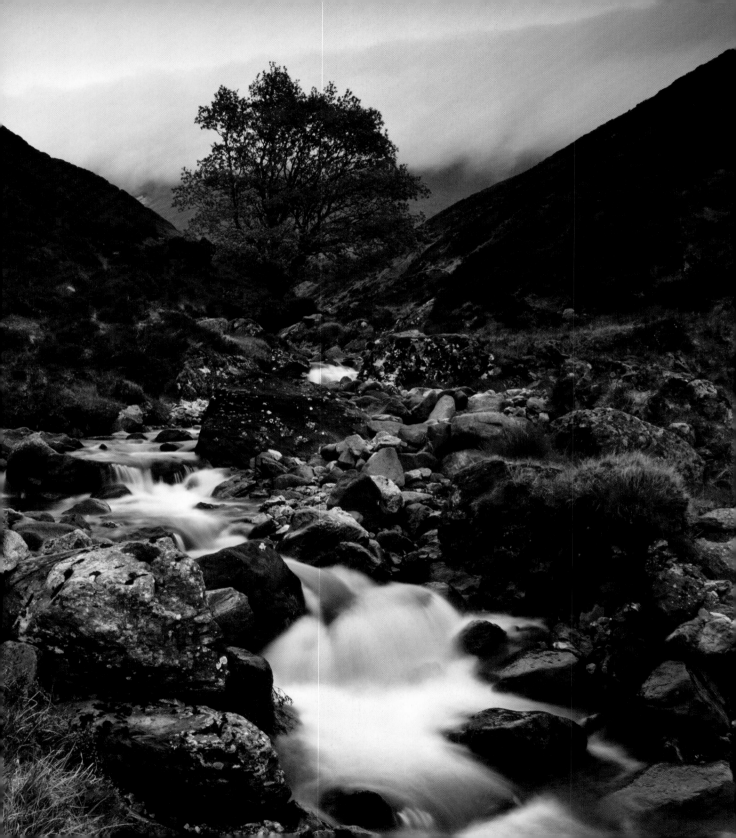

Storytelling Images

The previous chapter highlighted elements of images that help provide impact, interest, and information. Not until those elements are combined in individual frames, though, do they really begin to say something. As stressed earlier, persistent scanning for composition, light, and perspective will strengthen your photographic eye and your ability to use such facets of photography to your storytelling advantage. The images you produce as a result of exercising your eye in such ways say more than if you were not visually open to finding story. These are called storytelling images, and they come in handy.

The low light, muted colors, and low, dense clouds hanging over the mountaintops in the background help "establish" a characteristic mood for this Scottish Highlands setting.

Canon 5D Mk II, 24mm, 3.2 sec., f/22, ISO 50

No matter how unencumbered you think being a visual creative should be, shooting story requires you to pack a toolkit. This doesn't necessarily mean you need three camera bodies, nine lenses (five of which are primes), four flashes, a carbon-fiber tripod, and a vest. It does mean that along with your choice of equipment, it might be wise to pack a slew of image ideas and knowledge that will help you as much in telling story as your trusty 50mm.

Shooting story is purposeful, even if you just stopped the car to photograph a group of prickly pear cacti. You saw something about the cacti; maybe they were clustered more tightly than others you've seen along the fence. Perhaps it was their color, the ripe red pears among the nettles, or the muted lighting. Or, that you wanted to photograph life existing in one of the worst droughts in history. Whichever the case, the car was stopped, and deliberate action was taken to photograph the cacti growing along a barbed-wire fence. There was purpose, and there was story behind that purpose.

KNOW YOUR THEME

Remember the earlier discussion about themes? They are the essence of story. They inform photographic storytellers about what content to look for, where to look for it, and when might be a good time to make images that bolster the story. For those of us geared toward story, a theme is a guiding beacon in a complex visual world composed of one story after another.

Themes help you develop a plan of attack. They provide the right amount of structure for individuals who are often photographing within relatively flexible confines. For example, an assignment to photograph a kite maker invoked in me ideas related to youth and joy, tradition and flight. The use of bright colors and easygoing light were a large part of the shoot, as well as the connection between humans and flight. Wrapping my head around the particular themes this small story would involve ahead of time helped develop a variety of images that I previsualized and made me more receptive to other relevant images once I was on the shoot.

Ask yourself, "How does what I have in the frame of my viewfinder contribute to the story I'm shooting *and* represent the theme that provides the overall emphasis?" If you have to dig too deep as the image's creator, then it might be an even greater stretch for those not involved with the story. Asking yourself questions like this one only helps to develop your ability to tell deeper, more meaningful stories. Having a good handle on your theme will allow you to answer these questions with certainty.

The bright blue sky, the joyful smile on the kite maker's face, and the line connecting him to the kite all contribute to the themes his story revolves around—those of youthful play and tradition in humankind's affinity for flight (opposite).

Canon 5D Mk II, 32mm, 1/160 sec., f/10, ISO 100

More drought tolerant than most of the surrounding vegetation, this group of prickly pear cacti stands ready for the next year's worth of dry seasons and summer temperatures soaring over 100 degrees Fahrenheit each day.

Canon 5D Mk II, 17mm tilt-shift, 1/400 sec., f/4, ISO 100

THE IMAGE TOOLBOX

Up to this point, we've spent a lot of time on the storytelling strength of a single image. It's true that certain singular images have the power to convey large amounts of narrative information (something I'll cover later). However, for the bulk of our work as photographers, it's not just one image that says all there is to be said. Although only one image from hundreds might be selected to accompany a news story about violent conflict between two nations, it's safe to say that other images could help weave together the full visual story.

Most photographers are not hired to make just one photograph while trying to tell a complete visual story. Telling a story visually is just as involved as writing it down. Just as a writer would describe a scene to entice the senses, photographers look to attract viewers in much the same way. We're looking for the same things—characters, plots, environments, action, conflict, nuance,

Each tool serves a purpose. The same could be said for each photograph.

Canon 5D Mk II, 17mm, 1/40 sec., f/2.8, ISO 100

A look across the water, with sparsely placed houses among the rolling landscape, serves as an establishing shot for a story taking place on or near the Isle of Skye, Scotland.

Canon 5D Mk II, 105mm, 1/160 sec., f/7.1, ISO 100

gesture—and we're doing that with equal attention given to light, form, composition, and other elements that will help construct visually appealing images.

Telling the story effectively often requires multiple images. That is why we carry an image toolbox. Inside are several types of long-heralded images that enable the photographer to more fully engage and exhibit a visual story. Creating typologies can be a controversial endeavor, akin to stating that the rule of thirds is the only way to compose an image. Nonetheless, the types of shots identified below serve as foundational guidance. Understanding them is kind of like standing before you start walking and walking before you run.

Establishing Shots

The establishing shot is typically the one used to set the stage for the story. The story takes place within the environment shown in an establishing shot. Therefore, it is extremely useful in orienting a viewer visually and emotionally before more specifics of the story are produced with other types of shots.

Establishing shots come in all shapes and sizes. Typically, they are the beautiful, wide-open landscapes and the bright city skylines of the photography world. Of course, establishing shots need not be so grand. The perfect establishing shot is one that gives a good idea of the context for the story

Canon 5D Mk II, 50mm, 1/50 sec., f/2, ISO 800

Canon 5D Mk II, 200mm, 1/400 sec., f/5.6, ISO 100

being told. If the story centers around the natural features of a state park, then the expansive landscape might do the trick. But if you're shooting a story about something a little less physically encompassing, such as elder care facilities, a well-composed shot of the building or of a room might serve well as an establishing piece to the story.

An establishing shot serves several purposes beyond providing the background to a story. It makes the unfamiliar a bit more relatable to image viewers. Without an establishing shot, outsiders would have a hard time gaining traction in a visual story that features only tighter shots. They would then be distracted by nagging questions about *place* rather than noticing the story included in the visuals. Imagine being provided directions by street names in a city hundreds of miles away with no map. Upon arriving in the city, you would spend considerably more time finding where you were going than if you had that map. The same goes for establishing shots: a viewer can visually relate to the smaller aspects of the story if he is at least a little bit familiar with the setting.

A story's emotional dynamic is conveyed through establishing shots as well. The way you present the environment helps set the tone for the entire story. Establishing shots include not only the story's surroundings but the light and color, features that help project mood and ambience, putting a viewer in a particular state of mind for the remaining images.

Although using certain lenses might augment true perspective, establishing shots also help viewers visualize the physical relationship between various subjects. Establishing shots provide a sense of relative proximity and physicality among smaller components making up the environment.

Finally, establishing shots help a story come full circle. Viewers start out with a sense of place, and because of that, they're constantly, if subconsciously, aware that the story they are consuming has boundaries and they have a familiar environment to return to after the story has been told.

> Establishing shots help a story come full circle.

Both images of the Spanish Mediterranean city of Malaga might serve as useful establishing shots, despite one of them showcasing less of the city as a whole.

An image of a city the cathedral overlooks in Madrid might help imply the significance of religion in the area and in subsequent images.

Canon 5D Mk II, 50mm, 1/400 sec., f/5.6, ISO 50

A story covering castle gardens might benefit from an encompassing image of a large, intricate garden with strong natural colors, such as the green vegetation and the vibrant sky at Dunrobin Castle in Sutherland, Scotland.

Canon 5D Mk II, 24mm, 1/50 sec., f/8, ISO 100

Shot from atop a plateau south of Sheffield, Texas, the boulders in the foreground provide perspective for the size of and distance to the ranch headquarters below.

Canon 5D Mk II, 32mm, 1/6 sec., f/11, ISO 100

A medium shot is a practical choice to showcase these Mexican cowboys preparing for a day's work on a central Chihuahuan cattle ranch.

Canon 1N, 35mm, 1/125 sec., f/8, ISO 100, Fujichrome Velvia

Medium Shots

Medium shots are the photographer's meat and potatoes. They take a step in to the setting that establishing shots, ahem, establish, and they begin to really stitch together the story that the larger shot started. For the viewer, the medium shot allows for stronger engagement with all facets of the story.

Characters are introduced through medium shots. Not just human characters, either. Medium shots bring all parts of a story into greater focus, including people, animals, furniture, roads, light poles, and fire hydrants. Medium shots visually bring the viewer to any and all subject matter that is significant to the story. An image that shows wildlife biologists attaching a radio collar to an animal whose population has declined in recent years constitutes an involved medium shot, just as much as one that features a boat anchored in a calm island bay.

However, medium shots are not so tight that they completely decontextualize the subject matter from its surrounding environment. Quite the opposite. Medium shots highlight interaction among "characters" without disconnecting them from what the establishing shot does for the story. This is part of the utility of medium shots. They are able to include parts of the environment as well as the contained characters' activities, relationships, struggles, and exchanges.

The intimacy of a medium shot puts the viewer right in to the action, such as this wide-angle perspective of two wildlife biologists assessing a member of a dwindling bird population.

Canon 5D Mk II, 24mm, 1/6 sec., f/4, ISO 400

Even though the wide, dynamic sunrise might convey a sense of new beginnings in the Texas plains, it's not until you see actual creatures, such as this jackrabbit, that you have a little more of the story to comprehend the environment.

Canon 5D, 17mm, 1/200 sec., f/5.6, ISO 100

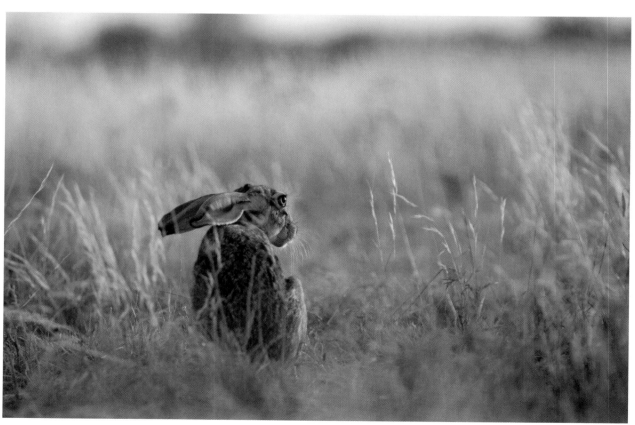

Canon 5D, 300mm, 1/320 sec., f/4, ISO 100

If establishing shots contextualize the story, medium shots are deeply rooted in that contextualization. This does not mean that medium shots cannot be specific or cannot isolate individual characters from others. It does mean, though, that they are specifically tied to where the characters exist at that moment in time.

Aside from identifying the characters in a given environment, medium shots also give us insight into who or what they are in relationship to the story. Building upon the perceptions created in response to the establishing shot, the characters play a very strong role in the story at this point. Their actions and their positions related to everything else in the environment become tangible, even to the point that viewers can more deeply relate visually and emotionally to them. Likewise, the thematic structure outlining the story becomes more concrete and specific.

Medium shots say something more finite about the story and its theme. Instead of interpreting the emergence of life from a shot of a rising sun on the Texas plains, we're now able to actually see the skittish scurrying of animals among the long grasses.

In this sense, medium shots powerfully convey the story to its viewers, and for good reason: specificity. Medium shots are more detailed than establishing shots, but not so detailed that meaning becomes abstract and storytelling is lost on visual ambiguity. They are the happy "medium" between establishing a context and moving in so tight on the context that interpretation is difficult as it relates to a particular story or theme.

Close-Ups

Close-up shots are often referred to as detail images, and rightly so. They highlight the smaller details that help make up the content of a story, and they do so in a way that fills the sensory holes of story left by establishing and medium shots. For example, a tight shot of a pair of leather work gloves is but one detail image that could be included in a story about a local farmer or rancher. Similarly, when a photographer shoots a newborn, close-ups of feet and hands provide viewers with a more artistic yet palpable portrait of the child.

Close-up shots provide entrée into the smallest of visual textures composing the story's setting and characters. You could consider detail images to be the adjectives photographers use to strongly describe a person, place, or thing that relates to the story being told. Grand shots of rivers and streams are necessary when creating a story around an area's water resources, yet a tight, almost flat

A tight shot of a young lesser prairie chicken's feather plays a role in the story about the population's sustained growth.

Canon 5D Mk II, 105mm, 1/125 sec., f/4, ISO 100

One small component of a larger story.

Canon 1D Mk III, 33mm, 1/40 sec., f/2.8, ISO 100

A shallow stream can be a great setting for close detail work full of textures. Guadalupe Mountains National Park, Texas.

Canon 5D, 45mm, 1/40 sec., f/4.5, ISO 200

Using shallow depth of field is a powerful way to direct attention to the finer details of a close-up shot. Here, the grooves and lines in the vegetables pair well with the colors in the frame to emphasize freshness.

Canon 5D Mk II, 50mm, 1/200 sec., f/2.2, ISO 400

shot of a few leaves floating along a slow, shallow stream may convey the wetness of the water more adequately. Close-ups of vegetables in a market can emphasize freshness to the point where the viewer can practically smell the garden where they were harvested, and tight shots of ancient carvings in a cave wall can make a viewer feel the ridges along the rock.

While they're the smallest, most specific components of a story, all of these images complement larger shots in ways that our senses can appreciate. Thus they are valuable assets to the overall story.

Tight, zoomed-in detail shots beg the viewer to ask questions, particularly if they are viewed before any other type of shot for the story. We've all seen the magazine story that starts out with a double-page spread of some smaller detail of a much larger subject, such as a classic car's tail fin or intricately woven bolts of fine fabric. These images are used to intrigue viewers, to entice both their senses *and* their curiosity. The same could be said of close-ups of ammunition used for a story dealing with war, or a backlit petri dish containing a sample strain of the most recent flu virus for a story on public health research.

Starting with a close-up may seem counterintuitive, but there is no rule stating which should come first in a story, as we'll see later. Close-up, detail images can be just as powerful in attracting and interesting viewers in a story as a dynamically lit establishing shot.

Marks by an ancient people under an outcrop in the plateaus of far West Texas. A soft yet angled light allows the depth of the carvings in the rock to stand out.

Canon 5D Mk II, 105mm, 1/50 sec., f/4, ISO 100

A close-up shot of a signature element of a classic car makes a viewer want to see more of the vehicle.

Canon 5D Mk II, 50mm, 1/1000 sec., f/2, ISO 100

Frames filled with color, detail, and tight composition not only pique visual interest, they also serve as great design pieces to open stories.

Canon 5D Mk II, 50mm, 1/100 sec., f/2, ISO 400

The Value of Interstitial Images

Interstice refers to the spaces in between individual elements of a whole. Truthfully, the more these spaces are filled up, the more complete the whole becomes. When we relate this to photographic storytelling, the more we fill in the gaps and holes in our stories with relative, contributory imagery, the closer we come to telling as much of the story as possible.

Interstitial images are not totally different from medium and close-up shots. In fact, one might consider medium and close-up images as interstitials. They might draw relationships between different environments in a story, or they might materialize in the form of simple head shots of individuals who play both major and minor roles in the narrative. As a result, interstitial images vary in importance, yet they remain the connective tissue between all strong elements of the visual story.

Interstitial images are what help photographers make up for not being able to tell a complete story with only one image. They are not necessarily the core building blocks, such as establishing shots of an empty small-town main street or an aerial made over a virgin landscape, but they are often the mortar that holds those blocks together. Close-ups provide detailed descriptions of the context, and medium shots highlight the issues surrounding the story's characters. Both increase the depth of storytelling, providing more complete coverage and viewer immersion.

There's nothing that says you must only create images that follow the parameters established in the previous descriptions of shot types. Notice that there is no preferred focal length for a medium shot or particular time of day outlined for the perfect establishing shot. But knowledge about shooting for story can be pushed into action by contemplating and experimenting with the types of images listed above. Like rules of composition, including establishing, medium, and close-up shots in your toolbox only enhances how you see and develop storytelling images.

Interstitial shots like this close-up of a raccoon track in a damp creek bed provide nuance for stories about small wildlife. Simple and efficiently obtained, they are not to be forgotten.

Canon 7D, 300mm, 1/400 sec., f/4, ISO 100

A couple strolls hand in hand through a Madrid rose garden. Images like this are symbolic, and it's not a far stretch for viewers to imagine themselves in their shoes.

Canon 5D Mk II, 50mm, 1/3200 sec., f/2, ISO 50

HUMAN INVOLVEMENT

Let's face it. We're downright obsessed with other people. Don't believe me? One visit to the local bookstore to study the imagery that makes up the magazine rack will convince you. The majority of the magazines in front of you feature cover images that highlight celebrities, dignitaries, cultural icons, politicians, craftsmen, chefs, and so on. Being obsessed with people isn't necessarily a bad thing. People make stories interesting.

The majority of activity occurring in the social world involves the interaction between human beings. Story surrounds people. Consider love and war, two of the most prominent themes covered in images. Stories on these themes invariably involve strong human elements. This is not to say that stories that don't concern humans are not really stories, but it does emphasize the value of stories that feature people. At the core, human beings relate to other human beings, regardless of the myriad of differences between us.

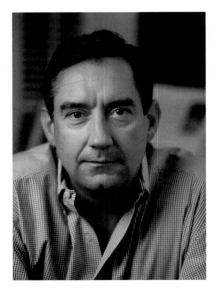

Never leave a shoot that involves another person without making at least one head shot. Sometimes, a head shot serves as a great study of a face belonging to a story's key character.

Canon 5D Mk II, 200mm, 1/60 sec., f/3.2, ISO 200

Although there is no actual person in this image, made at the end of a new 4 x 4 trail in Big Bend Ranch State Park, the vehicle implies the human presence that drove it to the destination.

Canon 5D, 105mm, 1/60 sec., f/10, ISO 100

People provide viewers relational perspective, not only in their physical proximity to other elements in an image, but in contrast to those elements. A person in a frame is perceivably more dynamic than a tree or a fire truck. That person can climb the tree or run a hose from the fire truck. People imply interaction with their surroundings, even if it is only one person in a frame composed mostly of open water. In a sense, including a person, or a group of people, in a frame invites a viewer to put himself in their shoes, and the more we try as photographers to achieve this connection, the stronger the story.

Compositionally, images do not always have to include entire bodies, or even heads and faces, to convey a living presence in the story. Sometimes all it takes is a pair of hands sanding a ceramic pot, or the feet of an athlete. A tight shot of a handshake conveys a powerful, universal message, even without knowing who's attached. Even images that show people lost in the bokeh of a wide-open aperture can abstractly suggest their connection to the story. At other times, the content in a frame so strongly implies human interaction that it's easy to engage with the image on that level. A smoking gun or an open car trunk with groceries in the back both say that there is a person around who pulled the trigger or is coming to get the groceries before the ice cream melts.

Even though the boat is a small element in the frame, the fact that the kayaker is a human being is attractive to the viewing eye.

Canon 7D, 300mm, 1/1000 sec., f/4, ISO 200

A few elements of the frame imply human involvement—the bodies out of focus in the background, the hands of the griller—but if everything else was gone in the frame, the food in the outdoor grilling setting would still say something about the human role in the story (opposite).

Canon 5D Mk II, 24mm, 1/60 sec., f/5.6, ISO 100

A more intimate shot of two hands, shown here sanding a small clay pot, still connects the viewer to the artist and captures the ambience that all the small backlit sanding particles have to offer.

Canon 1D Mk III, 48mm, 1/640 sec., f/2.8, ISO 200

Something as simple as a piece of clothing could throw off how the human element relates to the story. The vertical shot of Amanda in Palo Duro Canyon State Park shows her wearing a scarf that you might see on a downtown Chicago street. The other image of her, looking out over the Big Bend landscape sans scarf, leaves a clothing component out that might otherwise draw attention away from her presence in the environment.

Canon 5D Mk II, 400mm, 1/1000 sec., f/5.6, ISO 200

Canon 5D, 70mm, .6 sec., f/32, ISO 100

Of course, including people (or parts of them) in a story is not something to approach lackadaisically. It is wise to include folks that fit the story you're shooting. It's common to edit your images from a day's shoot, only to find that the human element in some of the shots you were excited about doesn't completely relate to the "great outdoors" storyline you set out to cover. Attention to detail is pertinent when photographing people, especially when you're selling that story to other people. Viewers, especially niche audiences, can and will notice deviations in the smallest aspects of human involvement, such as appropriate clothing and activity for a story.

KNOW THY SUBJECT If you are to say something about people or their involvement in the story, then it behooves you to take some time to get to know who you're shooting. Have a conversation with them during the shoot, Google his name or check to see if she has a social media presence (I know, seems kind of like you're stalking them), and talk to folks who have spoken with them before. Without being too intrusive, try to obtain the information that ties them to the story you're covering. Even having the slightest bit of information is better than going through an entire shoot without that knowledge. Your role is to connect them to the story. Having information will certainly help you do so.

For photographers who concentrate more on wildlife and domestic animals, the same could be said of creatures in the frame. Including animals in our images requires us to know a thing or two about them, maybe even more than with humans. Showcasing the natural history of animals in the wild is prone to quite a bit of potential criticism. Learning about an animal's movements, rituals, biology, and habitat contributes directly to making images that tell a stronger part of that animal's story.

A tricolor heron meanders among the shallow estuaries connected to Mustang Island, Texas, in search of food.

Canon 5D, 200mm, 1/1250 sec., f/3.5, ISO 50

Early morning light hits the eyes of a submerged bullfrog. Knowing when and where animals are naturally located in relationship to the season is important for wildlife photographers and the accuracy of the story they're telling.

Canon 5D Mk II, 400mm, 1/1000 sec., f/5.6, ISO 400

When I first started out in photography, I was bent on shooting landscapes. I bet that many of the folks reading this book are not that different. That's what got me into shooting—I was inspired by well-known landscape shooters, and I was passionate about my subject matter. When folks found out that I had picked up photography, I made sure to tell them that I was really only interested in landscapes and natural history.

I could soon see progress in my work. I was starting to pick up on the subtleties of light, find compositional layers in miles worth of desert expanse, and expose for dynamic color in the early morning and at dusk. As I was in the middle of farming country, I was building a decent portfolio of agricultural images.

I sent my first portfolio of images (separate from anything I had ever done in a formal class) to a magazine called *Progressive Farmer*. I was familiar with the publication, having grown up on a ranch and received it every month for many years, and I sent the magazine images that seemed relevant to its mission and that showed my abilities with the camera. Images of white cotton fields composed well and under great light conditions, cattle feeding along a long trough, the cotton stripper I mentioned earlier, and even an image of a threatening-looking rattlesnake were just some of what made up this portfolio.

A month or so later, I received a letter from Jim Patrico, *Progressive Farmer's* photo editor (and a great shooter in his own right). In the letter, he thanked me for my submission and noted where some of my strengths resided in the images. He mentioned that he had filed my images and contact information for future use, but before closing the letter, he made a great suggestion. He noted that out of all the images I sent him, there was no real strong human presence among any of them. He encouraged me to devote time to documenting the people involved in the agriculture industry.

I took his piece of advice to heart. It made me think about the value of including people in images and what it meant for editorial purposes. It's not that I was shy or feared meeting people—I had simply wanted to make images that were absent of what I thought was an unnatural element of the frame (remember, I was thinking straight landscape).

I started to become aware of what people mean to a photograph. They create another facet of storytelling. When photographed well with the environment, they attract viewers and readers. And let's not forget the money angle: They make editorial images more marketable.

Nowadays, the bulk of what I publish from assignments or stock includes the presence of people. Portraits, images of people interacting with each other, hikers hiking, athletes in action, business owners, you name it. I quickly went from a landscape purist to someone interested in the story told by people and their place. While I'm certainly not uninterested in the beauty of landscape photography, I'm now more aware of whether a person's presence might provide depth to the land's story or even a new story altogether. ∎

Gesture

I've heard storytelling likened to many things, my personal favorites being cake and ice cream sundae analogies (I just like food, OK?). Each layer reveals something unique. A story's layers are much like a dessert that includes different layers of flavor that somehow combine in a compelling way. The context, the characters of the story, the relationship between characters and the context, and the nuances of that interaction and environment all contribute to story. Even within each layer of the story, there might be more subtle ones. When people are involved in story, one such layer is gesture.

People both knowingly and unknowingly employ unique gestures when interacting with others and their surroundings. These might come in the form of certain mannerisms that include graceful hand and arm movements, suspicious eyebrow raising and sideways looks in response to receiving some very dark information, or the engaging way a man smiles at his date. Gesture is seen in the emotion of your subjects, as well as the unique positions in which you find them. When editing multiple images of the same person, composition, and overall context, gesture is high on the list for things to look out for. It's not just the icing on the cake, it's the particular way the icing pits and curls.

STUDY GESTURE **In his portrait work, Richard Avedon was a master of gesture. He was not only able to evoke emotional gesture out of those in front of his lens, but he was also able to see it among his images during the editing phase. This afforded his images both a signature look and larger appeal.**

Always keep an eye out for great images produced by others. In them, you might spot what attracted the photographer to choose to exhibit certain images over others. Look at portraits and images of people created by the big names in photography. See what they saw in their images: facial expression, the way their subject's hair fell, the bit of light that peeked over a shoulder in the frame. The more you're able to pick out the unique characteristics of others' photographs, the more likely you are to notice gesture within your own images, even as you are shooting them.

At other times, gesture might not be as subtle. Sometimes, gesture is as in-your-face as all the other elements of the image combined. Take for example Jim Marshall's iconic photograph of Johnny Cash flipping the bird to the camera. Sure, there is great gesture in his face and mouth, his posture, even the movement in the guitar's headstock. It's awfully

Canon 5D Mk II, 24mm, 1/800 sec., f/4, ISO 400

Canon 5D Mk II, 24mm, 1/1000 sec., f/4, ISO 400

Canon 5D Mk II, 24mm, 1/1000 sec., f/4, ISO 400

hard, though, to ignore that single, out-of-focus middle finger rising from an outstretched arm and closed fist. At that point in time, the gesture captured in a single image drove home the singer's personality and outlook. The story contained within this one frame has helped label an artist, a type of music, and a lifestyle.

Gesture is what keeps an eye locked on a photograph or forces a viewer to continuously come back to study the contents of the image. Being a diligent storyteller will afford you plenty of opportunity to capture unique gesture. It's not always evident immediately—sometimes not until the shoot is over, the gear is packed, and you're looking at the images late at night over cold pizza. When you see it, though, you know it.

Photographing the street musician with the passersby formed another piece of the story's environment. When the little girl threw her hands up in dance, it was a gesture that suggested this image was *the* one.

Canon 5D Mk II, 24mm, 1/1000 sec., f/4, ISO 400

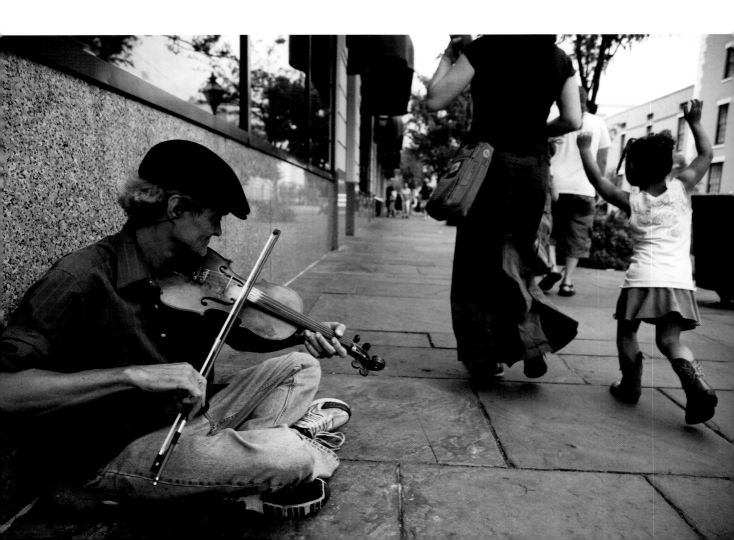

A winery owner among his facilities can serve as an establishing shot for a story about an area's wine grape industry.

Canon 5D Mk II, 17mm, 1/13 sec., f/5, ISO 200

Portraits

Portraits tell a piece of the story all on their own. Viewers already have a strong affiliation with people in images, and to concentrate that connection directly between subject and audience member is valuable to the experience. Any story that involves a human element should include a portrait or two of some of the primary characters, even if they're the simplest of head shots.

Remember the rack of magazines at your local bookstore I mentioned earlier? I'm willing to bet that 95 percent, maybe 99 percent, of those that feature people on the cover portray them in a portrait setting or format. Portraits not only satisfy our fascination with other people, they initiate a channel between us and the story inside the pages. Well-made portraits strengthen this human connection, even when you're already flipping through the images spanned by the article. Putting faces to names in captions, and seeing the bodies and actions contained within the visual story's frames, brings life to the story.

Portraits of people involved in a visual story are at times "think pieces." By this, I mean that portraits are sometimes designed for us to wander about, around, and through. As with all images, there's some audience interpretation that is left for the taking, but this characteristic is heightened with portraits.

An common example is found in studying faces. The deep, weary crevices in an old fisherman's wind-swept face, the joy and surprise in the eyes of a young child, or the tight lips on the face of a stern parent are all examples of details that invite a viewer to question and interpret why certain faces look the way they do. Is the fisherman tired from years' worth of long, cold hours in the North Sea? What is that child feeling? How many children have seen that expression on their mom or dad's face and run the other way? Mathew Brady's historical portraits of U. S. Civil War generals show in their faces the tiredness, the anxiety, and the violence of such a war. Even though most of the portraits were made on a simple neutral backdrop, the generals' faces alone conveyed a great deal of the story we would later read about in textbooks and historic accounts.

As significant and special as portraits are to the strength of a story, the photographs themselves are not all that different in format than the types of images discussed already. In all honesty, portraits can be made to fit the needs of establishing, medium, or close-up shots. Where they come in the sequence of the story, their prominence and value to the story, and their appeal for readers all play a part in determining how a portrait is created, used, and received. An encompassing environmental portrait of a winery owner standing among his stainless steel fermentation tanks can serve as a fine establishing shot to a story that also features a medium shot of a wine-grape variety scientist testing consistencies among a recent harvest. A close-up portrait—a head shot or something even tighter—can help isolate a person from contextual structure if desired, or provide a "think piece," as discussed above.

Focus On the Eyes

Not to get too pushy, but the eyes in a portrait are key to establishing a connection with viewers. There's something eerily cosmic about how we are drawn to the eyes in images of other living beings, even animals. I'm sure psychologists have this kind of thing figured out, but as far as I'm concerned, it's an amazing phenomenon. The eyes are telling facets of the face. We see emotion, intent, and movement in them. They even suggest where to look in the frame. Eyes become the gateway into the rest of the image.

An accompanying medium environmental portrait of a grape-variety scientist helps flesh out the story involving an area's wine industry.

Canon 5D Mk II, 35mm, 1/80 sec., f/4, ISO 800

Placing the plane of critical focus on a subject's eye or eyes is one of the strongest ways to establish a connection between viewer and character.

Canon 5D Mk II, 200mm, 1/200 sec., f/2.8, ISO 50

Animal and wildlife photographers also benefit from placing the focus on their subjects' eyes. Tack-sharp eyes imply life and vitality in an animal or human being.

Canon 5D, 200mm, 1/1600 sec., f/2.8, ISO 100

For this reason, focus placed on the eyes is crucial. Aside from the eyes in a frame, viewers will gravitate toward the area of the frame that is in focus, and if the eyes are out, an image may become subtly unnerving. A visual distraction such as this might force attention away from the story at hand. Placing the plane of critical focus on a single eye or both eyes offers the viewer the foundation from which she will explore the rest of the face and surrounding frame. For portraits, this is where the viewing eye starts—with another eye.

Portrait Lighting

I've said it before, but it doesn't hurt to say it again: Light is important to story, and lighting for portraits deserves quite a bit of consideration. Light in general is responsible for setting the emotional tone for an image, and using it to illuminate someone's face and form is no different. Depending on what you're trying to say about your subject and the story, lighting needs vary.

In portraits, harsh, direct light that creates hard-edged, deep shadows is usually interpreted as gritty, hot, and edgy, while soft, wrapping light is perceived as gentle, easy, and flattering. I tend to approach lighting portraits by taking into account the degree of diffusion either the ambient or the artificial lighting employed will offer. The three degrees of diffusion I use are:

- **Direct light:** The unimpeded sun or a bare flash would work in this case. Direct light is often bright and harsh, casting shadows that you could literally trace with a pencil. This type of light is very useful for bold, forceful portraits.
- **Diffused light:** The opposite of direct light, diffused light is very soft, absent of major shadows, and often created naturally through an overcast sky. It comes from all directions, hence the lack of shadows, and with enough light sources, you could technically create this type of light with bare flashes as well. Artificially, though, you're more likely to see large modifiers such as soft boxes or octas used in conjunction with heavy reflection in order to create diffused light. This type of light is seen most often in portraits that aim to create little conflict and emphasize finesse or beauty.
- **Directionally diffused light:** Combining qualities of both direct and diffused light, directionally diffused light (I know, creative name, huh?) establishes a position from which the light is hitting your subject but is soft enough to wrap around into the shadow side of the face and body. Shadows are still apparent, but they are filled in enough to reveal detail.

Direct natural light in the evening helps create sculpting, hard-edged shadows with detail that falls within the limits of the camera's dynamic range (far left).

Canon 5D Mk II, 24mm, 1/6 sec., f/4, ISO 400

Diffused light in this scenario allows the details in the little girl's festival wardrobe to show without distracting shadows, and it keeps her surroundings evenly exposed (left).

Canon 5D Mk II, 50mm, 1/800 sec., f/2, ISO 50

A feature shot of internationally recognized symphony conductor Tomasz Golka. The diffused light used implies the finesse that goes along with such an exalted career (far left).

Canon 5D, 150mm, 1/250 sec., f/3.2, ISO 200

A large window is an excellent source for directionally diffused light. Shadows are not hard-edged, but they do have enough depth to convey perception, such as the strength or authority that works well in executive portraits (left).

Canon 5D Mk II, 105mm, 1/160 sec., f/4, ISO 200

Light that forces shadows to fall toward the camera, often referred to as short light, is more dramatic than light that hits the side of the face closest to the camera. Here, short lighting is used to convey the sincerity and mystery surrounding the martial art sensei **Walt Bushey** practices and teaches.

Canon 5D Mk II, 125mm, 1/200 sec., f/4, ISO 200

The backlight hitting Kaiser car collector and mechanic **John Hewlett** helps him stand out from the somewhat busy compression of cars and office space, as well as convey a sense of the shop's ambience.

Canon 5D Mk II, 50mm, 1/100 sec., f/2, ISO 100

Directionally diffused light is very popular, and you often see it in the form of early morning and late evening sunlight as it passes through atmospheric debris, slightly diffusing the sun's rays as they head straight to Earth. A favorite source of directionally diffused light is a simple window. Shoot-through umbrellas and soft boxes are among the many artificial light modifiers designed to provide directionally diffused light.

One value of this type of light is its diverse utility. It can be used to sculpt faces, to complement another light source, or to re-create the natural direction and fall of light in any given area. Just like its name, directionally diffused light is useful for portraits that necessitate a more lively light source with an apparent direction, yet one that is not so harsh or soft that it begins to say something unintended about the person in the frame.

The direction from which light is hitting the person being photographed is also important to consider. This is something the classical painters recognized early on as significant in conveying the emotion and visual orientation of their characters. For example, light approaching the subject from the side on a parallel plane throws one half of the face into shadow, conveying mystery, darkness, trickery, or other dramatic emotions and interpretations. Although not necessarily the most attractive lighting, light from directly above the subject still says something, such as interrogation or menace. Lighting from below can cast ghoulish shadows upward, while light from a somewhat downward angle (the typical example is 45 degrees) to the subject is often used to mimic the characteristics of the sun when the sun is not actually used.

Backlighting your subject carries meaning as well. Although many lighting books discuss backlighting as a great way to separate your subject from the background, used in conjunction with another main light source, a backlight can resemble an angelic glow in a child's portrait, or perhaps the feeling of openness in a mechanic's garage.

Portrait Composition

Portrait composition allows the photographer to further imply the subject's connection with the story. Composition is always a crucial element of photography, but perhaps even more so now that you're working with a subject who demands more immediate attention than, say, a dormant tree.

When it comes to portraits, it's often advantageous to consider how to reduce compositional distractions in the environment, while at the same time searching for ways to direct attention toward the subject and keep it there. Common examples of distracting material that can mar a portrait are poles, power lines, or any other type of background material that might protrude from your subject's body or head. We've all let that happen, and we'll keep doing it. Sometimes it can't be avoided entirely. However, the more we look for potential hazards, the more likely we'll be able to find ways of composing the portrait that will not distract a viewer from the primary character in the frame.

Composing portraits to manage attention toward your subject is achieved the same way you would compose just about anything else, except that you're often more able to move your subject in and around any given environment. Framing, pathways, and leading lines all play the usual compositional role, and with a human subject as a focal point, they might just become more powerful tools. Keep this in mind the next time you shoot in a new environment. You might find even more elements of the scene that compositionally help you highlight your subject as the main content of the photograph.

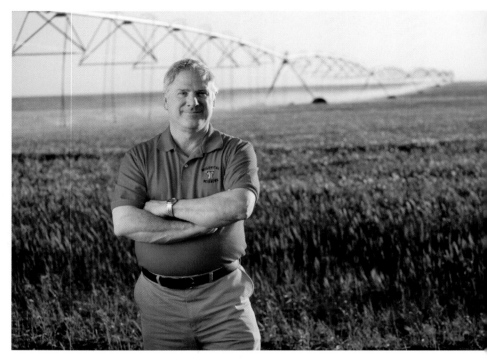

Even though the columns in this portrait of a local doctor are significantly out of focus, positioning the subject and the camera so that the lines in the background do not sprout from the middle of her head reduces the chance of viewers being distracted by what's important in the frame.

Canon 5D Mk II, 140mm, 1/125 sec., f/2.8, ISO 100

This image follows the rule of thirds, but the lines running through the field biologist's head threaten to be a nuisance. At times, the best way to resolve an issue like this is to throw those lines as far out of focus as your lens and aperture will allow.

Canon 5D, 70mm, 1/640 sec., f/4, ISO 100

All lines in this frame help "pen in" the viewer's attention on ranch owner Bob Macy.

Canon 5D Mk II, 65mm, 1/60 sec., f/4, ISO 200

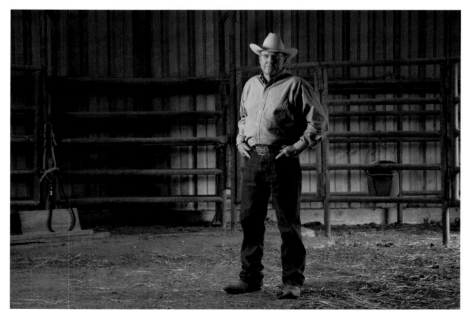

Everyone has his own opinions about self-portraits, but I'd wager every photographer has made one or two of himself at some point. I believe they are valuable parts of the storytelling learning process. Sometimes we photograph ourselves when we want to try out a new lighting technique, or even as a placeholder for the actual subject or model. At other times we set out to make serious portraits that say something about our own unique selves.

These are significant moments in becoming better visual storytellers. You know yourself better than anyone else in the world (despite what your parents tell you), and one way to improve your ability to showcase another person's story using photography is to do the same for yours. Socrates' words "Know thyself" are a useful photography tip.

Your assignment is to create five self-portraits in as many environments. Produce images that convey who you are in relationship to each location. Do you know yourself well enough to create five distinct portraits? What are you going to use to tell your story? Your personality, occupation, faith, hobbies, and dreams are launching pads for generating ideas for images that say something real about you. Think about the composition you might use, the type of lighting, as well as all the content in the frame. Then, actualize your ideas.

Each self-portrait does not have to say everything (there's no image out there that can do that), but each image should reveal important information about you if anyone ever sees the photographs. Work the way you would to make storytelling portraits of other people. Imagine how your audience would consume the information in each image and interpret and imply meaning back to, well, you.

Photographing yourself for storytelling purposes is one of the strongest ways to drive home the significance of portraits in general, as well as the value in learning more about your subject's life, role, and story. The same "insider" knowledge that you use to make portraits of yourself is the same type of understanding you strive to obtain when making portraits of others.

If for nothing else, you'll at least have five bio portraits should you need them for marketing someday. ◼

Self-portrait against an empty West Texas sunset, a background I frequent photographically from my home base in Lubbock, Texas.

Canon 5D Mk II, 24mm, 1/250 sec., f/5, ISO 100

The term *environmental portrait* gets tossed around quite a bit in photography circles, probably because it is one of the most popular types of portraits to make. Its purpose is to enhance the story being told of a particular person or a group by including them in their real or symbolic environment.

Unlike tight head shots or in-studio photographs made on nondescript backgrounds, environmental portraits connect the subject with a place and begin to fill in some of the interpretive void that pertains to who that person is and what role they play in the story. This is not to say that such portraits restrict the viewer's right to interpret meaning; they're simply a way to introduce the subject in a realistic setting that enhances the meaning available. As such, environmental portraits are powerful storytelling tools.

I've long been a fan of environmental portrait maker and iconic photographer Arnold Newman. If Henri Cartier-Bresson is the father of photojournalism, then Newman is the equivalent for environmental portraiture. His story-laden, biographic portraits of well-known and lesser-known people are some of the most informational and creative images available of those subjects.

When I began considering portraiture as a way to expand my own work, I drew inspiration from Newman's imagery. I subsequently discovered folks like Gregory Heisler (Newman's assistant and now one of the premier—or maybe *the* premier—environmental portrait makers in the world), Yousuf Karsh, Joe McNally, and Annie Leibovitz, among others. I was influenced by the attention these storytellers paid to the entire scene played out in the frame, whether they were shooting for editorial or commercial purposes. I quickly developed an affinity for these types of images, and to this day, the bulk of my own work is environmental portraiture.

One particular environmental portrait of mine stands out to me for a few reasons. Several years ago, I was visiting my family on the north Texas ranch where I grew

up. I had started a small, self-published book project focused on the near-100-year-old ranch, and I wanted to make a few portraits of my grandparents to complement the rest of the images and text. I intended to feature their legacy as ranch owners and operators strongly rooted to the land and resources the ranch had to offer. I pictured a fairly big shot, showing an expanse of the ranch, and I wanted it naturally lit.

We set up a time one evening and a location close to an area that locals driving by the ranch would recognize. A herd of Black Angus cattle were already in the pasture we picked for the shoot, and like the ever-prepared cattleman my grandfather is, he grabbed a bucket of protein cubes and poured them out on the ground in a line, encouraging the cattle to stay in a certain area for the duration. We wanted cattle to play a pretty big part in the portrait, and this allowed us to work around them without forcing much movement on their part. They were preoccupied with the food.

The sun was about ten minutes from setting after a few initial medium-length, torso-up shots of my grandparents standing together. At this point, I backed out with a 70–200mm f/2.8 to 70mm. This compressed the scene enough to maintain the cattle as a significant part of the frame, while also highlighting the stretch of land on which we were shooting. The light was warm and fell within the dynamic range of the camera's sensor, and as I turned my relatives slightly away from the sun (seen in how the shadows start to form on their faces and bodies), I added a sunlight-toned, 52-inch reflector just outside the frame to camera right to fill in some of the shadow area. The resulting light was natural, not too overbearing, and rather pleasing. The details of their faces and clothing are easy to detect.

Out of all the portraits I've made over the years, this one image, to me, tells the story of the people in the frame better than any other. Of course, it helps when you've known the subjects all of your life and have

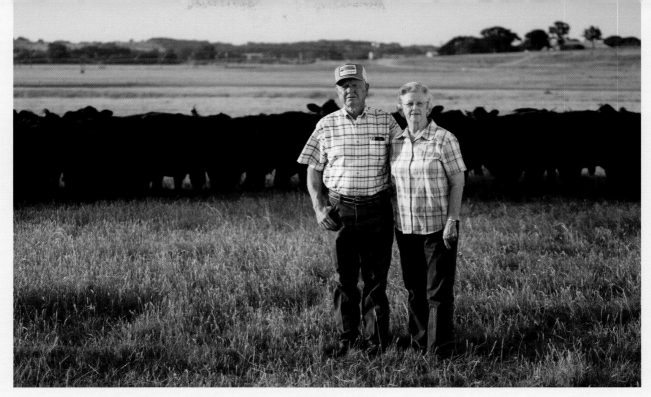

Melvin and Jannie Lou Meadows of Meadows Ranch in Cottondale, Texas.

Canon 1D Mk III, 70mm, 1/400 sec., f/2.8, ISO 100

grown up riding around in a feed truck, working cattle, and chopping down bull nettles in the very pasture you use as a backdrop. Then again, this is how it should be, right? I know my subjects. I did my research (being part of a ranching family), I scouted the relative locations (living on the ranch for 18 years), and I used that information to construct an image that tells at least some of their story. Everything from the green summer grass to the line of cattle to the pasture beyond and the road that cuts through part of the ranch and the hay barns sitting among the trees in the distance contextualizes and contributes meaning to the story. The couple's practical clothing is what folks working in agriculture wear, and their closeness to one another reflects their connection through the years.

Lastly, their faces may say the most out of everything else in the frame combined. One might interpret years

of hard work, stress, and satisfaction from their eyes and brows. The fact that they're not smiling feels natural, and it also showcases the seriousness with which their generation approached having portraits made. A bit of Americana resides in this photograph of two people proud to be a part of this family ranch.

If I were to use one image to sum up the story of this ranch, this might just be the shot. I'm not finished shooting my childhood home by any means, but this one image says to me what several thousand others of the same place do together. We're all biased toward certain images, due largely to the story behind making the image. However, when that story collides with the story you are trying to tell through an environmental portrait, run with it! You might just produce your favorite image ever. ■

Cotton is king in West Texas, and besides painting the harvested cotton module with a strong golden light, the dominant dark blue of the sky provides power to the image (opposite, top).

Canon 5D Mk II, 65mm, 1/60 sec., f/4, ISO 200

The variety of green tones among the rolling fields of Perthshire, Scotland, accentuate the fertility of the land and the beauty of the landscape (opposite, bottom left).

Canon 5D Mk II, 160mm, 1/200 sec., f/2.8, ISO 100

CONSIDERING COLOR

Photography is very psychological. Maybe the content contained within the frame is not always speaking to us subliminally, but forces exist in an image that yank at our psyche. Color is one of them, and it comes in handy when telling a visual story.

Even before story existed in a visual form, orators used color to denote and emphasize emotional messages in their stories. These connotations are developed throughout history, and as a result, colors take on cultural and universal meaning. Nighttime is typically feared not only because of our inability to see well, but also because certain associations with the colors of the night have been passed down to us. Angels have often been described or depicted wearing white and gold clothing, influencing our perceptions of other visual content clad in similar colors. As visual storytellers, we learn how colors combine with subject matter to create feelings or impressions.

Here's a brief list of some of the general meanings traditionally associated with different colors:

- **White:** pure, clean, empty, hopeful, beautiful
- **Black:** mysterious, mean, elegant, traditional, deathly
- **Red:** dangerous, energetic, powerful, strong, loud
- **Orange:** happy, spontaneous, creative
- **Yellow:** peaceful, passive, wise
- **Green:** growing, natural, fresh, unified
- **Blue:** trustworthy, peaceful, structured, strong, wise
- **Purple:** royal, luxurious

Colors hold rather broad and abstract meaning, and there's no rule that says the list above includes the only corresponding interpretations. However, for storytelling purposes, realizing what a color typically means out in the wild (remember the wild I talked about in Chapter 2?) helps us visualize how certain frames may speak to a much broader audience.

What about black and white? The absence of color speaks to audiences in powerful ways as well. At times you might choose to shoot in black and white (or at least convert to black and white in post) in order to visually direct your audience without requiring them to mentally process color, which could get in the way of seeing the story you are telling. Black and white might also say something about your subject as well, enhancing drama or suggesting tradition and history. My mentality toward black and white has always been one of intent. Like everything we do as photographers, there must be a reason for doing it.

The glowing yellow leaves of the tree, combined with the long focal length and shallow depth of field, convey a sense of solidarity among these woods in Canyon, Texas.

Canon 5D, 200mm, 1/1000 sec., f/2.8, ISO 100

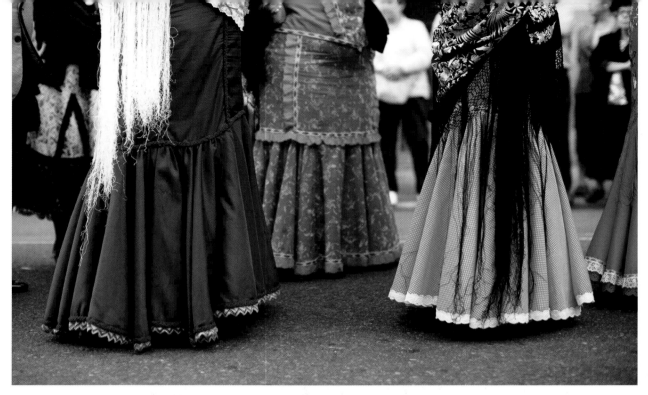

A palette of visual attraction. This tight shot of festival dress in Madrid emphasizes the "color" of Spanish culture.

Canon 5D Mk II, 50mm, 1/250 sec., f/2, ISO 200

The contrast of delicate white on a dark green tone pushes the rose toward the viewer and hits on thematic points of innocence and beauty (far left).

Canon 5D Mk II, 50mm, 1/640 sec., f/2, ISO 50

Simple and strong, black-and-white images drive attention to the power of dramatic light and remove potentially distracting colors from the frame, further pushing attention toward the subject matter (left).

Canon 5D, 45mm, 1/60 sec., f/4, ISO 100

Contrasty black-and-white images use the values of light to denote where the eye should travel within the frame, such as the dark shadow fall-off framing the musician.

Canon 5D Mk II, 17mm, 1/60 sec., f/10, ISO 200

Images absent of color are strong ways to create visual interest in and convey affinity toward even the simplest of life activities.

Canon 5D Mk II, 17mm, 1/50 sec., f/2.8, ISO 800

The negative space surrounding then 70-year-old triathlete Mike Greer not only allows him to stand out dynamically in the shot, it also provides space for editorial design elements to further bolster the story in the frame.

Canon 5D Mk II, 17mm, 1/200 sec., f/13, ISO 100

THINK DESIGN

Although it might seem out of place in a chapter dealing with types of story-telling images, design is a pertinent issue to keep in mind when creating visuals that back up an interesting narrative. With the variety of media from which to launch the stories that we produce, considering the design principles of each might compel you to photograph according to a particular style or format.

Magazines are standard examples of shooting toward design. Some images make better double-page spreads than others. Including negative space in a frame not only visually drives attention toward significant content, but it also provides an area for a designer to use for type—display type related to the

story that's meant to garner interest for the following pages containing text and your images. The same goes for many cover images. Vertical shots containing headroom and enough space to crop to 8.5 by 11 inches are often more attractive to editors and designers than even a somewhat stronger image that doesn't allow them the space to work with. After all, they need somewhere to put their snappy cover lines.

This is a very practical consideration, and I don't advise it being at the forefront of your mind at all times. Your main goal is to tell story and to do it well. It's worth keeping in mind, though, that one part of telling a story is making sure it fits the medium that increases its visibility. If you're an editorial shooter, the magazine format might influence the way you shoot. If you envision your story being presented in a widescreen cinematic format, this might also influence the way you see the story before you even make a frame.

Canon 5D Mk II, 170mm, 0.4 sec., f/9, ISO 200

When shooting for publications, always consider shooting both vertical and horizontal images so they can tell the story strongly. A vertical with plenty of headroom has potential for a cover image, while a well-composed horizontal may serve as a double-page spread. Eilean Donan Castle, Dornie, Scotland.

Canon 5D Mk II, 108mm, 0.4 sec., f/7.1, ISO 200

Eric Barth

I first came across Michael Clark after reading about one of his near-life-ending experiences while hanging over a cliff from a rock-shorn rope, all in the name of photography! Since then, I've followed his work across a range of outdoor topics and stories. His work spans the editorial and commercial worlds, and when he's not shooting a high-flying, rope-hanging spread for Climbing *magazine or a commercial project for Nikon or Red Bull, he's packing camera gear through some of the wildest country in Chile on Wenger's Patagonian Expedition adventure race.*

With a knack for painting and sculpture early in his youth (he drew a realistic American quarter when he was three years old), Michael's entrée into photography, as with many others, came as a way to channel his creativity. During his university work as a physics major, he took up rock climbing, and while living and climbing in southern France, he decided to rekindle his relationship with art and photography while shooting the sport. His dynamic work since then has made him one of the most sought-after adventure photographers on the planet.

Q **Who were your influences when you think about how the camera allows you to tell a story?**

A The influences I've had for all my life have had nothing to do with photography. I grew up as an artist, so I was interested in folks like Picasso and Dalí. Dalí was a really big influence. Modernists such as Monet were also big influences, and I drew from Renaissance painters like Michelangelo. Their sense of lighting was remarkable. Since I had started very young as an artist, I was left on my own in high school art classes and was allowed a lot of freedom to experiment.

In terms of turning photography into a career, I would just drool over climbing magazines and think how great it would be to go on location for those types of shoots. There were numerous photographers in those publications, but they all had similar looks and styles.

My influences have changed over the years. I think painters still influence me a lot, especially in my composition. In terms of story, Dalí was a huge influence, because of the way he created a story within a painting, such as the drooping clock. There was so much going

on, you just had to sit there and stare at it for hours to figure out what it was all about. Dalí's paintings are very graphic and simple, but very striking. In terms of the way I photograph, when I'm trying to frame up an image for an editorial or commercial client—where the images need to tell a story—I'm thinking in a similar way to how those Dalí paintings were put together. What can I put over in that part of the frame? Does this tell the whole story? Is everything in here?

More recent influences include James Nachtwey, the famous war photographer. I saw the movie that was made about him, *War Photographer*, and the way he composes images just blows me away and totally changed the way I look through the lens. Other current influences include Platon, Dan Winters, Joe McNally, and Andrew Eccles. They have helped expand my world, not necessarily away from adventure sports, but in terms of how I approach portraiture. This has broadened my work and the material I look at. It's almost coming full circle, to where I'm getting back to becoming more artistic in a sense, instead of just capturing images of somebody doing something amazing.

Q Describe your type of work—how do you see story developing through it?

A I think most people would know me for my quote-unquote adventure sports photography, the rock climbing, mountain biking, kayaking, surfing imagery, and anything to do with sports in an outdoor setting. I've started to become known for portraiture, and I've always shot landscapes here and there, just for my own sanity. However, I think my work is characterized more as adventure photography than adventure sports now. I get a lot of calls from editors who want me to go shoot something that's adventurous, where they need a photographer who has outdoors skills and would be a good fit for the assignment just because they're not afraid of heights or they can hang underneath a helicopter a hundred feet over the ocean to get the picture.

Q How important is previsualizing to the storytelling process?

A I think it's just about everything. Pushing the button is the easy part once you're there. On a lot of jobs, I have long conversations with clients where we're talking for an hour or two before I even go out and shoot. I might not shoot the assignment right away. Rather, I might go scout locations first, come back, have another conversation about the story and the reason behind all the images we're creating, and then shoot the assignment. It just depends on the assignment and how the client wants to approach the job.

There may not be those long conversations with the client for editorial shoots, but I might talk to the writer, or they might send me the entire article that's already written. I can read that and get a sense of what they're looking for. The images don't have to mimic the article, but I can pull out certain aspects that sound interesting to help add to the article, or shoot different images that I think will add a whole other sense to the article.

> I get a lot of calls from editors who want me, just because I'm not afraid of heights or I can hang underneath a helicopter a hundred feet over the ocean to get the picture.

After the conversations related to the assignment are held, even if it's a self-assignment, I'll do the same amount of thinking on my own. Then I put together what I call a "shot list." I basically write down all the different types of images I want to produce. I'm very specific in this process. If I envision a helicopter hovering above the ground with a light shining below, then I write that down. I'll previsualize a set of images in my head, and once I get to the location, or before if possible, I'll talk to the athletes or the people I'm working with to create the images and see what's possible. We'll determine which shots we can get on and go after those shots specifically. Sometimes I'll even make little drawings next to my shot list, just so I know what I'm going for.

In terms of the way I work, I'm not a photojournalist. I don't just show up and start snapping what is in front of me. I'm definitely influencing the situation to create images that I have in mind. I'm telling this person to go there to do this over and over and over, maybe 10 to 20 times, so that I can get the shot I want. I'm creating an image instead of just taking images most of the time.

Even those times when I do get to shoot events, such as the Patagonian Expedition Race that I've been shooting the last three years, there are moments when I'll ask the athlete to come by the camera again or do something again if they have time. I'll anticipate what's going to happen, and I have a shot list in my head of the images that I want to get. I look for those images, and I will get myself into position beforehand.

Q Do you see one or the other type of shooting as better for storytelling?

A No, I don't necessarily differentiate them. It depends on what the client wants. An editorial client sometimes wants only one image, and that one image is going to tell some part of a complex story. A commercial client may want a whole story, because they're going to use multiple images from one activity. I think it's actually more difficult to tell the story with one image than to tell it with multiple images. Obviously, you have to include more in that one image and you have to think about it a lot longer.

Q If you could pick one photograph you've made that in your mind successfully creates a visual story, which one would it be and why?

A There's an image I made in February 2010 of a fisherman in Patagonia that speaks to the value of story. I'm not sure if it conveys the entire story, but it at least gets people to ask questions. The fisherman is hanging over the side of his boat. He has a knife attached to his face mask, and he is looking off to one side. The image itself just makes one stop and ask what's going on. Where is this guy and what did he just do or is in the process of doing? It opens up the world of questions

and interpretation. I think some of the strongest images don't necessarily answer all of the questions, and they leave the door open for interpretation. This image definitely opens that door and leaves it wide open.

There's a great story behind it as well. I was photographing the Patagonian Expedition Race. While covering the race I was working with a photographer from Australia and a writer from the U.S. We had been hiking for three days through the middle of nowhere. We were some 500 miles from the nearest city—literally at the end of the world—in a place that's unmapped and uncharted. We came out into Fortescue Bay, where a boat was supposed to be waiting to ferry us to the end of the race. The boat was nowhere to be seen.

We were soaking wet, because it had been raining nonstop the entire race, and when we got out to the open ocean, the winds were so strong hypothermia was a factor. We started looking for a place to set up a tent when we noticed there was this tiny boat sitting on the edge of the bay. A guide who was with us radioed the boat and asked if we could come aboard for a little bit. The two fishermen were very generous, and we swam out to the boat with everything we had. It was a pretty good adventure just getting onto the boat. As soon as we got on the boat, the other photographer and I instantly realized that this was a pretty amazing photo opportunity in and of itself.

The fishermen were very weathered. It was a father and son, and the father spent 15 hours a day under the water cutting red algae, which they called luga, off the ocean floor. We ended up spending 30 hours with these guys. The next day, we told them we'd love to photograph them at work. The father dove to the bottom of the bay in a one-inch thick wetsuit, and he breathed through a garden hose connected to a compressor on the boat.

They decided they were going to dive for lunch, and they asked us if we wanted sea urchins and king crab.

From the time they mentioned diving for lunch, I started taking pictures and just hung with the father the whole time as he suited up. At the point when I took this picture, he was just hanging over the edge of the boat as his son was opening one of the bags of sea urchins. There must have been a hundred sea urchins in there. He didn't get back into the boat, because he was going back for king crab. That's when I made the image. Just him on the edge of the boat. The way the wood was rotting out and the mountains in the background worked well for the environmental portrait.

I think this one image tells the story. This isn't always the case. There's nothing fancy going on in the frame. I had one camera and one lens with me. There's no flash, just a straight shot. I saw him hanging over the boat while everybody else was cracking open sea urchins, and I stayed with him. He was so used to me shooting him, he wasn't really aware of the shutter. Maybe he was, but he wasn't really paying attention to it. That's a rare place to get to with a person when you're shooting a portrait like that.

Q How does being an extreme athlete yourself help you successfully pull together a visual story of your subject matter?

A There are a lot of other people out there shooting pictures of adventure sports who are excellent photographers. Some of them can put themselves into places I don't ever want to be or can't get to. But, for the most part, I can get just about anywhere I need to get. Rock climbing might be the most extreme in terms of positioning, especially when I'm hanging a few thousand feet off the ground. It is such an odd perspective for the average person. You can pretty much hold out a camera while shooting rock climbing while hanging above the climber and not even look through the lens and just snap pictures and get something pretty interesting. That

being said, a lot of my work involves finding new and interesting perspectives. I enjoy finding new angles and trying out new techniques.

I also share a similar mentality with many of the athletes I photograph. Take, for example, BASE jumping. We might be on location for a couple days before they jump off the cliff, and so I have a lot of time to become friends with these people. I might not necessarily do their sport, but since I do all these other sports that are similar in some respects, I can understand how they are preparing mentally and emotionally. I know the emotions they're going through without having to talk to them or ask them about it. I convey a lot of the emotions they're feeling through the photographs. So, there's definitely a connection with the people in the frame that not every photographer has, and it really comes out in the images. I think that's a big factor that makes a lot of those images successful.

Q You've nearly bit the dust a time or two on location. In thinking about the physical risks you take on many of your shoots, why face them for photography?

A That's a good question, and I'm going to turn the question on its head. For me, they're not extreme risks in any sense. Hanging off a cliff on a rope? I'm there because I trust the equipment and I don't really consider it a risk. Sure, there's a risk something could happen, but I could trip and hit my head walking down a sidewalk. It's a matter of acceptable risk and of training and knowing what you're capable of and trusting your skills and your equipment. If something does go wrong, it's more than likely something we couldn't foresee, like a car accident.

I've nearly fallen from a cliff due to a cut rope, I've been hit by a beach ball–size rock falling off the top of 1,000-foot cliff, and I've even fallen into quicksand. There's always a risk, but that's also one of the cool things about adventure sports and one of the reasons it's so fascinating to photograph. People are doing things out of the norm. People are taking calculated risks. You don't just wake up one day and decide to jump off a 50-foot cliff on a mountain bike. You jump off the one-foot tall embankment in your driveway. Then you jump off the two-foot tall boulder, gradually moving your way up to a point where you're able to calculate the risk against your ability. In terms of my photography, it's just a matter of what I can deal with. When you're hanging off a 3,000-foot cliff, however, everybody's on high alert. Everybody's paying attention.

Q Was there one instance that truly emphasized the significant role you play as a photographic storyteller? When you realized that what you were doing with the camera went beyond just you and reached others?

A A few years ago, I had the opportunity to shoot the Eddie Aikau Big Wave surfing competition on the north shore of Oahu; it turned out to be the biggest big wave surfing competition in history. I photographed it with my buddy Brian Bielmann, who's the godfather of surf photography. I live in New Mexico, so I'm obviously not a full-time surf photographer, but he let me tag along with him. At some point, I broke off on my own and went to some different locations, just to get something different, and in the middle of the afternoon at the end of the competition, I ended up on a rock on the complete opposite side of every other photographer who was there except a guy with a Red One camera and a giant Canon lens. It was just me and him for hours there.

I made an image of Andy Irons as he pulled into this shore break barrel that was some 15 feet tall and 50 feet from the beach. He rode the barrel onto the beach, and I was the only photographer to get the shot. Later that night while I was editing I showed Brian a few pictures, and I zipped past one of the images of Andy surfing the

Brian explained to me how rare a shot like that was in surfing, and how I had almost overlooked a picture that was, in some respects, historical.

beach break, because I didn't think it was anything special. Composition-wise, there was a lot of whitewater, and it just looked messy. Brian saw it and just about fell over. He explained to me how rare a shot like that was in surfing, and how I had almost overlooked a picture that was, in some respects, historical.

It just goes to show that sometimes you don't even know you're capturing something important. As it turned out, when it got published, Andy Irons saw it and wanted a print. I was blown away. Andy Irons, the king of kings in the surfing industry, wanted one of my images to hang on his wall. I made the print, and the day it was on my desk drying, I got the e-mail from Brian that Andy had passed away. I actually still have the print here, and I'm going take it to Brian this year so he can give it to Andy's wife. It catches you in the throat a little bit when you start to think about it too much.

In all honesty, I don't necessarily sit there and think this is vitally important work—as photographers we are not curing cancer or saving lives—but you know when it's good work. When I was young and drawing and painting, I would get a creative high when I knew the work was good. Adrenaline would race through my body, even though I was just sitting there painting or drawing. With photography it is the same way; when you know things are coming together, there's a high that you get, and you crave it. Like an addict, I'm constantly trying to get that to happen again so that I can create new and interesting images. I'm definitely making things happen in a certain way, so that I can get the image that I have in my head. You could call it my obsession.

Q **Besides camera gear, what is one thing you've found extremely useful in telling visual stories?**

A Previsualization and the shot list is everything. Once you're out there shooting, it's hard to think about this stuff.

Having a story to tell is also important. It's the obvious thing, but it's the thing that we forget so easily. All of my favorite images tell an interesting story and have really interesting and adventurous stories behind them.

Q **If you could give one piece of advice to those starting out telling stories with photography, what would it be?**

A It may be a generic answer, but perfect your craft. No matter what you do, whether you're a photographer, writer, wood artisan, or ironmonger, if you don't have your craft dialed in, it's tough to tell the story well. If you aren't comfortable with your camera and don't know everything it can do, it's going to be difficult to push the envelope and create interesting images to tell that story. Do whatever you have to do to perfect your craft. It's not going to happen overnight. Some professionals who have been doing this for 15 years are still learning every day. I am. As complicated as digital is these days, perfecting your craft is an even bigger issue. ■

To see Michael Clark's work, visit his Web site: michaelclarkphoto.com.

CHAPTER 5

The Story You're Telling

Story is all around us, and your camera is with you all the time, right? Right. Identifying a story and following through on creating the images that support it aren't necessarily a walk in the park, though. At times, story is as obvious as a three-story red brick wall, while at others it's hidden in the shadows the wall casts. It's up to us, the photographers, to be able to wade through the complexities of a given environment and determine what stories we're interested in telling, those that are worth telling, and how we're going to ensure they're told.

The emergence of renewable wind energy in certain parts of the United States has been both a sign of progressive conservation and a potential threat to wildlife populations, two conflicting perspectives on its value to the country.

Canon 5D Mk II, 130mm, 1/200 sec., f/2.8, ISO 200

THE INTERESTING STORY

A world of visually interesting mystery exists beneath the waters of our world's oceans. The Atlantic, South Carolina.

Canon 5D Mk II, 24mm, 1/1000 sec., f/4, ISO 100

For better or for worse, there is an undeniably evident pecking order to the stories that are out there. As much as we'd like to think that every story that exists is merited equal attention and consumption, that's just not so. For example, stories featured in *National Geographic* magazine seem to carry a bit more weight than a story on the local livestock exposition in the weekly gazette. Furthermore, there's also a pecking order to the stories that we envision or develop ourselves as visual creatives. We all generate ideas for a single photograph or a series of images, some of which we actually create, some of which are shelved for later review, and some of which are simply tossed out in the alley. Many variables influence these two distinct pecking orders, but among those variables, one stands out for both: whether or not a story is *interesting*.

So, what makes a story interesting? It might sound like that photojournalism class you took in high school, but often particular characteristics of a story seem to push certain images or photo essays over others. For good reason, too: These elements attract visual attention and consideration. It's important to keep in mind, though, that not everyone is interested in the same thing. Different audiences often dictate what a story is and where it goes. Still, a storyteller must always be aware of certain characteristics that determine a story's appeal:

- **Uniqueness or foreignness:** The novelty of a story is attractive. Visually, if we gain access to someone or something that no one else has, or if little about the subject is known, then the interest level in the story increases. I have a strong aversion to dunking my head under water. I'll lie down in front of poisonous snakes and snarling mammals all day long, but I'm not so great when it's time to take the plunge. Consequently, underwater photography, documentaries on oceanic discovery, and anything else that happens to take place under the surface of a large body of water is intensely interesting to me. Even though my phobia is not all that common, the ocean is still a mystery to an overwhelming majority of the world's population; hence the continual interest in the subject.
- **Proximity (in both place and time):** How familiar are you with what's going on in, say, Tasmania? What about Kyrgyzstan? Unless you've traveled there or live there now, you might not necessarily be privy to information about those countries, or even interested in them for that matter. The same could be said for pretty much anywhere in the world that is not in some relative proximity to your home or country of residence. Stories that hit close to home garner more interest than those far away. This includes those that relate to us as a

people, even if they're located elsewhere. Stories focused on the conflicts in the Middle East, for instance, may be just as relevant for mothers and fathers of soldiers there as a story about a national education award winner is to members of a small community in rural Idaho where the teacher lives and works.

Story is also given a time line, and the further the actual story grows from the current day, month, or year, the less appeal it has for photographers or the audience. Sure, timeless stories do occur, but for the most part, story has a time line with diminishing returns.

Take, for instance, a child's first year after being born. This is a pretty interesting year for parents and family members, but there's only one (and I hear it goes by fast). If you miss it, you can still catch all the other years, but you can never recapture those early moments. Or what if you wanted to photograph the new restaurant downtown that

The smaller their population dips, the more rare a sighting of a lesser prairie chicken becomes. A closer look at these unique-looking grouse is visually attractive for audiences intrigued by nature and wildlife.

Canon 5D Mk II, 700mm, 1/640 sec., f/5.6, ISO 1000

A pristine example of classic Americana will lure readers already interested in vintage cars and the 1950s.

Canon 5D Mk II, 50mm, 1/1000 sec., f/2, ISO 100

you discovered before anyone else? That sounds like something in which an "Around Town" newspaper column would be interested. The longer you wait to photograph that story, the less interesting it becomes, especially after more and more people "discover" the eatery after you. Your opportunity might last a few weeks, a few months, or even a couple years. Each story has its own time line—just be aware that they do.

- **Conflict:** Story that pits one element against another increases its appeal, particularly if you document the conflict visually. This doesn't mean picking fights to actually see conflict. What it does mean, though, is to stay aware of situations that pose a conflicting element. The small farmer being pushed out of business by a larger, corporate farm five minutes down the road, green energy technology potentially creating a threat to small, native wildlife species in the surrounding area, a protest occurring near the town

center because of recent price hikes on gasoline—these are all examples of conflict that don't involve a single punch (although the protest has a chance to get out of hand). Even sports involve conflict—one team against the other.

Stories that involve conflict, especially mortal conflict, are told every day. It's a characteristic of interesting story to keep at the forefront of your mind when determining the value of an image related to the narrative you're covering.

- **Celebrity:** I mentioned in the previous chapter that we're obsessed with people. Like it or not, the more prominent the people in a story are perceived to be, the more interesting the story becomes for a greater number of people. Even if all a reader wants to do is see enough to gripe about a celebrity's bank-busting disregard for money, or to check out what's in style for the upcoming red carpet season, folks are interested in celebrity. If you disagree, think about it this way: even the noncelebrities featured in local magazines or online blogs immediately become more prominent, and if these people are photographed well or creatively, audience members are more likely to seek more information about them.

The same can be said of locations. For many readers, the more famous the setting, the more interesting the image becomes in relation to a story. The Taj Mahal, Big Ben, and the Twin Towers are all universally recognized, and they pique interest in the information around them. However, this doesn't necessarily mean that only world-famous locations will do. In fact, it all depends on the viewers taking in the story. A prominent environment within a particular region will draw interest from those that have some *proximal* tie to the area.

- **Issue relevance:** This is another way of saying this story affects "X" number of people. This characteristic is a factor comprising all the other story

Conflict can be implied as overtly as the squaring off of two male animals in pursuit of one female, such as these two territorial lesser prairie chickens.
Canon 5D Mk II, 700mm, 1/640 sec., f/5.6, ISO 1000

Plenty of conflict is implied in competition. Environmental elements such as the dust rising from the motorcycles' tires add to this visual dynamic.
Canon 5D, 105mm, 1/2000 sec., f/4, ISO 400

characteristics. We're a fairly diverse population, and individuals have different tastes, habits, lifestyles, and so on. It makes sense that each story has a different societal impact. Stories geared toward a certain niche, such as a story creatively documenting a local cartoon-sketching club, have lesser impact than a story that uses fairly broad brushstrokes and more abstract concepts, such as nuclear crisis or, again, the ocean. Then again, the impact a story about a nuclear power plant has on individuals depends on their proximity to it. I can see how folks in the Rocky Mountains wouldn't be too interested in a story about a hurricane.

To be sure, asking yourself whether or not a story you want to cover as a photographer has enough relevance is a matter of scope. The audience you want to reach will help you make this determination. I'm the last person to ever discourage anyone from telling a story, no matter the size of impact!

There is no rule saying that each story has to have equal parts novelty, proximity, conflict, celebrity, and relevance, but stories that generate interest among large audiences often possess more than one of these. A story exists between the subjects (those whose story is being told) and the creators (you, the photographer, and when involved, an author or narrator), as well as the story's consumers (the audience). Keeping this in mind will help you discover, shoot, and exhibit interesting story.

Dolan Falls, the largest volume of water flowing over a waterfall in Texas, is a prominent facet of the state's natural environment.
Canon 5D, 17mm, .4 sec., f/22, ISO 50

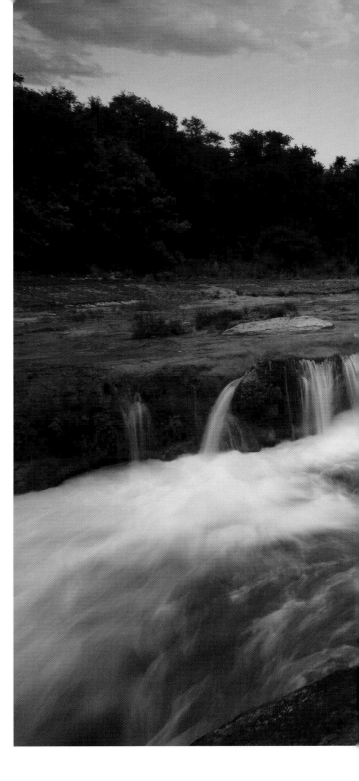

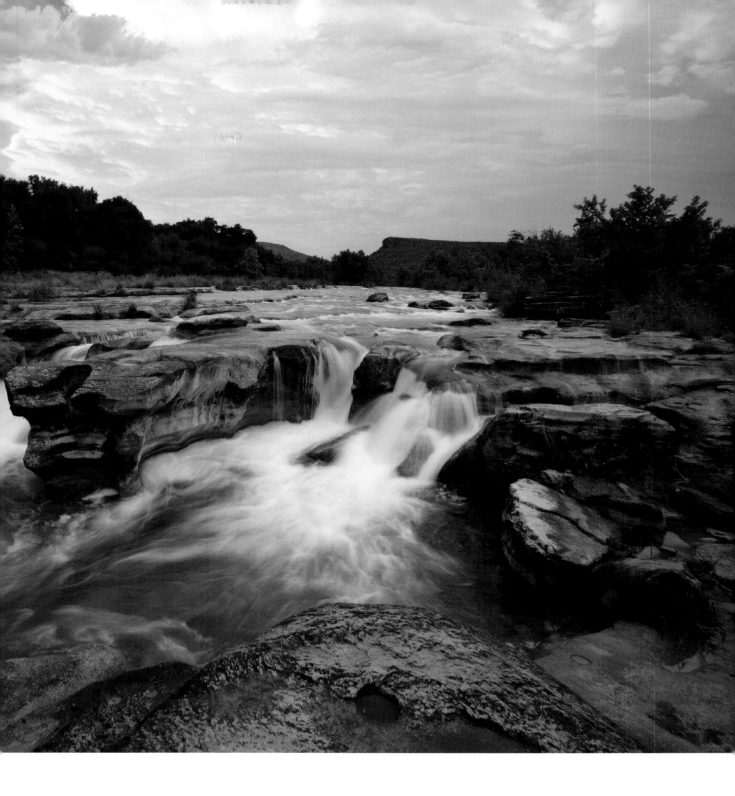

KEEP YOUR EYES AND EARS OPEN

Story can be difficult to generate. With all the distractions of the modern world, it's easy to overlook some rather interesting and visually inviting story. The same thing could be said for finding a story to tell. With social media as well as more traditional forms of telling story, never have we had such means to conceptualize and exhibit a story to such a large audience, and yet, it's still often tough to make something stick.

Spring colors in Texas.
Canon 5D, 105mm, 1/60 sec., f/4, ISO 100

Being Receptive

One of the best ways to conceptualize story is to be receptive to it. There's no substitute for being open to what's going on to help you envision how a story will play out visually. When you're receptive to story, just hearing about a set of new hiking trails in the nearby national park or seeing a road sign directing drivers to nearby city activities can suggest a story idea.

Keeping your eyes and ears open to interesting places, people, and events is an essential part of being a visual storyteller. Even if it occurs over a cup of coffee at the local convenience store, a conversation with the cashier might inform you about an up-and-coming high school football player overcoming adverse odds to have recruiters knocking on his door and would make a great feature for the county newspaper. A visit with your next-door neighbor might reveal that he and his wife are master gardeners who raise roses for competition. Likewise, the evening television news report might prompt you to dig a little deeper into the effects of the unrelenting weather on statewide wildlife numbers.

It pays (financially and spiritually) to be receptive to the stories around us that we're interested in telling with our images. However, being open to story need not only occur before you actually begin to shoot. Often, I get a much better sense and "clearer picture" of just what it is I'm photographing when I'm clicking away. At these times, I'm focused on the story at hand, such as the colors of the backlit leaves in a dark forest. When you're shooting, remain engaged with what brought you there in the first place.

When I'm photographing people, I'm constantly asking questions and eating up any information offered. For magazine stories, I often say that my job as the photographer is better than the writer's, because my relationship with a subject sometimes isn't as formal as the one established during a writer's interview. Thus, it's often easier for me to talk with

Asking questions during the shoot revealed that Jeff Haley's grandfather wrote the definitive biography of one of the most popular conservationists in the world. This information proved to be a turning point in the story I was shooting.

Canon 5D Mk II, 24mm, 1/30 sec., f/4, ISO 400

the subject because he may not necessarily feel like he is being examined or always has to have an answer ready. If I'm knowledgeable about the written story, though, I can go in with awareness of the subject and continue the conversation the writer started under different circumstances.

Remember Jeff Haley from earlier? I photographed him for the first time *after* the story's author had interviewed him. My conversations with him about his connection to his land revealed that his grandfather wrote the definitive biography on legendary Texas rancher Charles Goodnight. I relayed this to the writer afterward, and it quickly became the focal point for the beginning of the story and the way I saw the rest of the story's photography pan out.

You'll also find it beneficial to stay aware of how a story progresses even after you finish shooting. You may wrap up what you charge yourself with photographing, but many times, there's a future element yet to play out. You photographed the high school football player, but where is he now, ten years later? Has Jeff Haley seen the return of the lesser prairie chicken on his ranch? These kinds of questions regarding any subject that you photographed at any one time might come in handy in generating a story line to, at the very least, investigate. Even if they don't become a follow-up story, you'll learn a lot in the process.

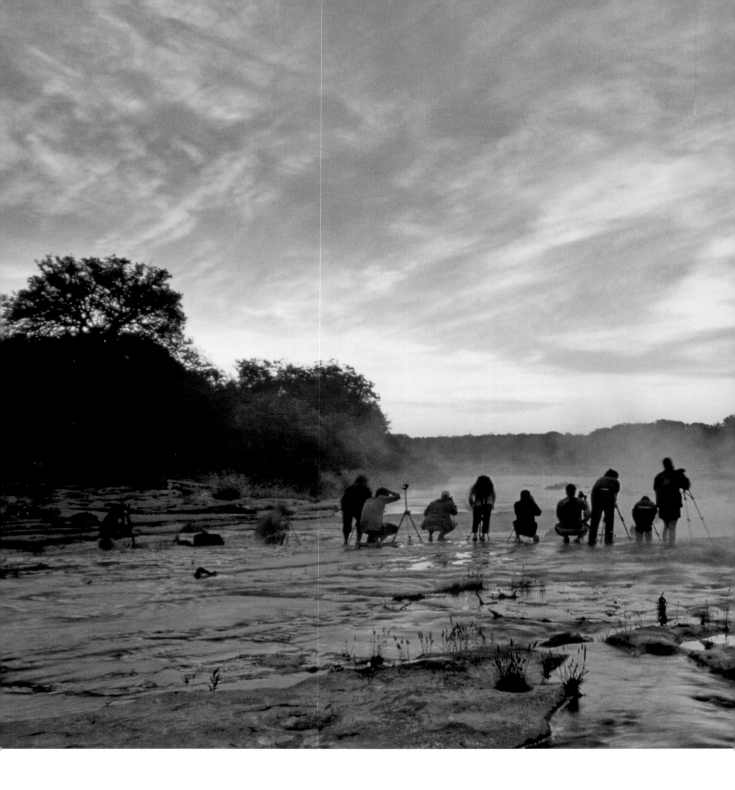

Reading: The Gateway to Story

I mentioned earlier how important reading is to exercise your imagination and develop your understanding of how others tell story. At the same time, reading is valuable to sparking ideas for stories to cover. A recent newspaper article announcing the city's 100th anniversary might be enough to prompt you to pitch an assignment to make portraits of ten city residents, each representing the decade in which they were born. A book of nature poetry might make you think of a project geared around shooting one image for each poem.

Read daily. No matter if it's a favorite photographer's blog, an online newspaper, or the back of the cereal box, you might just come across a topic or a few words that help you develop a visual story from scratch.

Seek Out Other Photographers

There's often a lone-wolf persona that goes along with carrying a camera on your shoulder. But looking at other photographers' work and having conversations with shooters can be enlightening. When you have the opportunity to discuss why or how another shooter does what he does or to dive into another colleague's portfolio or archive, be open to inspiration.

One of the reasons you picked up the camera in the first place was probably due to some connection you had with another photographer's images. Stay open to this kind of connection as you begin to build a network of industry and community members. On more than one occasion, I have developed a story beyond a mere idea because I passed it by another shooter.

Photography workshop students shooting the Llano River together on a brisk spring morning. Experiences like this help build a photography community and contacts to share and develop story ideas.

Canon 1N, 17mm, 1/250 sec., f/8, ISO 100, Fujichrome Velvia

It's advantageous
to the photographic
storyteller to
be in tune with
her surroundings.

At the same time, portfolio images that strike you as interesting and inspiring can motivate you to work in areas you never considered or were too anxious to try. This does not mean copy or steal ideas. It simply means to use others' work as an inspirational springboard. Other photographers with similar interests might just be the folks you need to correspond with about your idea or what you might need to flesh out a work in progress.

As for your own work, although you might worry that revealing your story idea will risk someone else taking it as their own, be assured that I've actually never heard of this happening before. I've certainly never experienced another photographer stealing my own ideas (although I've had nonphotographers steal my produced images—another story for another time). Photographers tend to be a pretty honest bunch. However, when you're working for a publication, it's smart to check with your publisher about sharing details regarding stories that have not yet run. Many publications have strict rules about keeping story concepts secret.

BUILD A NETWORK **The photography community is vast. Do a quick online search for the type of photography you're interested in shooting, and voila, you have a plethora of names of related photographers and organizations. With this type of information at our fingertips, it's natural to start making contact with other shooters.**

Develop a network of photographers to create friendships with, bounce visual ideas off of, support and receive support from, and exchange portfolio critiques and reviews. Look for this community locally and afar. Check out Flickr if you haven't already. Social media has presented itself as an outstanding way to keep the worldwide community plugged in to one another, and the amount of photographic education and storytelling is immense because of it.

However you choose to do it, you'll benefit from getting engaged with other photographers around you.

Stay in Tune

On more than one occasion, I've heard other photographers talk about images they've successfully made primarily due to knowing what was going on around them at the time. This goes beyond accidentally being in the "right place, right time," and although there's no denying that occurs, too, it's simply more advantageous to the photographic storyteller to be in tune with her surroundings.

When winter hits, many ranchers feed hay to their livestock. Staying aware of the changes allowed me to make a photograph of a normally mundane activity more interesting by shooting during adverse conditions.

Canon 5D Mk II, 195mm, 1/400 sec., f/2.8, ISO 200

Staying in tune with your surroundings entails much more than reading the newspaper (although it certainly helps). It means combining all those aspects of generating story we've talked about so far, and then some. Think ahead and see what event is coming around the corner. Get a vibe for the social activity of the area. Be aware that your neighbor across the street has been raising the nation's flag every morning right at sunrise for the past 30 years he's lived in that house—maybe there's a reason.

Take advantage of your presence as a photographer in new places as well. Plan ahead and make the most of traveling. There's nothing more frustrating than taking a vacation with every intention of concentrating on your photography and coming back without a visual sense of the places you visited. You might have thousands of pretty pictures, but if your goal is to tie them together in some way that speaks with nuance about the destination, you might be planning a return trip already.

Plan (not the most comfortable verb for us shooters sometimes) ahead of your travels, Google the city, state, or country you're visiting, get to your hotel and talk to the concierge about local events and places to visit. Better yet, walk into a pub or coffee shop and chat up a local who is not so tied to pleasing hotel guests (plus, you'll always find the best restaurants this way). Use all your resources for developing story ideas as a way to become more fluent in how your environment works and presents opportunities on which to follow through.

Canon 7D, 200mm, 1/2000 sec., f/4, ISO 100

Canon 7D, 200mm, 1/1600 sec., f/4, ISO 100

When I'm on the road for an assignment, I always try to use up the downtime as much as possible with, you can guess, more photography. One of the primary reasons I do this is to shoot stock along the way, and honestly, to stay tuned in to the camera. Keeping up my chops, you could say.

A little over a year ago, I was assigned a commercial shoot that took me to several locations in the Texas Hill Country. I decided to drive the six hours after balancing out the costs associated with shipping more gear than I like checking into the cargo hold of a plane. Plus, there's something comforting about having your own vehicle on a multiday tour across a large chunk of land. Knowing when and where my shoots were let me travel at times I saw necessary. During this trip, I had roughly 10 hours between shoots in Fredericksburg and Marble Falls, two small cities approximately 55 miles apart. After finishing the first shoot, I hopped in my car and drove to Marble Falls, booked a hotel room (in a small town, you can usually get away with last-minute bookings), and scouted the location arranged for the shoot later that evening.

After scouting, I drove through downtown and started noticing signs for local festivities. The signs started saying "soapbox car race." I became intrigued. Images of the town's youth racing in small carts put together by them with help from their parents flashed in my head, but by the time I parked, packed a small bag of street gear, and walked to the start line, I found out it wasn't the children racing. Rather, it was the *parents* participating in the Marble Falls Soapbox Classic.

The city's leaders, business owners, and assorted citizens were cramming themselves into thoughtfully designed and skillfully constructed buckets, water troughs, and aerodynamic fiberglass molds. An event announcer paraded along the start line in cargo shorts and work boots, while the teams representing each soapbox car readied their vehicles. At the word "GO," a pair of racers was forcefully pushed down a 300-meter

Canon 5D Mk II, 24mm, 1/1600 sec., f/4.5, ISO 100

Canon 7D, 200mm, 1/3200 sec., f/4, ISO 100

stretch of downhill, two-lane pavement blocked off for the activities, and classic rock or country music would blare for the duration of each heat. Hundreds of people were in attendance, mingling beside booths set up along one of the main streets for other businesses and refreshments. Needless to say, it was a relatively exuberant time for all.

Canon 7D, 200mm, 1/2500 sec., f/4, ISO 100

And there was story in it. It's not every day you run across a full-fledged adult soapbox car race, and I quickly went into photographer mode. I first started shooting the cars themselves. Whether they were racing or in the pit, it made sense for a guy with a camera to shove a lens around the main action of the event. I also started to concentrate on the attendees and their relationship to the festivities. Pretty soon, I gained enough entrée to the event that I was crossing the "track," recording audio without the slightest look from a stranger, and shooting head shots of the racers and their colorful attire. I even spent some time with one of the crews, resulting in a few more portraits and an education in how to construct a racing machine with no engine.

A bit of youthful nostalgia existed in each competitor and observer, even if some attendees weren't old enough to remember the heyday of soapbox car racing. Photographically, staying receptive to the story potential in the area allowed me to document a small piece of Americana playing out on the streets of Marble Falls, Texas. ■

Canon 5D Mk II, 60mm, 1/20 sec., f/18, ISO 100

IT'S ABOUT WHAT YOU KNOW *AND* WHO YOU KNOW

I'm not the biggest fan of the saying "It's not what you know, but who you know." Sure, I get it, and I know how true it can be at times, but I think it downplays the world's appreciation for skill, knowledge, and elbow grease. I believe we ought to start saying, "It's about what you know *and* who you know." It's not as catchy, but it's more accurate.

My new twist on the old saying hits home for visual storytellers. Let's consider each part of it separately.

What You Know

Unless you know a thing or two about its components (theme, setting, characters, and so on), the visual story has no legs. Many of us start out in photography shooting images of subject matter that we know through professional or recreational experience. My entrée into landscape photography was built on an interest in nature and conservation. A genuine enjoyment of and knowledge of sports lead many to pursue a career in this realm of photography. To be a bit controversial, how many wedding photographers do you know who started shooting because they weren't satisfied with their own wedding's images? Sad to say, they knew a thing or two about their wedding and what they expected it to look like, and they weren't satisfied with the quality of what they (or Dad and Mom) paid for.

It's important for the photographic storyteller to be versed in all elements of the narrative. It might take a bit of research, but it pays off. Before shooting a story related to samurai sword training, I read as much as possible about the particular school of technique the students and master I was going to photograph studied. I looked at relevant images on the topic and watched several videos exhibiting specific tsuka uchis and ishizuki uchis (try spelling those correctly for captioning) before actually going to the shoot. Even though I was not going to be a master by the time I arrived at the dojo, I wanted to be as prepared as I could be to enter into this world and feel somewhat comfortable with the movements and language—enough to know what kinds of images might help tell the story. This initial research is valuable, and we'll talk more on this later.

Who You Know

Several years ago, I became interested in an area close to where I live called Blanco Canyon. This cut in the ground is home to a number of cattle ranches, and its visual appeal is characteristic of more than one song about far west Texas. I wanted to start building an archive on Blanco Canyon, and after shooting from the highway for some time, I decided a portfolio on the land wouldn't amount to much without getting to some locations deeper inside private property.

A quick online search of the area revealed the names of the ranches and, in some cases, the names of their proprietors. After a few calls to directory assistance, I had the numbers for each of the ranches I was interested in photographing. I made a few calls, introduced myself, relayed the reason for my call, and asked if I could meet with the owners about my photographic intentions. Each ranch owner was more than accommodating, and I met with several of them. We chatted about our mutual backgrounds in the ranching world and my passion for documenting the space they occupy daily. I don't remember any of them refusing me access to their land, and during the course of our conversations, I came to know them and I gained several new contacts.

Visual storytellers need to know people. Aside from the simple human value of connecting with others, strategically, people are really useful. They are full of what academics like to refer to as indigenous knowledge. This means

Stopping in for a pizza after a hard evening chasing a thunderstorm, I met the two proprietors, Enrique and Rosalinda. The way they served the youth of their small community was a story in itself, and one worthy of an environmental portrait.

Canon 5D Mk II, 17mm, 1/50 sec., f/4, ISO 1000

A thunderstorm rolls in over Blanco Canyon in West Texas. I was able to build a portfolio of this little-known area by getting to know the landowners.

Canon 1N, 24mm, 1/60 sec., f/11, ISO 100, Fujichrome Velvia

that they know the ins and outs of everything that goes on around them. They have the keys, literally and figuratively, to the gate to accessing images you want to make and stories you want to tell. Knowing which people to get in touch with for what purpose is part of the storytelling process.

As strategic as people are, though, to refer to them as such is a bit cold. Calling the ranch owners to gain access to their land gave me what I wanted, but meeting and having a conversation with them allowed me to get to know them and enriched my understanding of this pocket of the world. This is my favorite part of the job. Making connections with those who are related to the story you're interested in shooting is infinitely valuable, from both a professional and personal perspective. Spending time with those you come in contact with for the sake of the story helps build trust and lets them know your true interest in the issue or topic at stake.

Planning is one of those necessary evils in life that more often than not is beneficial for the creative mind. Don't get me wrong, some photographers are already meticulous about planning and take pride in making sure every detail is checked, filed, and quickly accessible upon retrieval. Others...not so much. Most of us, however, sit somewhere in between. We're able to determine when a project needs scrupulous notes and a time line, as well as when one might not need that much attention to detail on the front end.

Just the same, though, we know that some sort of a plan is a big part of how a project of any size and shape is pulled together.

What's the next photography project you want to shoot? Is it a portrait series of construction workers on the job at the housing development across the street? An essay on the private fishing industry in the Pacific Northwest? How about a story centered on coastal foods of Vietnam? Every one of these story lines would benefit from a little (or a lot of) planning.

Develop an outline for your next project. One way to move from an idea to engaging with the story is to identify what you want to do in a more formal manner. Give your outline a title, and write a broad mission statement that identifies the purpose behind your work on the project. (Don't worry, this won't be set in stone; you can adjust it as you go if it turns out the story is not quite what you expect.) My suggestion is a couple sentences that do no more than sum up the essence of the story you're planning to tell. This statement will serve as your practical guide to completion. It will keep you on track.

Next, begin to ask yourself the questions that get the ball rolling. The answers will prepare you to move on your storytelling project. Here are a few you might attend to first:

1. **What is your audience?** I'll touch on this again a little later in this chapter, but this question is vital, especially for those making a living from their photography. Who is *interested* in this *interesting* story? Be as descriptive as possible. If it's 90-year-old great-grandmothers who enjoy cross-stitching, then write it down. Some stories appeal to large, diverse audiences, while more are geared toward niche

A key to a locked gate and a 30-minute window of time is all you get for this particular shot of an old bridge just down from the Falls of Dochart near Killin, Scotland.

Canon 5D Mk II, 55mm, .3 sec., f/22, ISO 50

Gulf coast shrimpers docked in Port Isabel, Texas.

Canon 5D Mk II, 105mm, 1/250 sec., f/10, ISO 200

consumers. Envisioning who you think will be interested in your story will help set the stage for the way you produce it.

2. **What is your time line?** This should include an allotted amount of time to complete the front-end work (plan, research, make phone calls, rent equipment if necessary, and so on), the actual shooting, and a deadline for completion. This last piece of the time line is an important element. It serves to motivate you toward finishing a project, and the ability to consistently make deadlines is essential if you want to have a career in photography, as we'll consider further, below.

A time line also comes in handy when you travel with story in mind. If you plan on creating a visual essay on agriculture in the Australian Outback, it might behoove you to determine a day-by-day schedule to provide some structure to your traveling. Once there, you can assess whether that schedule can be more flexible, but having it in the first place helps you, at the very least, see where you're going and positions you to hit key areas of your story.

3. **Who do you need to contact in order to actually shoot the story? Do you need to gain access to a particular place or group of people?** Jot down the names and contact information for those folks you know might be able to help you actualize your project. If you're on assignment for a publication, it can usually provide some or all of this information.

If you're on your own, you'll need to do more legwork. Need to access that construction site for your portrait series? Get in touch with the contractor or foreman before you contact the workers. Identify people in positions who a) will grant you access

Graceful rapids in the Llano River near Mason, Texas. Water issues are at the forefront of conservation in many areas. Getting to know your subject in this area might mean you get your feet wet.

Canon 5D Mk II, 17mm, 3.2 sec., f/22, ISO 50

to areas or people that you might not otherwise be able to visit or get in touch with, and b) might serve as essential characters in your visual story. List their contact information and why they are necessary to claim a spot on your story's outline.

4. **Is a budget necessary? Is money available?** The importance of this question is contingent on how tied your income is to your photography for some stories, but it's always a question worth asking. If a budget is necessary, how are the funds procured? Self-funding is a limited option, and sometimes a project is big enough to enable you to seek backers or grant opportunities. Many clients provide money for photographers' expenses, but inquire about it before you accept an assignment.

 The idea here is to gauge what it will take financially to pursue the story you want to visually tell. If it costs nothing but spare time, great. If it costs more than what a few rolls of film would have cost you 15 years ago, then it's worth building in to your outline.

5. **What format are you planning to use for presentation purposes?** The variety of outlets is wide, and knowing exactly where you want to see your images go might just help you determine the answers to some of the questions above. Be specific. Do you see this as an online-only type of project? Is there any chance it might turn in to a multimedia piece? Again, interesting story is always going to be interesting story. Knowing how you will tell that story might determine how you go about putting it together.

Your outline need not be made up of volumes of information and mounds of paper. Even the most complex of outlines starts out small and then develops the more one engages with the storytelling process. Outlines are useful tools in putting ideas down on paper. They provide direction and structure, but at the same time can be modified to fit our needs as photographers. Get into the practice of outlining the stories you want to pursue, and you might just find yourself shooting more than you did without them. ■

WHERE'S YOUR STORY GOING?

The storyteller must have a place to tell her story. We don't just collect the evidence that there ever was a story and never share that fascinating narrative with anyone. No, indeed, that's not the point of becoming a storyteller. Others want to see the stories you have to impart. Remember, you gain access to people and places that the majority of other folks don't, and that alone creates a layer of intrigue for your visuals. So, why not share them?

Do you have intentions of pitching a story to a newspaper? What about a city magazine? The channels for distributing story are multiplying. Traditional print outlets have been joined by online publications, educational and professional blogs, and a slew of other postprint media. Some of these outlets are harder to break into than others, and some demand a level of perceived quality and commitment that you may not yet have proven. However, when you ask yourself where you want to see your story featured, one common characteristic exists among all of them—the audience.

Your Audience

Professionally speaking, one, if not the first, thing a storyteller of any sort—be he a journalist, songwriter, poet, or photographer—thinks about is his audience. I don't believe this should be any different for nonprofessionals. Stories are created for, told to, and relate to certain types of "consumers." This variation depends upon age, gender, professional experience, extracurricular interests, whether the consumers have children or not, and a plethora of other differentiating characteristics. Some audiences are very broad, such as the *New York Times*'s readership, while an audience for a blog that focuses on small strobe lighting is considerably smaller.

To illustrate the importance of an audience, just think about this: Many of the magazines I work with conduct a sizable amount of market research, which really translates to demographic assessment of their readership. They statistically determine the characteristics of those who respond to some form of questionnaire, and that general information is available to pretty much anyone who sends the publisher or editor an e-mail.

This determination also affects how I see a story taking shape for their audience. Occasionally, this has no bearing on how I photograph a story, but in many cases, knowing a suburban lifestyle magazine audience is made up of 60 percent women with an average age of 55 and an annual individual income of anywhere between $65,000 to $90,000 helps me know who I'm talking to,

Shot for a feature on releasing snagged fishing lures, this image's audience is relatively small and niche compared to a general-interest magazine's readership.

Canon 1D Mk III, 17mm, 1/200 sec., f/4.5, ISO 100

Images speak differently to different audiences. The multiple crosses in this Chihuahuan desert cemetery near Shafter, Texas, attract an audience of particular religious convictions.

Canon 5D, 155mm, 1/250 sec., f/8, ISO 100

or in this case, shooting for. My story about the newest, hottest metal band to ever hit the airwaves will be lost on the majority of this audience. My story on the newest xeriscaping trends might resonate more in this case. We could all shoot the things that interest us the most, all the time—but we most likely don't have the funds to support that.

Aside from thinking about it professionally, though, starting out on a story with an audience in mind is extremely helpful. Don't think about it as one more restriction on how you tell a story. Consider an audience a focal point for successful delivery. Knowing who makes up your audience is arguably just as important as knowing who it is you're photographing. This information is a significant part not only of shooting story, but also of editing and selecting the images that will best showcase the story.

For example, if your homeowners' association catches wind of you being a photographer and convinces you that you'd be the right person to photograph the neighborhood yard sale for the HOA website (that's OK, you'll get them back), you're going to cover the day pretty thoroughly, shooting establishing shots of entire yards full of unworn clothing, old stereo speakers, and used baby strollers; medium shots of folks haggling over prices; and close-ups of the wares of the day. When you get to editing, though (keeping story in mind, even though you just want to dump all 1,000 shots on a DVD for the HOA to sort through), you're now in the mindset of pondering what the website's audience members—the people who live within the HOA—want to see.

Although they might like to see a few images of their old silverware collections, they probably don't want to be visually inundated with what was on the lawns as opposed to the social scene that was happening there: the exchange, the conversations, and the tough customers who drove by real slowly peering out their windows, turned around, and eventually walked up to the yard for closer inspection. It's a comical example, but it's also a prime opportunity to flex a little story muscle and use that knowledge of your audience.

LEARN ABOUT AUDIENCE One way to learn about a particular outlet's audience is to go straight to the source. If you want to pitch a story to an online conservation magazine, visit its website, read the "About Us" page, and more important, browse the contents of its publication. Within four or five articles, you're more than likely going to find out what type of audience is interested in the stories published there. If your story isn't a fit, seek out an audience that is. One of the best ways to make a pitch is to know who you're pitching.

> Knowing who makes up your audience is arguably just as important as knowing who it is you're photographing.

Personal Outlets

Self-publishing is far more than a twinkle in a nascent photographer's eye nowadays. In fact, it's as common as registering for a free account with Wordpress or Blogger. Plenty of photographers out there have never published with a traditional outlet, yet the stories they tell and the way they present them are just as powerfully received. A custom book, a personal blog, or even an account with a photo hosting service, such as 500px, can serve as a dependable and attractively viable storytelling platform for everyone in the photography community.

The fact remains, though, that there is always an audience you want to reach with your stories, whether you distribute them through traditional media or personal outlets. Even if you start writing and shooting for your own blog, you need to generate content that is directed toward your readership. My own blog is geared toward discussions with other photographers, not the general public. Plenty of newlyweds and parents create websites to keep other family members in the loop, and if Dad has a hankering for photography, the website might be an inexpensive and infinitely valuable outlet for showcasing thoughtful visual stories of his children for that particular audience.

Personal outlets also allow those who make a living as visual communicators a way to publish stories that don't necessarily relate to the type of work they do professionally. We all have varied interests, and a personal Tumblr blog might be just the right format for posting smaller vignettes of life on the neighboring stoop. The opportunity to present story is bountiful, and all it takes is determining which format is best for you, your work, and the stories you're telling.

ASSIGNMENTS: THE PRESSURE'S ON!

Well, you've done it. You built your portfolio up, you contacted and met with an editor, you pitched a story idea for the magazine, and it was accepted. Congratulations! Now get to work.

For those professionally inclined with their photography, being assigned a story (one you pitched or were selected for) is a nice feeling, especially when keeping good tires on your vehicle is on the line. At the same time, though, you start to realize that the seat you're sitting in just increased in temperature.

There's always a bit of anxiety at the beginning of each assignment, no matter how many shoots you've conducted or stories you've produced for a particular publication. The goal is to take that in stride and remember why you were hired for the job: to be the photographer. The more you're engaged with photographic practices that focus on creating compelling, storytelling images,

There is always an audience you want to reach with your stories, whether you distribute them through traditional media or personal outlets.

the more effective and competent you become as a shooter for a story in a print publication.

This opportunity allows you to practice many of the points raised in this book. Who is the audience for this story and this publication? Keep in mind the general topic, the story's setting, the characters, the plot and storyline. Think about your story's thematic structure. What type of mood are you trying to represent with your images, and how are you going to do it? All of these things you've learned in regard to operating your camera and what it is to be a visual communicator meld together at this point, and it's topped off with just enough pressure to make it exciting.

With assignments come editorial expectations. These differ in certain ways among different outlets, but many of them have to do with the quality of your work, your professionalism, and meeting deadlines. This is no different than any other job out there and what other employers expect from their employees. A full-time employee might see this a little differently than a freelancer, but regardless, staying on top of your work is essential (on the bright side, it keeps you motivated to shoot and tell story).

Keep in touch with others involved with the story. If you're the sole photographer and the images will accompany a 2,500-word document, call or e-mail the editor or writer and ask her if you can read the manuscript. This puts you both on the same page, and it might even spark some collaborative thought toward the story's thematic characteristics.

If you've been assigned a photo essay about teenagers who work after school to help make ends meet at home, develop an outline that will help you touch on aspects of the story that you might not know much about without being offensive or too threatening. Use those resources we discussed earlier in this chapter for access, and build relationships along the way (you never know when you might need to call someone again for a similar story). Have conversations and take

Uncovering hard-used tools in Cottondale, Texas.
Canon 1D Mk III, 42mm, 1/6 sec., f/11, ISO 100

notes. Your job may be to photograph, but the more you understand the story you're assigned to shoot, the more capable you become in finding the important visual elements of the story itself.

And, like many photographers before me have said, the camera does not go in the bag until you've left the story's environment. In a sense, you're never finished telling a story, but don't pocket the means with which you have to tell it before you're out the door. Keep yourself ready for *the* shot that leads the story but maybe doesn't arise till five minutes before you pack up. Throw your camera over your shoulder as you cart gear back to the vehicle, and put it on the passenger seat of your car as you drive through the gate. There might be something along the driveway that contributes to your story.

Each May, I help lead a group of university students on a 15-day field photography course in and around Junction, Texas. This time of year sees the transition between spring and summer, and it's usually a vibrant period for photography. We cross several rivers (I've only dropped a rig in once), hike mountains made of pink granite, and march through cane-covered swamps; and the fun usually starts around 4:30 a.m. and ends anywhere between 9 p.m. and midnight. Quite a bit of photography content is covered in this intense two weeks, and it helps build memorable, practical field experience for the students.

Canon 5D Mk II, 105mm with extension tubes, 1/8000 sec., f/2.8, ISO 100

Going back year after year also helps me build a strong portfolio of the areas we shoot. One year, I decided to concentrate part of my time shooting a small set of images focused on the flora that annually return to the fields we traverse on our way to the next river crossing or rattlesnake. This isn't an uncommon story to highlight, especially since the Texas Hill Country is full of photographic color every spring. However, I wanted to shoot it in a way that isolated each flower from the rest in the field.

Along the hikes or while we were stopped on the side of the road, I would keep an open eye for an arresting flower or plant. When I found one that was a healthy representative of the species, I set up a tripod, camera, shutter release, a telephoto lens with extension tubes, and one or two Speedlites hypersynced in order to shoot with such a fast shutter speed that the background went almost or completely black.

The resulting images were stark studies of color and growth. Stark because of the immediate separation of the plant from its surroundings, color due to its emphasis in the frame, and growth because of the feelings we associate with life and the vitality of these particular plants. They were quick images to make, and the subject matter was quite accessible.

A small series of photographs was made over the course of two years, but that's exactly what I wanted. It was based off a quick idea I developed when considering how one year's workshop might result in some different ways of seeing familiar subjects from years gone by. The idea proved to be a not-so natural way of shooting the subject matter in a natural setting, but it captured the essence of the plants and the visual significance of their relationship to some relatively abstract themes, centered on delicacy and power in color. ■

Canon 5D Mk II, 85mm with extension tubes,
1/8000 sec., f/3.2, ISO 50

Canon 5D Mk II, 160mm with extension tubes,
1/8000 sec., f/3.2, ISO 50

Canon 5D Mk II, 100mm with extension tubes, 1/8000
sec., f/2.8, ISO 50

Canon 5D Mk II, 80mm with extension tubes,
1/8000 sec., f/2.8, ISO 50

Canon 5D Mk II, 100mm, 1/2000 sec., f/2.8,
ISO 50

FOUND STORIES:
KINDA LIKE "FOUND ART"

Photo walks are exciting. They present a prime opportunity to exercise our technical abilities, and they allow us to develop our creative eye and storytelling vision. They're also frequently useful for identifying and producing a small story. For that matter, this type of practice may result in a project that lasts for years. The point is, story can be stumbled upon much like finding a penny on the sidewalk if you know what to look for. There's no guarantee that it has the legs to make it past an outline of the idea, but it can be found.

Photographing with theme in mind hones our ability to find story. I spent the formative years of my photography (who am I kidding, the formative years never stop) putting thousands of miles on my vehicle while I photographed the Llano Estacado, the southern (and flattest) portion of the American High Plains. My agenda? The power in the sky. I didn't have much directive beyond that, and during the time I spent on the road, I was able to make some interesting images that related to this abstract idea of power.

Along the way, I built knowledge of the land and the people I came across while shooting. I came to visualize the stories taking place across the cotton and corn fields I drove past. Since then, I've been able to shoot more than a few stories based on my knowledge of the area (all from initially traveling those lonely West Texas highways).

Skimming your archives is another way to unveil a topic of interest you might follow up on at a later date. Just in selecting images for this book, I'm reminded of locations I've visited, people I've met, and events I've either been a part of or photographed. Each time I dive in, I find myself looking at these people and places in new ways, and on more than one occasion I've jotted down a few notes to remind myself to revisit an idea for a story. Your images reveal what you're interested in as a storyteller, and they also highlight what you might have missed the first time around. This is a valuable thing to notice, and if you're so inclined, it can help you re-engage with your craft and storytelling vision.

West Texas is known for its flat horizon and colorful sky, as featured in this early morning farmland silhouette near Tahoka.

Canon 1N, 300mm, 1/200 sec., f/5.6, ISO 10, Fujichrome Velvia

A lonesome, lived-in school bus sits on a dry beach in the middle of Padre Island, Texas. This is one of those moments when you ask yourself about the unknown. There must be a story behind this vehicle-turned-shack.

Canon 5D Mk II, 24mm, 1/800 sec., f/9, ISO 200

WHAT DO YOU DO WITH THE UNKNOWN?

This is a good question. Do you ever get that feeling that there's something to what you're seeing, but you can't put a finger (or camera, in this case) on it? I've often come across certain areas or met people that have something unique to offer in the way of story, but it's just not coming together like I want, or for that matter, they want. Something about a person's face can tell you he's seen a lifetime of hard work and perhaps heartache, but what? Or, with non-human subjects, the disorienting rhythm of how trees were planted hundreds of years ago along the rolling hillside is intriguing, but *why* are they visually awkward? The ransacked blue school bus on the dry beach leaves one with only questions to ask.

Stay primed for information or images that will contribute to the story you want to photograph.

One of the answers to the question above is to simply dig deeper. Often, it's upon the photographer to investigate a potential source of story. The headstone marking infamous gangster Machine Gun Kelley's grave sits just up the road from where I grew up in Cottondale, Texas. Even though his life is relatively well documented, there's plenty of mystery still involved with how he was portrayed to the public during the Prohibition Era and how he eventually found himself in prison, only to be buried in a nondescript location in a rural cemetery. An interesting story about Mr. Kelley's life starts right there at his headstone. All it takes is a little history lesson to start the storytelling engine.

An alternative answer to the question posed is to table the idea. When your photo essay on a custom mailbox builder hits a bump in the road during the planning phase, sit on it a while. This might be a few days, two weeks, or even three or four months. I have digital folders and physical notebooks full of ideas and outlines for stories I've either started considering or just jotted down for future consideration. I revisited a coffee table book outline recently, and the date at the top of the page read June 2008.

Still, when you table an idea for the moment, don't just forget about it. Stay primed for information or images that will contribute to the story you want to photograph. Developing stories around themes helps you stay receptive to images and other content that might help you develop a story with a particular universal structure. For example, a recent teaching trip to Europe reinvigorated my thoughts on rural life and solidarity in the United States. A comparison of the two continents' similarities and differences in this regard excited ideas I had for stories in and about my own country, but it also helped me outline two more story projects that bridge the gap, if you will, between the two global areas.

SOMETHING'S BUILDING When you light on something that has story potential, take a moment to get a sense of just what attracted you to the subject matter in the first place. Was it the colors of the person's dress, the look of the pub bar's patina, or perhaps the way two gents greeted each other?

When you have in mind what it was that attracted you in the first place, start to forecast where and when you might see the same thing again. This practice keeps you on your toes and may present a consistency of look or behavior that will eventually shine light on the story that initially drew your interest.

George B. Kelley, aka Machine Gun Kelley, is a name associated with other infamous Prohibition Era gangsters.

Canon 5D Mk II, 17mm tilt-shift, 1/30 sec., f/6.3, ISO 100

The point in all this is to not discount any thought you have toward telling a story. If you are keeping your eyes and ears open to the stories you want to tell and you're tuned in to your surroundings (whether they are your local neighborhood or all the islands in the Pacific Ocean), you're going to be able to identify and photograph interesting stories. It could happen overnight, or over the course of ten years and several thousand air miles. However, always being primed for exploring the unknown is a way to see your work in a particular area grow into something that presents itself as a well-thought-out visual narrative.

Rural Scotland on the edges of the Isle of Skye.
Canon 5D Mk II, 75mm, 1/160 sec., f/8, ISO 50

Now I am finding even more depth on certain stories by adding audio and motion.

I thought Saleh would go back to Iraq with his father after he was medically stable. But when their family in Iraq was threatened by insurgents, they were all eventually granted political asylum and settled in Oakland. I am continuing to follow the story of the Khalaf family as they adjust to life in America. Saleh is facing a new set of challenges in his teenage years. Raheem works as a truck driver but still finds it difficult to support his family. I will probably continue to document Saleh's life until he tells me he is done.

Winning the Pulitzer was humbling, and it meant that many more people saw this story. My great photo editor, Kathleen Hennessy, helped develop this story and edit the images. She believed in it and gave me the time I needed to document it.

Q Do you find yourself shooting stories that fit within the description of a particular universal theme?

A I gravitate toward stories that humanize social and health issues; an Iraqi family torn apart by war, a boy with kidney disease whose robot goes to school for him, gay marriage, life in a brothel, sex trafficking. I am also drawn to behind-the-scenes stories, off the field with athletes including Barry Bonds and Tim Lincecum.

Q If you had to choose among your images to show how effective storytelling can be achieved through photography, which would you choose, and why?

A I'd pick three pictures in the series—Saleh in the hospital bed with his dad, drawing with a Sharpie taped to his arm, and playing soccer in the hospital hallway—that were all shot on the same night. [To see these shots, visit www.deannefitzmaurice.com.] This was the first day I went to the hospital without the reporter and my most productive day in terms of hospital pictures early in Saleh's recovery. It was vital to collaborate with the writer, and we worked closely together, but it was important to step away and make my own connection with Saleh and Raheem. The picture of the two of them in the hospital bed showed how difficult this was for Raheem, who had lost his oldest son in the accident. It also showed the bond between father and son and how much Raheem loves Saleh—he would lie in bed with him to comfort him.

I wanted to show both the emotional highs and the lows of what he was going through. Saleh was coming to the realization that he and Raheem would not be able to return to Iraq, which might mean he would never see his mom again. When he had a meltdown in a grocery store, I shot it. It was hard to watch what he was experiencing as people were staring at him in the store, and it was not easy to shoot this scene where Saleh fell to Raheem's feet crying. Raheem really didn't know what to do.

I felt like I was walking a fine line. We hear that as a journalist you cannot get too close to your subject, but I find that is the only way they open up to me and reveal themselves and share their stories. I feel it is simply connecting on a human level. So yes, I did get close to them, but if that prevented me from picking up my camera at the moment Saleh was crying at his father's feet, then I would have failed as a photojournalist.

Deanne Fitzmaurice

We hear that as a journalist you cannot get too close to your subject, but I find that is the only way they open up to me and reveal themselves and share their stories.

For his family's reunion at the airport, we did a lot of preparation, including meeting with officials at San Francisco International Airport. That way when we arrived on the plane from Jordan with the family, I could get into position without getting caught up in customs, possibly missing the moment when Saleh was reunited with his mom, Hadia. He hadn't seen her in over a year, and the last time she saw him, she didn't know if he was going to live. My editors were sending another photographer to back me up at the airport in case I got stuck in customs. When we arrived, the customs agents helped me get through ahead of the crowd, and I spotted Saleh and Raheem. They were both wearing ties and big smiles. Saleh was so excited he was jumping up and down.

I positioned myself halfway between where Saleh and Raheem were standing and the door where their family would come through. I focused on them and kept my eye to the camera until I saw them react. Saleh and Raheem took off running to meet their family. I shot that frame, then spun around, and the next moment Saleh and his mom embraced while Raheem scooped up his little girls he hadn't seen in over a year. I had spent a year photographing Saleh, knowing how much

he missed his mom, and seeing her face as she held him and witnessing that mother/son love and connection was probably the most emotionally powerful thing I had ever photographed.

Q **If you could give one piece of advice to those starting out telling stories with photography, what would it be?**

A Be curious and read everything. Go toward stories that genuinely interest you because that is where you'll do your best work. ▪

To see Deanne Fitzmaurice's work, visit her Web site: www.deannefitzmaurice.com

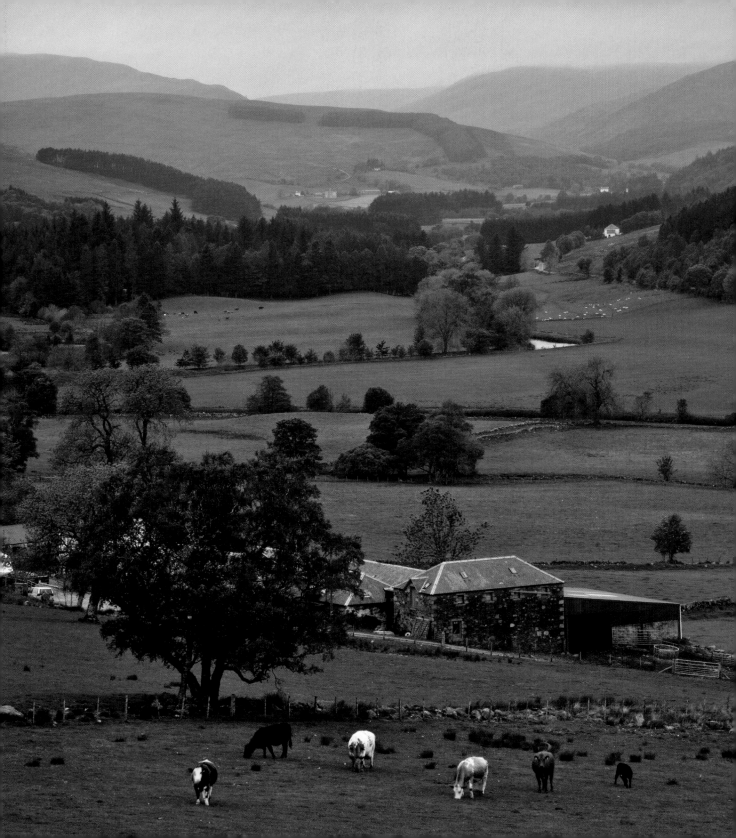

Do the Research!

Finally, some quiet time. It's 9 p.m., the dogs just now quit barking, and I can stop thinking about the insane day I had. I sit down at the computer, and I pull up a document that I'm using to compile notes on an idea I have for a photo essay on local barbers. I type a few names of some barbers I know personally, and then I jump online. A quick search for *history+barbers* pulls up 3,900,000 results. I'll start with the first ten and see where that gets me.

Before I traveled to Scotland, my research led me to focus on its abundance of natural resources and conservation efforts, its recreational activities, as well as its rural atmosphere.
Canon 5D Mk II, 17mm, .6 sec., f/22, ISO 100

Pretty soon, it's 1 a.m., I have ten tabs open on two browser windows, and I've switched to real paper for some copious note-taking. I'm streaming a barbershop quartet after reading about the origins of the musical format. I've read about how *barber* is a word derived from the Latin word for *beard*, the various styles of combs throughout history, the striped, round, spinning column that is visually associated with the craft. I've looked at about 300 images of barbers from around the world. I'm sketching image ideas for the essay, and I've already identified seven more barbers to contact about a potential shoot.

All of a sudden, my browser crashes. Well, it's a good thing I have all the Web pages bookmarked.

Research can be tedious. One does it alone, and it frequently eats up time that we'd rather spend shooting. Researchers might win trivia games, but they're not likely to be the life of the party. Our research can keep us up at night, but then again, it sometimes cures our insomnia. Zzzzzzz.

Nonetheless, research makes us better storytellers.

EXPANDING THE TEMPORARY EXPERT

Generating story ideas is just the beginning of the storytelling process. The next step is to become an authority on the subject matter involved.

Truthfully, it's hard to think about telling story without becoming more knowledgeable about the characters, the settings, and the activities you will be photographing. Can you imagine shooting a story about train engineers in the Southwest without at least going online to see what lines run through the area where you'll be located? Research, however light or extensive it is, is a crucial part of storytelling that serves several purposes.

Versed in Variety

On the surface, research helps us become versed in our subject matter. One of the greatest things about being a photographer is the assortment of topics, issues, and people we are tuned into visually. Our job stimulates the mind every day. Some of us will concentrate on one area of interest our entire photographic lives, such as wildlife or conservation. Others will have a generalist perspective, never shunning a new topic or area that lets them tell a visual story. No matter which end of the spectrum you see yourself on, each story

you shoot necessitates a level of learned expertise in order to tell it appropriately, creatively, and uniquely.

This doesn't mean that you must obtain a Ph.D. in everything that you shoot, but it does stress the value of knowing the terminology, the language, the relationships, or even some of the mechanics of what's in front of your lens. For wildlife photographers, this might mean developing an advanced knowledge of animal natural history and a certain species. For photojournalists, diving into multiple arenas of thought and story is necessary, and boning up on the ins and outs of a particular story quickly before moving on to the next may be required. In each case, taking in as much as possible helps the photographer create a better picture of the story in general.

Research helps us cope with the assortment of interests we're charged with photographing. When I stop to think about it, the schedule of shoots I'm on at times is almost comical. I'll be shooting head shots for a Web site one day, cowboys working cattle the next, followed by a two-hour drive photographing stock for a personal project on small-town religious faith, and I'll finish off the week shooting a step-by-step process for baking a sugar-free pumpkin pie. An assortment indeed. The one thing that keeps me working without confusing my cowboys with my pumpkin pies is the amount of research I do for each topic. This amount may vary depending on the subject matter—if I'm just doing headshots it's a lot less work than learning about cowboy culture—but making sure I've done my homework for each of my stories makes a more effective and efficient shooter out of me.

SET ASIDE TIME FOR RESEARCH The scope of your project will determine how much time you actually spend researching, but setting aside a regular amount will help you manage the preparation portion of the storytelling process.

Some photographers reserve an hour an evening for research, while others use entire days during the week. Large projects, on the other hand, may require a schedule of research that encompasses months of work fit in around smaller projects and activities. The point is to give yourself the time to adequately prepare for the story you want to tell.

Getting into a rhythm of research will also help you get excited about the story and initiate the next one, especially since your attention is already geared toward devoting time to dig up and digest information. Many stories lead to future assignments on the same or a similar topic.

Although much research may not be needed, getting to know a little about your subject while taking her head shot may help you determine the type of lighting and background you use.

Canon 5D Mk II, 93mm, 1/200 sec., f/2.8, ISO 200

Studying other published images of pumpkin pies, in conjunction with a conversation with the shoot's art director, helped shape the look of this particular dessert.

Canon 5D Mk II, 50mm, 1/125 sec., f/11, ISO 200

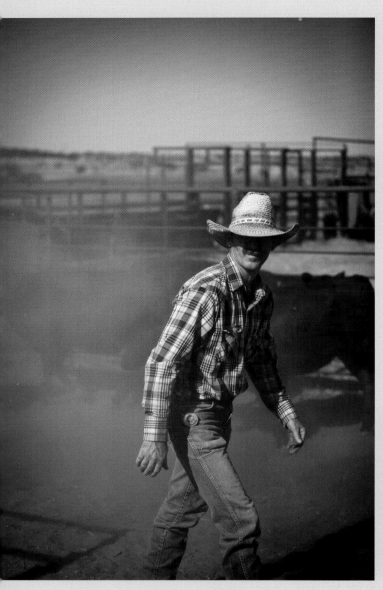

A lone cowboy walks out of the dust kicked up from cattle exiting the ranch's weight scales in Chalk, Texas.

Canon 5D Mk II, 70mm, 1/3200 sec., f/2.8, ISO 100

The Church of Christ in Bend, Texas, population approximately 120.

Canon 5D Mk II, 17mm tilt-shift, 1/30 sec., f/11, ISO 100

The Bigger Picture

Research opens you up to a much larger world surrounding your story. The pile of information you can pull up in a single Internet search on any given subject is sometimes intimidating. However, that "pile" is a potential pot of gold for those concentrating on story.

Being versed in your subject matter is one thing, but realizing that there is a "bigger picture" for the characters and settings you are photographing is like being able to stand still in a hurricane. Telling a story visually doesn't have to mean that you set out to impart the definitive knowledge of your subject. Rather, you're better off keeping in mind that the story you are telling is a *part* of the entire scope surrounding a particular narrative. You're presenting a particular angle on the story, not writing an encyclopedia.

On a job several years ago in northern Mexico, my colleagues and I were charged with photographing and producing high-definition video material of a very large conservation area, a truly wild place. Half a million acres of desert floor, impressive desert mountains, and expansive plateaus took the place of the office for nine days. It was our goal to document a place that, through extensive land and wildlife management, had been transformed to the way it looked like, say, 10,000 years ago.

Our research and interaction with primary sources provided us a much larger narrative than the one we set out to tell at this time. We researched the history of the area, only one facet of which was the presence of conservation workers in recent years. Their work restoring the landscape was what we were compelled to showcase, allowing us to focus on creating images that complemented the idea of a rejuvenated natural area.

We were not charged with telling the entire story, from page one to the end. That would entail creating several more visual stories. At the time, we could concentrate our energies on shooting exactly what we were there for, because from our research, we could see where the one story we were shooting about this beautiful land fit into the "bigger picture."

> Telling a story visually doesn't have to mean that you set out to impart the definitive knowledge of your subject.

Continuing the Story

Knowing where your story fits in the "bigger picture" also gives you some insight on how to continue working along the same lines. Research takes you to many places, and where you find holes in the story, or where you key in on a particular juncture in the narrative, might just become your next project. If what we do as visual storytellers is to contribute to the larger story, then there is always plenty more to add.

Understanding 500,000 acres of pristine land in northern Mexico meant studying the layout of the land to show its immensity. Short trees dot the top of a 30,000-acre mesa high above the desert floor.

Canon 5D, 30mm, 1/30 sec., f/13, ISO 100

The vast expanse of conservation land in Maderas del Carmen, Coahuila, Mexico.

Canon 5D, 17mm, 1/125 sec., f/9, ISO 100

For example, my photo essay idea on local barbers may lead to a comple-
mentary essay on the gender differences in the profession—the typical male
barber and the often-female stylist. From there, work in that area might
bloom into a large feature story focused on the social aspects of regular salon
attendance, followed up by a small portrait series on the steel-blue hair color
that is iconic of older women. Although this series of stories seems sporadic,
they are all ideas resulting from giving the original story idea its due diligence
in research.

This is a very important part of the research process. Once you "finish" one
story, you have information and ideas that can help you produce another. And,
voilà, you've already completed some research to help you along. No story
ends—just ask all the photojournalists out there.

Another way to put this is that there is always something to continue say-
ing about the characters and the settings in which you're interested. Research
allows you to recognize when and how to continue the conversation.

SYSTEMATIC AND NOT-SO-SYSTEMATIC RESEARCH

There are several ways of going about doing research, some with more for-
malities than others. However, each has its merits. The important thing, of
course, is that research is actually conducted, but it helps to know a few ways
of gathering information about your story.

Primary Sources

To be academic about it, one way to systematically go about the research
process is to use both primary and secondary sources of information. Primary
sources are those sources you engage one-on-one. For example, in a story
that revolves around a city's emerging art movement, the artists themselves
would serve as primary sources. If you are shooting a story on a range of wil-
derness in a state or national park, primary sources might include park rangers
and area and departmental biologists and range scientists. These folks will
give you, the photographer-turned-researcher, the richest information possible
in helping you shape your visual story. Consider primary sources the experts
who can inform you about your story's subject matter better than anyone else.

Primary sources don't necessarily walk around with name tags that iden-
tify them as Joe Expert, and locating them takes some work and access. This
is where a little planning comes in handy. If you're using a story idea outline

like the one I described in the previous chapter, you've given yourself a structure for listing as many primary sources as you need. Some stories may only require you to get in touch with a small handful of these sources, while others (think *National Geographic* assignments) may require dozens of reliable primary avenues of information.

If you're working on assignment, the publication can often give you contact information for some sources. After all, the story's author should have already done quite a bit of research herself. But if not, one nice thing about primary sources is that many also have an online presence. Business owners, scientists, artists, and even other photographers are for the most part easily located on the Internet. If their contact information is available, they are only an email or a phone call away (call well before you need to talk to them, though, as you might have to leave a message or play phone tag for days). Finding other primary sources might require you to talk to several people along the way who can point you to them. Your own network of friends or colleagues is a place to start asking about primary sources, and you might even find that some within that network will serve as such.

Two more advantages primary sources have for your research include their potential as characters in your story and their ability to connect you to more sources of information. More often than not, at least one or two of your primary sources could play a significant role in your story, particularly if the story involves a human presence. A photo essay on guitar luthiers not only directs you to find a few specialists with whom to discuss the craft, you more than likely will also include some of the luthiers you contact in the story's visuals. Likewise, the same luthiers you contact for information related to their intricate work can connect you with other luthiers, as well as musicians, instrument collectors, accessory manufacturers, recording studio engineers, guitar technicians, and so on. If your story has room to go beyond just that component that involves your first primary source, be sure to finish each conversation or photo shoot with a question about finding other individuals who will help produce the visual nuance from which your story will benefit.

Secondary Sources

The alternative and complementary reservoir of information in systematic research is found in the form of secondary sources. These include just about any research or pieces of information that you didn't collect yourself. Books, magazine articles, blog posts, interviews, podcasts, and even other images—all serve as potentially great secondary sources. Just because you might not be able to make contact with a primary source doesn't mean you can't find valuable information related to your story among secondary sources. In fact, secondary sources may constitute the bulk of your research, in terms of information and time spent.

Seeking information using secondary sources is generally the way research begins, and it is often more efficient than trying to contact and set up meetings with every individual you might consider a primary source. In addition, secondary sources help you sort out who might serve as the best primary sources among a list of potentials. If the same name pops up several times in your searches for magazine articles and book chapters dealing with ghost towns of the American Southwest, then that individual might well be a more informative primary source than a well-meaning, one-time blogger who mentions that the neighboring village once had a thriving economy but is now no more. Similarly, while Wikipedia can point you toward some interesting background on just about

A depiction of village life in Toledo, Spain. The active street life and social coming together of the country's population coincided with my academic interest in informal socialization.

Canon 5D Mk II, 35mm, 1/200 sec., f/8, ISO 400

any topic, you'll have to look further down in your search results to find more authoritative sources.

It is helpful to keep in mind, then, that not all secondary or primary sources of information are created equal. However, the deeper you research your topic, subject matter, or story line, the easier it becomes to tell the "good" from the "bad" sources. The last thing you want is to photograph a high-level official at an environmental company and not be well informed about what his company has been up to for the past several years. Being diligent about your research helps not only in spotting accurate and helpful information among the, well, not so accurate and helpful, it also helps establish a level of rapport and authority with your subject matter.

Personal Experience

Doing research often seems, and is, a grand ordeal—a very involved, time-consuming process of distilling from a large amount of available information what it is that will help you out the most in telling a compelling, dynamic, and hopefully accurate story. From this perspective, research seems rather plodding and separate from the connection we have with our craft and vision. However, researching a story can actually be fun. Think of it this way—you're learning new things every time you do a story. We need to exercise our brains just as we need to use our bodies. And research can involve your own experiences as well.

One of the reasons you want to tell a particular story in the first place may well be the result of a visit to a foreign land or a long conversation you had with a friend over coffee. Many of our deep interests in a variety of social behaviors or occupations drive our passion toward storytelling. And so, it's reasonable to consider our own perceptions of a story's setting or characters to be part of the research process. Experiences and feelings are important parts of being a photographer, and it's often beneficial to bring them to the research stage, along with analytically consuming primary and secondary source information. After all, your own experiences as a shooter inform your ability and style behind the lens; why not allow your own life experiences a little room in developing the story you're about to visually tell?

Photographing a recent Ironman triathlon event gave me a deep respect for the participating handcyclists and a great interest in developing a visual story about this inspirational area of the triathletic world.

Canon 7D, 300mm, 1/1600 sec., f/4, ISO 200

Of course, depending on the type of story you're setting out on, it's impor-
tant to consider the amount of subjectivity your own experiences bring to the
table. This isn't an ethical discussion, but it does stress the value of finding a
balance in research between the systematic and not-so-systematic approach
to developing the story. As I've already mentioned, keep in mind your audience
and how introducing your personal experiences as an influence in how a story
is told will affect their experience.

SOFTWARE **I wouldn't say that research these days is any easier than it used
to be, but improvements in digital technology have enabled us to create a more
effective research workflow. No matter the size or amount of research you
do, it might be helpful to employ software that is geared toward aiding you in
the process.**

**The list of software applications that can be handy is long, and their plat-
form availability and usage range from smart phones (with apps like Evernote
and Things) to full-scale products for personal computers (like FileMaker and
Bento). They also range in price from free to over a few hundred bucks, so
choosing the right one may take some shopping (or at least some deliberation).
Either way, putting a research-oriented software application to work gives you
the type of mental freedom and physical organization you need to clearly con-
ceptualize how the story is coming together.**

> Part of telling an interesting story is how different it is from others, and this includes the way it looks.

WHAT'S ALREADY OUT THERE?

It sounds obvious, but it's a step many overlook; part of your research should
be to become familiar with what has previously been produced in the way of
a similar story or subject matter. This is a type of secondary research that is
invaluable for both developing a new, compelling story and picking up where
an old one left off.

Part of telling an interesting story, something we discussed in depth in the
previous chapter, is how different it is from others, and this includes the way it
looks. Stories stand out more if they feel original and don't have a predictable
angle. Studying what is already out there in regard to your story—what has
been published online as well as in a physical format—allows you to stay fresh
and up to date on the available visuals.

Canon 5D Mk II, 105mm, 1/4 sec., f/22, ISO 50

Canon 5D Mk II, 28mm, 25 sec., f/22, ISO 100

Canon 5D Mk II, 50mm, 1 sec., f/22, ISO 50

Studying the available images of certain subject matter may help you maintain compelling technique while exploring interesting composition, such as in these three images of moving water. All use the proven slow shutter speed plied in many water shots, yet variation in perspective and composition help uniquely explore a common photographic subject.

> Looking at a large number of images related to your story is simply good practice, and it's a healthy way to exercise your visual mind.

One of the first things I do when I start to research individual pieces of a story (the characters, the locations I plan on shooting, and so forth) is a quick Google Images search for related material. Depending on how thoroughly the topic has been covered, these images may lead me to more images and the photographers who made them.

After looking at a number of photographs (sometimes even hundreds of them, for a big feature), the photographic researcher has not only a better understanding of the scope of what's been visually said about the story, she's also more aware of two other things: the visual style and techniques that have been employed to tell such a story, and any gaps in the visual storyline.

Knowing what styles and techniques have been used to successfully (or unsuccessfully) create images related to a story gives the photographer an idea of both how to make images in a particular setting with a particular character and what still remains to be done with them. Many published images of running water are technically created with very long exposures, as evidenced by the water's milky, flowing look. This technique has been a compelling way to imply the motion and constant life of a stream. On the other hand, if most of the shots are big, wide, expansive views of rivers and waterfalls, perhaps it's worth the time and effort to shoot tighter, more specific, and somewhat abstract images of the same areas.

Looking at a large number of images related to your story is simply good practice, and it's a healthy way to exercise your visual mind. Whether for research or not, studying other photographers' work can be very inspirational. More than once, I have dived into someone else's images, only to come away with an idea on how to photograph completely different subject matter. Being open to inspiration and sometimes-subtle influence is certainly a beneficial aspect of doing your research—learn from what you see and use that knowledge in new and interesting ways the next time you plan and set out to shoot story.

ENVISIONING IMAGES: PRE-STORYTELLING

There's one other big thing that research does for you as a photographer: It gives you an idea of what the story's visuals will look like before you get on location. Do enough studying of your subject matter, and your mind's eye starts to generate not only the content in your shots, but the colors, the lighting and mood, the emotional appeal—everything that might relate to the story and even the larger thematic structure.

Previsualization

Previsualization is just that: seeing the image before you make it. It is an intentional way of seeing your story come together, and I daresay that every photographer does this. Even a photojournalist, whose main goal is to report and cover "objectively," cannot avoid imagining what a frame (or ten) of the mayor's speech may look like. Previsualization is a good thing, and it further exercises your creative tendencies toward story and telling it uniquely.

Along with being a creative workout, previsualization offers a few more pragmatic benefits to the visual storyteller:

1. **Focus:** Previsualizing the images that coordinate with your research and story's settings and characters further places you in the mind-set to actualize your visual interests. Picturing the types of images you'll be able to achieve while planning a photo essay on your trip to a foreign country will motivate you to do more thorough research and engage fully with a new subject or environment.

2. **Visual direction:** If you read about athletes training for an important event, you'll often read about how they visualize their performance throughout the event. Many swear that this technique helps them achieve their goals. When you set a visual goal for one, several, or all of your images and focus intensely, the consistency and connection you want to create is apparent. Each must contribute sufficiently to the whole.

 If your cultural photographic interest in traveling is color and food, then previsualizing images in this vein will keep you primed toward scenes featuring such content. Along the way, you'll note the relationships food and color have with other significant cultural factors. Keep in mind, though, that while it's good to have goals, it's also important to be flexible. Visual direction is beneficial unless you walk around with blinders on, missing other key shots and ignoring interesting images to make that might spark or tell another story.

3. **Time-saving:** Like research in general, previsualization helps you produce story in a more efficient manner. You don't necessarily have to arrive on location and all of a sudden come up with something unique for the story's visuals (although this happens quite a bit). You're able to arrive much more prepared, enabling you to work more productively and have some free time to spend concentrating on other, perhaps unplanned material.

Several years ago, I photographed sports photographer Norvelle Kennedy for an ongoing personal project. Envisioning the image's lighting beforehand sped up the process of the shoot, saving us a significant amount of time and allowing us to work on expression and compositional variation.

Canon 5D Mk II, 200mm, 1/200 sec., f/16, ISO 200

Canon 5D Mk II, 50mm, 1/125 sec., f/1.4, ISO 100

Canon 5D Mk II, 50mm, 1/80 sec., f/2, ISO 100

Canon 5D Mk II, 50mm, 1/250 sec., f/2, ISO 200

Canon 5D Mk II, 200mm, 1/3200 sec., f/2.8, ISO 100

4. **Working with Your Hands:** Previsualization should not be wrapped up solely in your mind. Your craft is a physical one, so previsualization necessitates that you put your hands to work (especially since up until this point in the research process, all they've done is click a mouse, turn a page, or burn themselves on a hot pot of late-night coffee). Here's your chance to simply transfer what is in your head onto paper. Grab a pencil, open up your Moleskine, and draw. This not only gives you a change of pace, but it also frees your mind up to generate new material related to the story.

In short, previsualization is an active component of researching and shooting story. It can take place over a long period of deep thought or on the fly. The moment you see a person in attractive light or some nice compositional flow to a particular room, you're previsualizing. Put it to work during the research process, and you'll notice that the steps you take in actually seeing the story progress while your knowledge about your subject matter broadens.

Some photographers might even find storyboarding their photo essays and features useful at this point in the process. This type of prestorytelling is an in-depth way of determining how the story will look, particularly if it has a flow much like a film or a multimedia piece. Moving beyond simply drawing certain images that come to mind, storyboarding to some degree solidifies exactly what needs to be achieved visually for the story. Although it sounds a bit less flexible than the simple previsualization previously mentioned, this process is often beneficial when you're working with a large crew or under strict time constraints.

The goal of prestorytelling is to start shooting your story with as much visual content in your mind as possible. Think of it as a certain amount of image insurance you carry with you. I wouldn't consider previsualization a way to make sure you take care of the safe, easy shots—it's just being prepared for what might happen on a shoot.

A sketch of a sketch, if you will. Putting pencil to paper doesn't have to produce a masterpiece, just a visual guide for you to follow later.

Canon 5D Mk II, 50mm, 1/80 sec., f/5.6, ISO 100

Previsualizing a series of food images for a recent trip to central and southern Spain kept me primed to photograph characteristic facets of the Spanish culinary culture (opposite).

I have a good friend named Craig, and he's one of those guys with an infectious personality you can be around for hours. He's seen a little bit of everything, and he has a variety of interests. He's a woodworker, a painter, a ceramicist, a philosopher, a musician, and a helluva cook. His quaint kitchen is comfortably full of utensils, his immaculate backyard is populated by a vegetable and herb garden, two buildings that he built himself, and a cantina, and his old VW bus sits in a corner opposite a wading pool. He's a man of character, and his eclectic authenticity is obvious here.

He's also a barber. One of the last times I was out at his place, he showed me his newly renovated barbershop. The small room is attached to one of his backyard buildings, but the exterior door to the addition opens up to the street outside. The entire room could not be more than 150 square feet in size, and yet, that's all he needs. An old, traditional barber's chair sits in front of a hand-finished counter and shelves, where all the necessary items a barber requires to do his job are stored. The room has as much characterizing personality in it as the rest of his property does, and I expected nothing less.

As time went on, I started putting together an idea of a portrait of Craig. I liked the look of that barber's chair in his small shop. There's something nostalgic about those old chairs, and I started to depict in my mind what a portrait of him might look like. I previsualized it as a simply lit, full-body shot of Craig sitting in the chair. I knew I would need one main light to camera left, but I wanted to use it in conjunction with the existing ambient lighting from the ceiling and wall lamps. I wanted this portrait to speak about this particular part of Craig's life—a community-oriented occupation in which his personality can shine.

A couple months later, I let him know I had an idea for a shot of him in his barbershop. Within a couple weeks, we got together, and while a few friends of ours were finishing up dinner in his backyard, he and I took leave to his shop. I had already set up a Speedlite through a 28-inch Westcott Apollo soft box. I had to remove a few blades from the ceiling fan to position the light where I needed it, but the lighting quickly fell into place. I had him sit down in the chair and let him know that I wasn't going to forcefully pose him in any position, but I told him how I had imagined the shot and what it might say. We ran through a few looks, a couple lens changes, and within 15 minutes, we were finished.

The entire shoot took less than 45 minutes from setting up and shooting to replacing the ceiling fan blades. Previsualizing the portrait increased the efficiency with which it was produced, but at the same time, this relatively short shooting time also kept my subject engaged in the moment, his story, and me. He didn't have time to become complacent in the chair, and our conversation centered on the context in which we were working. In fewer images than a roll of film contains, I had exactly what I wanted, as well as a few other looks, each of which contributed to the narrative that surrounds Craig. ∎

Craig the barber: a character worth getting to know.

Canon 5D Mk II, 50mm, 1/160 sec., f/2, ISO 400

Sketching visual ideas is a valuable part of the research process, and it's also a fun and intuitive way to break up your studies of background material.

Photographers love behind-the-scenes illustrations. Lighting diagrams are some of the most popular sketches in the industry and the community. As useful as they are, though, they provide insight after the fact. Equally useful at times are sketches of the frame itself. Illustrating images from a lens-eye perspective is an additional way of previsualizing and putting thoughts down on paper. In many cases, these sketches will provide you a better understanding of where your story is headed.

As an exercise to help get you in the habit of sketching out your ideas, do some research on three subjects you would like to photograph for your next story. Whether or not you think you'll be able to photograph them is not an issue at the moment. We tend to generate ideas for stories before we have approval for a shoot anyway. Compile your research on the story itself with them in consideration. As you begin to develop a direction for your story, start to sketch out exactly what you foresee yourself being able to achieve photographically

with these subjects. Sketch the composition and identify the background and what your subject may be holding, touching, or doing. Is it a formal portrait? Are you photographing him working with other people? Be specific, even to the point where you have a strong idea of what lens and f-stop you will use.

To be on the safe side, complete five sketches of each individual. Label the content in the frames as specifically as you can, and be able to recognize how the sketches relate to the story you're going to tell. It doesn't matter if you've never taken an art class or if you never traced cartoons when you were young, channel your inner child and draw the frames in a way that lets you know what's going on. These sketches are for *your* research. They're just as valuable to you as is some of the information that you cull on the Internet pertaining to your subject, and you're not setting out to win an arts-and-crafts award with them.

Put this exercise into practice each time you shoot a story. Do it during your designated research time or anytime an idea hits you. It's worth carrying around a notebook so you're able to jot down ideas on the spot. Better yet, download a sketching app for your smart phone. It doesn't have to be anything special, as long as it lets you transfer that creativity from your brain onto something more physical. If your next story does not involve people, sketch just the same. If you're putting together a photo essay on types of cars, sketch out exactly how you want to photograph them. Whether it's animate or not, you're always able to previsualize your subject matter.

Keep in mind that you can't always achieve photographically what you sketch, for myriad reasons, both technical and environmental. Don't let this discourage you from practicing this form of previsualization. It will allow you to react that much faster when you need to generate a new idea for the shots. ■

Canon 5D Mk II, 50mm, 1/1250 sec., f/2, ISO 50

After scouting the old Roosevelt church near Junction, Texas, my colleague Wyman Meinzer and I realized that a light painting at dusk was going to produce the most attractive and compositionally unencumbered wide shot of the building.

Canon 5D Mk II, 24mm, 4.5 min., f/5.6, ISO 100

SCOUTING: RESEARCH ON LOCATION

Let's face it. We can't always be shooting, particularly if we have in mind a certain image that requires a specific type of light, time of the year, wind speed, and so on. However, while we're not shooting, we can always follow up our paper trail of research for future stories by visiting a specific shoot location or region.

Even though it's time-consuming, scouting saves you time later when you're on the shoot. It's never a good feeling to show up on location and be let down by the surroundings or ill prepared for the environment presented to you. Not only does your subject matter—the characters of your story—make for interesting images, the context in which the person or thing is placed is also crucial. Imagine walking into that guitar luthier's workshop and realizing no guitars were hanging on the wall. The intrigue and romance

of the craft for viewers would be deeply diminished, even if they had nothing with which to compare it.

Scouting locations beforehand protects you from being stalled by what might hit you while "on the job." It might influence you to make more tight shots than wide or make you recognize how beautiful the location would be during the morning as opposed to the evening because of where the shadows would fall. You'll find unique and attractive composition, as well as backgrounds and colors to work with, all because you gave yourself the time to *see* the location before the shoot. Scouting combined with a bit of previsualization is hard to beat. After seeing a church you want to include in an essay on historic buildings during the day, you might decide to wait until dusk to paint it against a western sky.

Along with saving time during the shoot, scouting helps you take advantage of the time you won't be shooting. If you're a landscape shooter, use your time during the middle of the day, when the light is undesirable, to take a walk or a drive to locations you know you want to photograph later when the light is stronger and more dynamic. If you're assigned to shoot an environmental portrait of a chef, be sure to check out the restaurant he manages either during business hours or after hours. At the very least, show up to a shoot early so you have the time to quickly scout for the elements of storytelling images you want to include in your work.

SHOOT WHILE YOU'RE SCOUTING **Don't forget to take your camera along while scouting a location. Even though you might be scouting at a time of day when you would never choose to make *the* shot, you'll still benefit from making a few images of the location itself. This enables you to look back on the area when you're not there, plan with your crew should you have one, and compare it to other locations.**

Also, there's always a chance that you'll find something along the way you'll want to delve into. For a landscape shooter, this might be the vegetation in the shade of a location, or perhaps tight detail shots and softly lit portraits for an editorial shooter.

WHEN IT ALL FALLS APART

There are times when all the research you do in order to prepare for creating a visual story feels like it is for naught. Thankfully, for the most part it occurs when you show up on location. The environment doesn't look like you imagined or it has changed recently. Half of the characters you were supposed to shoot call in sick on the only available day for the session, leaving you with less than what you bargained for. If you've been thorough and mindful of your research and the direction it's taking you, then the front end will work for you. Only when you get to the actual shooting does it fall apart.

You didn't do all that research for nothing, though. If you show up to a shoot and the location isn't exactly what you expected (even if it's just during the scouting phase), use the knowledge you gained about your subject matter and the storyline to envision how you might change the course of your plan in order to get that story. Be flexible but focused. That's the name of the game when you're on assignment and when you're not; it's very much the role of a photographer.

Preparation is a constant. The story is the variable.

On other occasions, you might be in the middle of the research process, and you learn that the primary character in your story is no longer in business or has decided that he no longer wants to take part in your work. Sometimes other events occur that throw a wrench into the works: war, a strike, death. Your research up to this point can still help you develop an alternative storyline. Retrace your steps on researching local inventors, and see if following just one of the ten people you outlined for a photo essay may be worthwhile. If a massive forest fire ravages the national park you were planning on visiting for stock photography purposes, continue your research on the park as well as doing research on forest fires, and create a journalistic piece on this particular event and its aftermath.

When it comes down to it, the research you've conducted only makes you that much more versatile and more knowledgeable about your subject. Your passion as a photographer and storyteller gives you the ability to roll with any changes or speed bumps put in your path. Preparation is a constant. The story is the variable.

While scouting a waterfall shot, I found a trove of riparian ferns in the shade on which I concentrated for much of the afternoon. Who said scouting was reserved for just waterfalls (top right).

Canon 5D, 120mm, 1/6 sec., f/16, ISO 100

A few quick glances at the restaurant where chef Toby Blakley cooks was all that was needed to determine a warm and appropriate backdrop for his portrait (bottom right).

Canon 5D Mk II, 105mm, 1/30 sec., f/4, ISO 800

As you may have noticed, I can't say enough good things about scouting locations. Sure, we often don't have time to do much of it, but when we do, we're better storytellers for it. At other times, scouting a location results in serendipitous circumstances.

On the team shoot in Mexico mentioned earlier in the chapter, the other photographer, Wyman Meinzer, and I spent at least eight hours each day scouting locations to shoot either in the evening or the following morning. Scouting in this wild land gave us a grasp of the setting, and we were able to previsualize how particular undulations in the plateaus and steep falls of the mountain ridges would look under desired lighting conditions. There's no telling how many miles we put on the 4X4 we were provided to travel across the 500,000 acres of wilderness (but we only had *one* flat tire).

One afternoon we drove along a primitive trail above a canyon in El Carmen, and every once in a while we would stop to survey the landscape around us. The road ran on the edge of a ridge, where one side kept climbing farther to the top of the mountain, and the other dropped several hundred feet to the next level surface. This gradual and rather hair-raising climb overlooked an expanse of canyon land, and we were set on finding a location from which to photograph its depth the next morning. The days had been fairly clear, and we figured it would be nice to have a detailed shot of the forest that was perched on the steep canyon walls.

We soon found a large boulder from which to shoot down toward the openness. The rock was as tall as an 18-wheeler—tall enough for us to get above the desert mountain tree line on our side of the canyon. A few places on the boulder offered hand- and footholds, and it proved to be a doable climb with gear on our backs. Once on top, we could survey the entire canyon in front of us. We went ahead and took a few scouting images for reviewing purposes before heading back in the morning. This was our spot. We climbed back down, got in the pickup, and moved on in our scouting endeavor.

The next morning we left the house at close to 4:30 a.m. and drove nearly two hours to our location. It was pitch black for the most part besides what the

At high noon, the sky was hazy and the light extremely weak, but it was a good time to scout a wide shot of the canyon. I took a couple of scouting shots in case we came across a better vantage point.

Canon 5D, 105mm, 1/1600 sec., f/4, ISO 100

Emerging out of the "blue" hour, our scouting efforts proved to be fruitful, especially with a blanket of clouds sitting in the canyon.

Canon 5D, 105mm, 1/4 sec., f/7.1, ISO 100

As soon as the light emerged above the clouds, the visible mountainsides took form and became islands in a literal sea of sky.

Canon 5D, 105mm, 1/13 sec., f/18, ISO 100

headlights illuminated in front of us, but as we got closer to the boulder, the blue hour of day emerged. We were able to start making out forms off to the sides, and the sky was slowly transitioning in color.

Ten minutes before we stopped, I looked out of the passenger-side window, and to my surprise noticed clouds sitting in the canyon we were about to photograph. I couldn't see them well through the trees, but after we stopped the car and climbed on top of our boulder, we saw that a vast sea of low-hanging clouds blanketed the entire canyon below us. Needless to say, we were excited and marveled at the beauty of this scene. We were literally on top of the clouds. From where we stood, the sun had no impedance once it rose above the visual horizon. This was going to be a good morning.

Right place, right time? Sure, but without first doing our due diligence by scouting, we might have missed a golden opportunity to make some very interesting shots. We could have driven by this location, around the next corner, and never seen those clouds hanging low in the canyon. If we had not scouted the day before, we probably would not have even imagined a shot of the canyon itself. Scouting led us to a beautiful location and an exciting natural event that we would have hated to miss in these Mexican mountains. ■

I first became familiar with Matt by listening to one of his popular "Depth of Field" podcast interviews, a series in which he hosts periodic discussions about photography and storytelling with other members of the industry. Come to find out, Matt's a heck of a storyteller himself.

Like many photographers, his passion for photography began when he was young, but it took a backseat to other occupations (including being a mounted ranger) early on in his professional life. After moving to India with his wife to start a trekking and tour operation, which coincided with the emergence of dSLR technology, Matt re-engaged with his passion for photography, and since then it has taken him all around the world.

Based in Malaysia now, Matt works with a variety of NGOs, as both a photographer and a consultant, to help communicate their mission. He also leads cultural photography tours with other storytellers, including Ami Vitale, David duChemin, Karl Grobl, and Gavin Gough. His advocacy for storytelling is well recognized among the photography community at large.

Q **Who were your influences in how the camera allows you to tell story?**

A Three names come to mind. Dorothea Lange has always been a huge influence. I think her images are so emotional. Probably the most famous shot of hers is the lady sitting there with her three kids, the Migrant Mother. There's just a blank stare on that woman's face, and yet there's strength, like, "I'm going to keep this family together."

Then later, of course, Steve McCurry, like most people who like travel type stuff. Steve is one of our living legends. Finally, one of my current mentors and friends is Ami Vitale. She's also an amazing storyteller.

Q **Is there a particular moment that truly emphasized the role you play as a photographic storyteller?**

A The first picture I remember taking that I thought told a story was a photo of my dad taken when I was a kid. I had a little plastic camera, a plastic gray box of some sort. I remember using that camera with black-and-white film. I took a picture of my dad sitting in his armchair in the living room, reading his newspaper.

The lighting was coming in through the window, and there was no flash.

Even as a kid, I realized, "That's my dad. I have captured my dad. That is *him*." There was something about that picture that just really told a story. I also realized that photos could tell stories when my mom would pull out boxes of family photos and look at them with me, recalling the moments the images were made.

Some of the images that I was actually a part of didn't resonate with me as much as those photographs that I didn't have any memory of, such as pictures of my mother when she was a child. With these images, it was easier to see a story unfolding within the frame. My imagination went crazy playing out the story of my mother in the images.

Professionally speaking, the first time that it actually felt like I was doing something with my images was during the aftermath of the 2005 Kashmir earthquake. I was at the site of the quake, and it was an opportunity to be able to deliver images to both media outlets, such as the BBC, *and* to a lot of NGOs that needed them for their fund-raising and organizing efforts for disaster relief. That was an important time to realize how powerful my images were *for* other people.

Q Story comprises characters, settings, and relationships. What part are you most interested in photographing?

A I don't think I have one sole favorite. I do have certain things I'm better at, though, and this has influenced or determined how much emphasis I place on one type of image over another. I fall back into what I do well, which is the environmental portrait. However, along the way, I noticed I wasn't shooting a lot of details. So, I find now that I'm actually pretty heavy into shooting detail shots.

When I first started taking pictures, it was always just portraits of people. Like what so many young photographers produce, they ended up becoming almost mug shots—real tight portraits of people with amazing eyes and wrinkles on their faces.

At some point, I had a photographer-turned-camera-rep review my images, and one thing he noticed about them that made a huge difference was that I was using a 70–200mm lens for all the portraits. He told me, "This could be an Asian girl in L.A., and this could be an Indian in New York. Nothing about these images except for some of the headdresses gives me a sense of the environment and context."

That was like a light going on in my head. The best thing that a photographer can be is teachable, and I've always thought of myself as such.

Q Do you compile a shot list for your stories?

A I generate a shot list for most every assignment. I'm too ADD not to have one.

I have a very broad idea of about six basic shots that I need, and then I fill it in throughout the story. The details have a lot to do with what I'm uncovering about the story and what is important to it. When I put a story together, I'll have a shot at the beginning that is like the cover image. I call it the hook shot, and it's the image that engages an audience as they flip through the publication or Web page.

It could be a big vista; it could be an iconic symbol of something; it could be just an amazing photograph that is helping depict the story. There's no visual description of what the hook shot is itself. It's simply a shot that grabs the viewer and says, "This is going to be an interesting story."

In the story's layout, that's the first thing that I do. I don't necessarily go out and specifically look for a hook shot. I will look at my images when it's all over, and I might come across one that is really powerful and contains a lot of what the story is about. I'll use that edit as the very first image with the title of the essay.

Then, I'll include some sort of establishing shot. This shot tells the reader what's going to take place, what the story is about. It is often an encompassing vista type of shot, but it doesn't have to be. It's usually near the beginning of the story, and it can even be the hook shot.

I'm also going to include medium shots, where the viewer gets more details about what's happening as the story starts to unfurl and the characters start to develop. There's going to be a detail shot, and it does exactly what it says—give details. It's like an author in a book describing the detail or texture of the environment. I'll include a portrait of some sort. It may be an environmental portrait or something more tightly composed.

I also have to include a gesture shot. It's a shot that captures an interaction between two people, or a person and an object. For example, people hugging, a person crying and someone consoling her, an Egyptian camel trader exchanging money with another man. The gesture shot shows life. It shows interaction. It brings humanity to the story.

Then, there is simply what I would call the closure shot. It's the guy walking into the sunset, for example. It provides some sort of resolution. It puts the story to bed.

This is the outline of the story, if you will. Once it's created, I'll produce a shot list for the meat of the story.

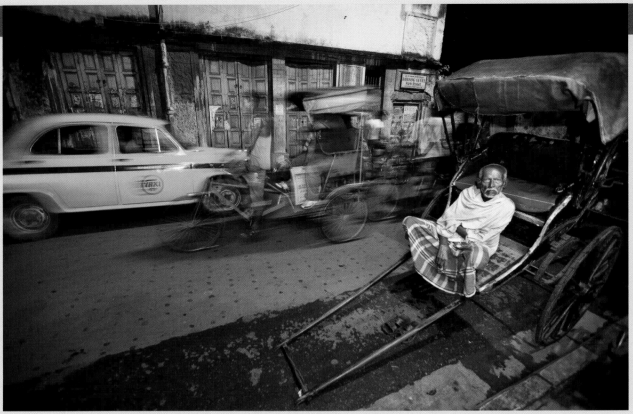

The politicians of Kolkata have made the city's pull rickshaws illegal in favor of taxis and bicycle rickshaws. Yet the pullers union and the pullers themselves defy the ban by plying the streets every day. I feel this shot tells the whole story in a single image.

Q **You travel quite a bit for work in different countries. How do you make sure that you're previsualizing enough to constantly work in different cultures?**

A Sometimes you can't. We've got to be honest and say that sometimes you have to make do. Sometimes, you don't get the images that you want. I often have to go back and shoot again. I try never to shoot a full story in one afternoon. That's really doing the story a disservice.

Sometimes, the actual content of the story can sidetrack your initial work. You can be out shooting and suddenly realize you've been concentrating on one bicycle maker when the story is about transportation as a whole. You have to keep going back to your brief in order to stay focused.

I recently created a story centered on durian, the fruit. I'd look at my dailies, and I'd go through my images and determine if something was good or not. I'd see a lot of interesting close-ups of the fruit, but I was missing people making faces at the fruit's odor, for example. So, the next day I'd go out and I'd get people eating or smelling durian. I'd come back and look at that, and I'd say, "OK, that's good, that's good, uh-huh, OK." I'd look at my shot list and add something to it. I'd go out the next morning or that afternoon and shoot some more.

If you have a brief, it keeps you on track of what's important. It is true, sometimes, that the story develops as you shoot it. However, I think you have to be careful, because this is where we can get off track. If we know the story, then we shoot the story. If we're shooting and the story is evolving, then it may go anywhere, and when you're done, you may not have the right pictures. You may realize there's no continuity to your images.

Q **You've really increased your efforts on the multimedia approach to telling a story. How does this differ from other ways of using photography for storytelling?**

A For me, there are at least three ways to tell a story using photography. One is with a single image, and I think that's really hard to do. It's 1/1000th of a second of life, and so it's essentially 1/1000th second of a story. However, it nevertheless encompasses a depth of what you're looking at in regard to story.

Another way to tell story is through the photo essay. An essay may include anywhere from 5 to 25 images. I think the better ones are told with fewer images. You can tell a complete essay with 10 images. You can create a plot arc of an individual where you start with an introduction of where you are and who this person is. Then, you introduce the characters and build intimacy with them. You bring in some sort of conflict, and it builds until it is resolved in some way. The story comes back out the other end of the arc with resolution and "riding off into the sunset."

At this time, I'm primarily using only stills and audio, but others I know, like Gary Chapman, are using much more video, and I'm going in that direction. It's important to remember, though, that multimedia comes with a learning curve, and you have to learn how to proficiently build a workflow that includes handling both stills, audio, and video.

Q **You've had a chance to formally converse with several prominent and emerging shooters working around the world. What makes them strong photographers and visual storytellers?**

A That's a tough question. I think I was drawn to interviewing them because they are all good at telling the story. When I look at Ami Vitale's work, David duChemin's images, and Michael Clark's, I don't even need to read the text. In fact, I often feel sorry for the writers who are helping, because I never read their stuff.

I look at the photos, and I know the story. I think that's what sets them apart from others. There's emotion in their images, especially in Ami's work. When you look at her images, you just want to cry sometimes.

Q **What is one tool you've found extremely useful in telling visual stories?**

A A good flash set on rear-curtain sync. I use it a lot. It gives the image a lot of motion and yet allows for a sharp moment at the end.

Q **If you could give one piece of advice to those starting out, what would it be?**

A My biggest advice is to slow down. If you don't, you miss the story, and you miss the photo. You also miss a chance to make friends. The ability to make friends, taking time to get the right image, and understanding the story—put those three together, and you're going to have a killer story. ∎

To see Matt Brandon's work or listen to his podcast, Depth of Field, visit his Web site: www.thedigitaltrekker.com.

Storytelling Workflow

Far more than a mere digital buzzword, visual storytelling workflow has existed for a very long time. It has evolved over the years and will continue to change and meet the needs of contemporary storytellers into the future. Workflow is much more than using a card reader and launching Adobe Photoshop Lightroom.

A workflow is a process, and if the process is finely tuned and approached with intention, it will be a productive one. Consider storytelling workflow the nuts and bolts of telling a story. It is what keeps every part of the storytelling process together. From research to shooting, to editing, exporting, and submitting, a good workflow can seamlessly pull together what can be an arduous, multifaceted task.

Fall colors in the Guadalupe Mountains—an image that is the result of a workflow that took into consideration much more than digital processing.
Canon 5D, 28mm, 1/200 sec., f/2.8, ISO 200

Our goal as visual communicators is to tell interesting story, and a well-managed process ensures that we accomplish it effectively and efficiently. If this all sounds a little too "big system" to you, don't worry. If you interviewed ten great photographers, they'd all have a somewhat different storytelling workflow. A useful workflow is flexible enough for the story to breathe from time to time but structured enough to help you complete the task at hand.

WHERE DOES WORKFLOW BEGIN?

In truth, this entire book is about workflow. We tend to restrict this term only to the computerized component of our work as photographers, but everything we do to tell a story with our images is part of a workflow—*our* workflow. With all the buzz these days about having a digital workflow, I would hate to see the parts of our craft that lead up to the computer neglected. Whatever benefits there are to having a digital editing workflow, surely they should aid the entire process, not just the endgame.

The storytelling workflow begins with the nondigital component (I know, we're all pretty much shooting with *digital* cameras these days, but the non-digital component I'm talking about includes what you *do* with the camera). The moment you take that idea that has been percolating and start conducting some initial investigation as to how you might be able to make a story out of it is the first step you make in your workflow. You jot it down in your notes, do a little digging around for information, decide there's something interesting about this story, and sink your teeth into the process. You, my friend, just initiated your storytelling workflow.

Remember that outline I mentioned a couple chapters ago? Here's a good opportunity to start creating one or expanding on what you already have. Really start fleshing out the details as you devote a few nights, days, weeks, or months to researching your topic, getting in touch with primary sources, previsualizing images, and so on. Schedule times to meet with sources or story characters, travel to locations, and handle any other logistical matters you need to be able to tell the story.

Then choose your equipment. If you need to rent a lens or two, or borrow an extra camera body, make it so. Prepare your gear (you'll find some great resources out there for setting your camera up for maximum production) and conduct your shoot or shoots.

The next steps engage the digital side of your workflow process. Import, organize, edit, select, and process your images. Export them according to the

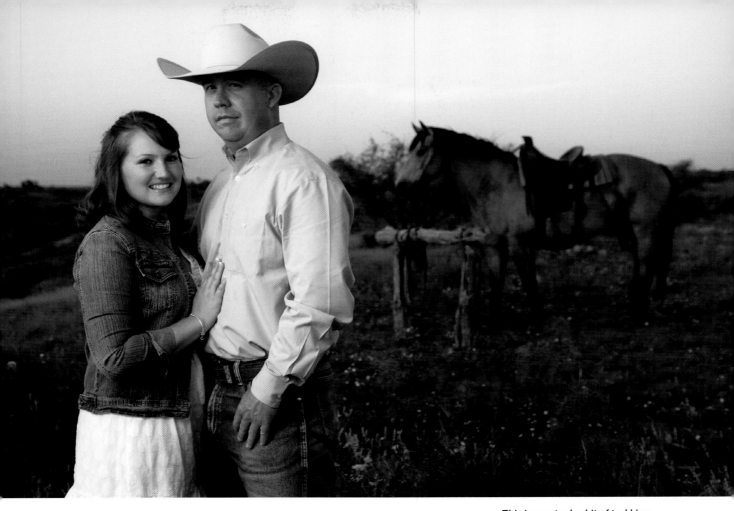

outlet you plan to use in order to exhibit your story. Digital side or not, this is *all* part of a workflow, and it behooves any visual storyteller to have one.

Plenty of photographers and photography educators will be happy to give you a certain set of steps for a successful workflow, and for the most part, it's great advice. However, it's tough to be prescriptive about workflow, especially when each story you tell might necessitate a variation on your regular process. While this particular point deals more with the editing and archiving end of your process, what needs to be said before anything else is simply: Implement a workflow that works for you.

Some of you might have a well-tuned workflow; others of you might have one that works, even though you're not really aware of having one. Then there are those that are fairly slack about the way they go about their storytelling process, and it's not panning out for them (no snarky remarks allowed here).

> The more organized you are the entire way through the storytelling process, the less strain you put on yourself and the story in the long run.

Regardless of where you're at in terms of establishing a photographic workflow, putting one together that is right for you is the crucial part. Some photographers have workflows that are heavily focused on the computer end. They do their research, they do the shoot, but they are most anal about their workflow when it comes to the computer. I know others who are the exact opposite—they labor hard and are excited about their research and the process of the shoot and less exuberant when it comes to the computer work.

However, they all have a workflow of some sort, and that's a big part of their success as storytellers. I believe photographers who pay about the same level of attention to both sides of the workflow process would say the same.

STAYING ORGANIZED: THE STORY DEPENDS ON IT

Have you ever lost your images? What about showing up to a photo shoot and realizing you didn't actually pack a camera (I've heard tell of it happening)? Have you ever permanently deleted an e-mail that contained your main subject's contact information, forcing you to call your editor in a panic for a phone number or address? We've all done one of these things or made one of a multitude of other embarrassing mistakes, and there's no doubt, we'll make a few more. That's part of the job, but a part that having a storytelling workflow can minimize.

One of the reasons you want to implement a workflow is to stay organized. It's actually the most important part of a workflow. The more organized you are the entire way through the storytelling process, the less strain you put on yourself and the story in the long run.

Asset Management

There's a simple way to define asset management: knowing where your stuff is. Well, I'm about to go into a little more detail, but that's the gist of it. Visual storytellers accumulate *things*. Be it a book, a strobe, a couple hard drives, a few thousand images, or a collection of stories produced over many years behind the camera, we're constantly inputting in an effort to output. Organization keeps all of those elements we obtain in their place, and because of that, we're able to quickly find a tool or an image that will help us be more productive.

As an example, when I first migrated over to digital, I had no sense of organizing my images. At the time, I was just simply shooting, and plopping

the images on my computer haphazardly. I imported them to my computer's default Pictures folder. I did not categorize them, tag them with keywords, or even embed any copyright information.

One day, I realized I was bogged down in unorganized files when I had to put together a story that spanned several areas of my film and digital stock images. It quickly became a digital nightmare searching for all the images without any simple way to pull up the ones I needed. It's a good thing I put them in dated folders, otherwise, I would still be searching for some of those images years later. That episode proved to me the significance of being able to keep up with my assets (particularly when those assets were helping me make a living).

Nowadays, I'm as particular about storing my digital files as anyone—they're organized by year, topic, name, and finally by actual date. I create Adobe Lightroom catalogs for each year, and for most of the stories that I'm assigned or create. Given that my images can originate from multiple shoots and exist in several catalogs and on multiple hard drives (even on the cloud), I have no choice but to be organized. And neither do you, if photography is an important part of your life or is even your career.

Wildlife photography is only one example of images pertaining to a particular story that can stretch over many years of shooting encompassing many folders, digital catalogs, and even multiple hard drives, computers, and in some cases, filing cabinets full of film negatives and slides.

Canon 5D Mk II, 400mm, 1/2500 sec., f/5.6, ISO 100

Staying organized increases your efficiency in pulling up images for story callouts or wants lists, particularly if you have to dig back several years for the images, such as I did for this one taken near Sonora, Texas.

Canon 5D, 24mm, .3 sec., f/22, ISO 100

BACK UP, BACK UP, BACK UP While I'm on the subject of organizing digital files, it's a good time to emphasize another essential habit: making backups of your work. Just do it. I've literally seen grown men and women cry over losing single images. Imagine if you lost a terabyte's worth—I don't even want to think about it.

Your images have everything to do with story, and making sure you don't lose them should be a priority for all photographers, storytellers or not. Hard drives die, buildings burn down, and someday you're going to need at least one of your backups. It's a good rule of thumb to maintain your originals plus two more copies of your work, ideally in different locations and on different computers or backup devices. That's your story's insurance.

Efficiency

Managing your photographic assets allows you to work more efficiently. Need a light stand? It's in the blue stand bag in the back of the vehicle. Need a gel for that light? It's in the second transparent inside pocket of your camera backpack. Your medium-sized soft box? In the black bag next to the blue one in your vehicle.

Soon you're engaging the subject, not your gear. Knowing where your stuff is will help you work quickly and efficiently on location, leaving you more time to concentrate on story.

The same can be said for working on the image files later. Archive organization provides you with a streamlined process of accessing and working with your photos. In building a story, efficiency is only enhanced when you use a workflow software application, such as Adobe's Lightroom or Apple's Aperture.

I'm a Lightroom man myself, but remember what I said about implementing a workflow that is useful for you and your style? You can use Adobe Bridge or the proprietary Canon or Nikon software, and as long as you are employing it in a way that works for you and increases your efficiency along the way—less digging around *for* images and more actual work *with* them—it will help you tell the stories you want to tell.

Keeping your images organized is also helpful when you get an e-mail from an editor or designer saying she needs a certain photograph for a story her publication is running on, say, ferns. (If you start working for publications, you'll find that they're often in a pinch and need an image fast.) Assuming you've shot ferns before, you'll know exactly where to go, and even if you're out of town, you can use remote tools to efficiently access your organized archive of images to send the designer's way.

Professionalism

Being organized, managing your assets appropriately, working efficiently—these characteristics would describe a professional in just about any occupation in the world, and when you're producing visual story, it's no different. Especially if you want to make a living from your craft, it's worth considering how being seen as a professional helps you out as a storyteller.

Think about shooting portraits for your story. When you know exactly where that light stand, gel, and soft box are, you look organized and efficient. Your subject will perceive you positively when he sees you are prepared,

On assignment, it pays to come prepared, work efficiently, and be respectful. Being disorganized takes up your subject's precious time, whereas being professional creates a good impression of you that might just get around.

Canon 5D Mk II, 65mm, 1/25 sec., f/4, ISO 400

Street photography necessitates being organized and prepared with the essential gear for working quickly around your subject, such as this interactive Dutch baker in an organic market in Amsterdam.

Canon 5D Mk II, 50mm, 1/500 sec., f/2, ISO 100

working hard, and not wasting *his* time. If he's expected to be ready to go at the 6:30 a.m. sunrise shoot, then you'd better be as well.

A nice side benefit is that creating a good impression might just give you a rapport that helps you more deeply engage with your subject. You'll also have more time with him, which might reveal a new facet of the story you're telling about or around him.

Being organized also helps you see yourself as a professional. Building organization into your routine, although it may seem laborious and taxing at first, is a good discipline that will become second nature. This doesn't mean being a stiff, inflexible prude about process. Be flexible, because your story certainly is. But be as organized as possible so you are ready the next time you have to rush out of the house on assignment or grab a fleeting shot of a Dutch baker

selling her wares at market as you walk down the street. Being prepared is a confidence builder—for you and those involved in your story.

Having your ducks in a row in the form of an organized workflow frees you up to be creative, to pay real attention to the story and its characters, settings, and all of the visual (and nonvisual) information surrounding it.

EDITING FOR STORY

OK, so, you've planned, prepared, packed up all the necessary gear, and traveled to your location. You spent the entire afternoon and evening shooting for your story on coastal birds. You load everything up, get back to the hotel, download your images on your computer, and back them up to your external hard drive system. You do this for three days in a row, hoping you've adequately covered the story you had in mind. After you get back home, though, your work is not finished. You still have the whole digital side of your workflow to complete before the story is ready for distribution.

If you did your research, you already have an idea of what the story is going to look like. Again, even if you are shooting photojournalistically, you still cannot avoid previsualizing some images that contribute to the subject you're covering. The shoot itself surely helped you gain better insight and form a more nuanced idea of how the story is going to play out visually for the audience. When you have the story's entire take (even just a portion of it) in front of you, that's when you start seeing it all come together.

This is when you begin to edit.

Just so I don't confuse anyone or myself, when I refer to editing for story, I mean selecting your highest-quality and best-suited images to stitch together a visual narrative. Or if you're after (or were assigned to shoot) only one image, then from that take, you'll select the one that conveys the essence of the story contained within its frame. In both cases, keeping the story you want to tell in the front of your mind is of utmost importance when editing.

On the surface, there are two ways to edit your images: seeking out just the highlights of the shooting experience, and taking it from the top. The former is not necessarily a rushed way of pulling a visual story together after the shoot, but it is usually more expeditious than the latter. Seeking out the highlights allows you to go directly to the image or images that seemed successful during the shoot. This approach is useful for shooting quick stories on assignment, and it really exercises your vision and decision-making skills related to shooting and selecting the most important or interesting aspects of a story.

When I refer to editing for story, I mean selecting your highest-quality and best-suited images to stitch together a visual narrative.

A great egret wades among the shallows of Mustang Island State Park near Port Aransas, Texas (above). Bird photography may result in thousands of images over the course of only a few days, emphasizing the need for an editing workflow back in the office.

Canon 5D, 200mm, 1/1250 sec., f/2.8, ISO 50

On a recent trip to Amsterdam, I used some of the downtime to edit quickly through the images I made each day, pulling a few along the way that I thought gave a good feel for the biking culture of the city (right).

Canon 5D Mk II, 50mm, 1/2000 sec., f/1.2, ISO 100

The second approach is much more time consuming, deliberate, and focused. Not to say there's no focus in seeking out the highlights of a shoot, but I've sometimes looked back at one of those quickly chosen images and found one or two others that might have been a better choice. Editing your images from the beginning (or at least from the first photograph to the last in a particular story's archive) affords you the time to discern why one image serves the story better than the other. Larger stories that involve multiple shoots and a relatively long time period grant us this editing opportunity.

The opportunity to revisit all of your images from a story is a blessing and at the same time a curse. Yes, you're able to spend more time with them, become more familiar with what you shot, and develop a stronger relationship with the story itself. Nonetheless, it's a daunting task. Any shoot that lasts an entire day or more can produce thousands of images toward a single story. Editing a week's worth of shoots can take nearly a week in itself. However, tackle the heap you must, and it pays to have a process before diving in.

1. **The once-over:** Before you start picking and choosing images, take a big-picture glance at the entirety of your story's take. This settles you into the work ahead of you. It also opens the door to images that you may have not looked at for several days or over the course of several shoots. The once-over also slows you down deliberately, so you're not carrying that "seeking highlights" mentality into the workflow with you.

 I use this point in the editing process to also flag images as a) trash and b) ones to consider. This narrows the field down when I start to drag the fine-tooth comb over the images. Those slotted for deletion, those that are out of focus—particularly eyes or subjects I know I wanted tack-sharp— are out of there unless they speak to me more powerfully than my urge to take them out of the mix.

2. **Sort by story:** If it helps, collect all of your images for one story together. As I said earlier, some stories may be spread over several days, across topics, and even across catalogs. Programs like Lightroom or Aperture make this simpler with "smart" grouping functions, but don't hesitate to simply create a copy of all of the images, group them in their own filing system, and work from there.

 Last but not least, you can always jot down a few notes on where to look later in your archive for contributory images, and hit them one at a time, saving you the hassle of copying, pasting, and then throwing images away after you're finished. When grouping, the name of the game is maintaining your originals and nondestructively editing them along the way.

Shooting lightning often requires you to take more than a quick glance at your images to find *the* shot. Going through them all requires time, but you might notice a unique-looking bolt in an image you didn't even know you captured.

Canon 5D Mk II, 200mm, 1/10 sec., f/3.2, ISO 100

3. **Grouping ideas and concepts:** Once you have a good sense of where the shooting took you, start generating groups of images that resemble the different parts of the story you're telling. Consider your research, your outline, and your shot list. Select groups of images that are contenders for important concepts you want to cover in the story, and flag them accordingly.

I generally use the color labels in Lightroom for this part of the process. If the areas of the story are more numerous than the labels provided, I'll use more specific collections to group images. If I'm working on a story about the edges of the Chihuahuan desert in far West Texas, I might have a label and collection for topics like State and National Parks, People, Vegetation, Wildlife, or Dry/Wet, Art, Culture, Danger, Life and Death.

This is also a good time to revisit the thematic structure under which your story originated during research, developed during shooting, and possibly changed after you gave the images as a whole a look. You might find that what you thought was a dark, weary, desperate story on an individual suffering from cancer developed over a few weeks into one of hope, enlightenment, and faith. If you're on assignment, though, it's a good idea to check in with your art director or editor to see whether he's OK with your new tack.

Using Lightroom's collections function to group a story on classic convertibles by vehicle model was a nice way to keep the story organized, and it gave me quick access to the images without having to dig through the features section of my archive.

4. **Take notes (again?):** Yes, again. Here's a rule to live by: Never be far from something on which to make a note or two, even if it's just a napkin. I bury this step in the middle of this list because in reality, you will probably find taking notes handy the entire way through. While doing a once-over of your images, note the topics and concepts you want to later group images by. During the grouping process, note the types of images you see that really speak to

you and pull the story together, and the areas that need improving or are nonexistent. The latter might be where note taking comes in handiest. Filling the holes in your story is an essential part of trying to build completeness. If the story you're telling allows you the time, don't shirk this part of the process. Take note, and follow up on areas you are missing.

5. **Make the selection:** After you've grouped your images by topic or concept, it's now time to filter them based on how well each will contribute to the story. You've already gotten rid of the technical mishaps, portraits with closed eyes (assuming you were going for open eyes), images where your lights didn't trigger, and now you're looking at the cream of the crop. From this point on, you're only interested in images that help tell your story.

There is no magical number of photographs to select from each grouping. The best choice is, however many it takes. Try to focus on the images themselves instead. If you're like me, you probably shot several images that are basically the same, with slight variations. It might be a tiny difference in how someone's mouth looks in an environmental portrait, or the position of a leaf that is blowing in the wind. Be very picky, study the images for some time if needed, and make the cut. Don't send the rejections to the trash, but when you're sure about your choice, move on to the next topic, position, framing, and so on.

During the once-over and as I start grouping, I begin rating images. In Adobe Lightroom, you're

Out of 144 images, only this one completely grabs my attention for a story centered on spring color. As small as it may seem, the primary difference between this and others is the fact that parts of all three flowers' pistils are in focus.

Canon 5D, 95mm with extension tubes, 1/320 sec., f/2.8, ISO 100

given the option to rate images with a star and color system. As mentioned, I use the color labels to group by parts of the story, leaving me the stars to determine which images in a particular group are worthy of including in the story. To be honest, I only use the five-star rating. I'm an "it's all the way or nothing" type of image editor.

Only during this more stringent phase of the process do I back off the ratings. I might have rated seven portraits of one character with five stars earlier, knowing that I only need one. At this phase, I will cull the seven down to one by taking a closer look at each and considering story and story alone. But unless the other six portraits aren't nearly as good as I thought, I will not unrate them, but I will lower their rating—four stars. I want my workflow to be simple, so I can find my select images quickly. If I only use two different star ratings to make that happen, it enhances my workflow efficiency.

The final take for a story I shot on a local nature trail. At this point, I begin to identify areas that need improvement, what's missing, and even where this story may go in the future.

It's a good idea to quickly edit multiday shoots before you close out the day. You'll find gems of the day, such as this one on the North Sea in Arbroath, Scotland, and identify areas you want to engage with in the following days.

Canon 5D Mk II, 108mm, 1/200 sec., f/5.6, ISO 100

6. **The final once-over (maybe):** Once you've culled each group or collection down to *the* images that make the cut for your story, it's only right that they get another critical pass over. You wouldn't finish writing a book without reading it at least once to see if any mistakes jump out at you, right? Right. Then conduct another once-over with your final selection of images. Place them in their own folder, and instead of just a quick glance, spend time with your story's final images.

Make sure your decisions were the right ones. One thing to look for is consistency. Not that the images need to look similar (in most cases you won't want that), but check that they all contribute to your story, playing a role in helping unfold the visual narrative.

It might help to have another astute pair of eyes look at your selections. You've been married to this story for a little while and may be losing perspective. Sometimes having another individual take a look and simply tell you if the images work together or not can benefit the story. This is what a publication's photo editor or art director will do, and the thicker your skin while hearing constructive criticism, the more you'll learn from what they're saying to you.

What if you or someone else notices something that just doesn't work? You either look deeper at the other images you have for the story, or you have to go out and get something that does work. Simple as that—you've made it this far with the story, don't give up if one or two of the images don't gel at the end. Do something about it.

This basic series of steps is the foundation for editing story. Customize it to your liking. We all use different applications, filing systems, and so on, and we all have different perspectives on workflow. But starting with a root process is advisable, particularly when pulling together a story with multiple facets of interest.

EDIT AS YOU GO Done shooting for the day? Ready to call it a night before the three days you have left to cover your story? Not so fast. If you're on a multiday shoot, it is a good idea to edit as you go. Do a quick once-over of the day's production, and flag a few for a closer look later. This will help you notice any obvious holes you need to fill along the way and ease the editing burden later.

You might also want to export those you flag and keep them with you on a smart phone or tablet for deeper consideration.

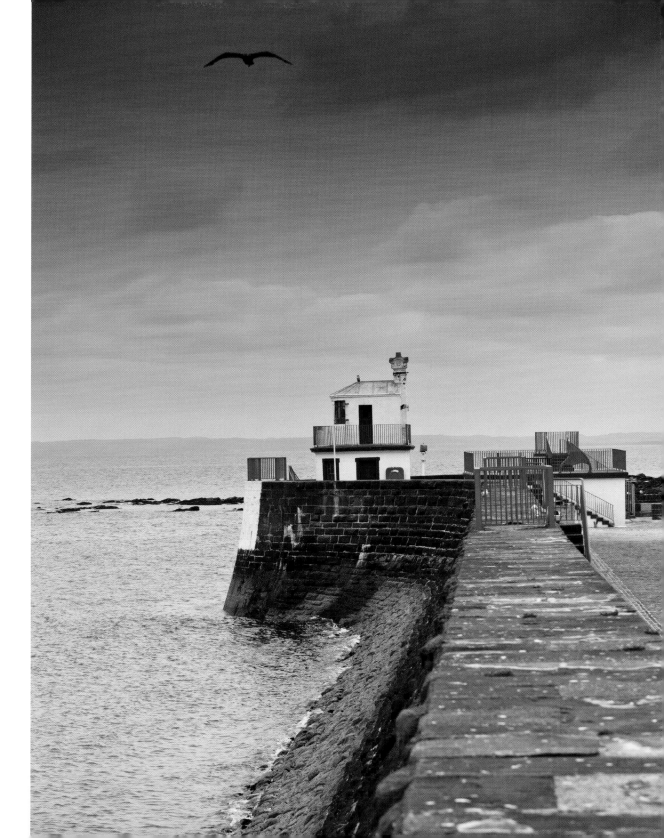

Something I encourage implementing in your editing workflow, the five-star commitment is just that: editing for only the best images you have to tell a story. When we start out as visual storytellers, if given the option, we rate each and every one of our images along a worst to best five-point scale. Several images get five stars, while a few more may be fours, and the bulk are rated with threes, twos, ones, and finally zeros. That's why software makers gave us *five* stars to work with, correct?

To start building better stories, approach your entire process with a greater expectation of quality. Do not rate every image you make. Rather, when you go through them one by one, only rate those that you know might make it to the final selection. Rate them with only a five (or the maximum your software provides). The five-star rating represents *the* best images you made. Questioning the quality of one you are thinking about rating a five? An audience member or an editor will likely question the same thing. If you have doubts, it's probably not a powerful enough image to make it through to the final edit.

This does not diminish your abilities. Rather, it pushes you, raising your expectations of your images, and it makes you a better editor. When you get to the final edits, you can do whatever you want with the several top-rated images. Rate some lower, label them with a color noting that they're nice shots but not vital to the story, or remove all ratings and labels and throw them back to the pile that you might end up removing from your archives. Be strict about your edits, and you'll see your editing skills become more acute and efficient.

If you're just starting out, this is a strenuous task. You might be emotionally tied to the images you made. Learn from the images themselves. Compare the ones that really stand out to you to those whose quality is more iffy. If you're a seasoned photographer, if you're anything like me, you have a lot of cleanup to do. Go back through your archives. Spend 30 minutes each day for a couple weeks (or set your own timeline) solely on determining which images are worth keeping around. Save the ones you've used in stories previously, but go back through years' worth of other images and determine which truly make the cut. This is a practice especially suited to stock images or those that you know will contribute to a story that has more life (something abstract and ever-present, such as weather).

This "exercise" is more of an everyday practice. Each storyteller develops his own workflow, but this type of discipline will strengthen your editing eye and increase your ability to tell a better story. Use the rating system as you see fit, but know that when you edit for only five-star images, your stories are going to be far more compelling. ■

Thematic Discovery

During the editing phase of your workflow, stay aware of two things: images that relate to the larger thematic structure you planned for and were shooting under *and* the emergence of new themes that your images reflect. This stage may take place at any time during the editing process; however, it may be more observable during the grouping and selection stages.

Editing becomes more structured and guided when you look for images that address the themes you initially developed your story around or picked up on during your research. Images that are visually powerful but do not relate to the thrust of the story may get set aside. For instance, an image that includes intriguing artificial lighting, leading composition, and directive depth of field but doesn't further the story may not make the cut, despite its technical qualities. If you did your "homework" up to the point of the shooting, making sure your images are on thematic track should be fairly easy.

A shot of a female lesser prairie chicken perched high for her admirers, all vying for her attention, to see. Sounds like a thematic storyline I've heard, read, and viewed elsewhere.

Canon 5D Mk II, 500mm with 1.4 extender, 1/800 sec., f/5.6, ISO 1000

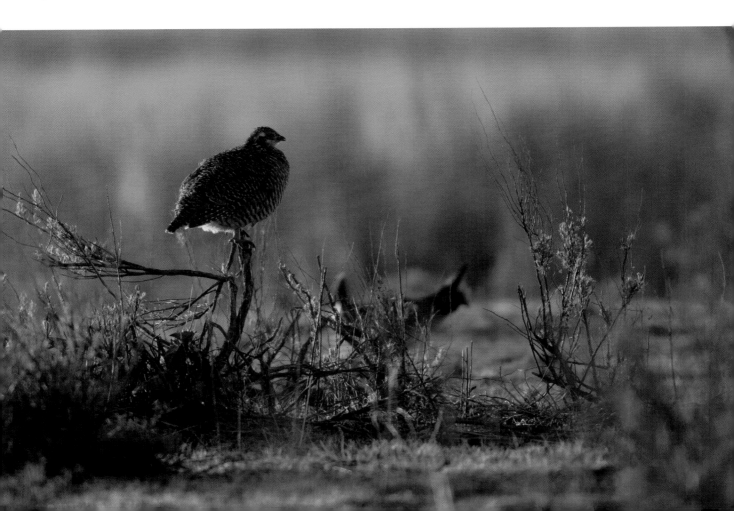

Probably more complicated during the editing phase is acknowledging the shifting of themes and the connections your images create with each other, resulting in newer themes you didn't anticipate. If this occurs, it's most likely around singular images that start to say something beyond your initial intentions. For example, an image of a female prairie chicken I shot several years ago was intended to exhibit the birds' fleeting population. The image was made in pursuit of a theme about a struggling species, but it also reveals a deeper message about relationships and to some degree love. Picking up on such subtleties in your images just might be the spark you need to generate a new story, as we'll discuss later.

THE PHOTO ESSAY

Single images are useful, but they rarely succeed at comprising an entire story. They definitely have story in them—parts of it—leaving us either more interested or turned off by the lone frame. The photo essay has long been recognized as the optimum way of telling a visual story. However, putting a carefully selected number of interrelated images together in essay format is no easier than connecting sentences in an order that tells a good yarn. The photo essay's job is to create a visual journey through a story, to convey feelings, behavior, and context, just as a single image creates the same for one frame.

There is no hard and fast rule about how many images make a photo essay. It would be nice if you had an exact number to go by, but the photo essay is made up of however many images tell your story in the most powerful way. This could be 5 or it could be 15.

I've heard many photographers say the fewer the better. This statement is not meant to diminish the value of the photo essay but to instill a sense of focus and intentional selection. Too few images may not paint a full picture of the story, while too many may water it down and lull your viewers into complacency.

Creating a Shot List

Putting together a photo essay is at times tedious, but being prepared and maintaining a flexible sense of organization through your research, shooting, and editing are especially helpful here. The photo essay embraces the entire storytelling workflow. Along with the front-end research, developing

a shot list will come in handy for both shooting the story and editing for it later. The shot list is what it says: a list of images you plan to make that, based on your research and previsualization, will work together to cover your narrative. This list is like a cheat sheet you keep on hand at all times during the development of a story to pinpoint the exact areas you need to concentrate on.

The shot list can be specific and descriptive, or general, listing only the topical areas you need to shoot. Whichever way you feel comfortable going, keep in mind the categories of images I referenced in Chapter 4: Describe the content of an establishing shot or shots, medium shots, and detail, close-up shots.

For example, a shot list for a photo essay on, say, the hometown return of a platinum status band that started out as local heroes might include a wide shot from behind the band looking over a crowd of concertgoers as an establishing shot, shots of the band preparing for the sound check, and earlier interactions with fans during a signing session as medium shots, and close-ups and detail shots, including a tight shot of hands picking the strings of a guitar, and a frame full of fans' raised arms and hands. The shot list is essentially an extension of your research and previsualization, so use it like you would them: as guidance along the path the story takes you down.

THINK VARIETY **When developing your shot list, notice whether your ideas are very similar in regard to angle and perspective; if so, come up with some others. The last thing you want is to start editing and realize that you primarily focused on establishing images. Your list should include a variety of image types, as well as several ways to photograph a single idea or subject.**

Keep this in mind as well when you start to edit and select your images for the essay. Compiling a photo essay with different angles and types of images gives your story dynamic variation. It strengthens your storytelling abilities, and viewers will appreciate the depth your story has compared to one composed mostly of detail images.

Start Strong

Much of the work in compiling a photo essay occurs during the editing phase. This is not to say that researching, planning, and shooting are not also a lot of work, but editing for the photo essay forces you to weed out all but *the* most

The photo essay is made up of however many images tell your story in the most powerful way.

telling images for the story. Now the ordering of the images becomes a big responsibility. If the photo essay was shot for a publication, the photo editor or art director will often work with the photographer or do the work herself. Otherwise, we're on our own.

One rule of thumb with a photo essay is to start strong. After editing your conceptual groups of images, you may have a solid ten that say everything you want to say about the particular story. Choose one that will help engage a viewer and encourage her to continue with the essay. This might be a wonderfully lit, dynamic establishing shot or a carefully selected medium or detail shot. For example, an environmental portrait of a carpenter bent over his workbench, or perhaps a tightly composed shot of his hands at work, may serve as leading images in an essay on a wooden boat builder.

Regardless of the type of image, this photograph will either suggest enough of the story to attract further viewing or leave enough of the story mysterious that the viewer's curiosity will lead her through to the next image. This image must be visually strong and quickly relatable to the rest of the images included in the essay.

The standing gate to the Presidio San Saba serves as a contextual establishing shot for a photo essay on a Texas Archeological Society field school excavation in Menard, Texas.

Canon 5D, 24mm, 1/40 sec., f/22, ISO 100

A characteristic detail of an archeological dig against a backdrop of field school participants.

Canon 5D, 24mm, 1/125 sec., f/4, ISO 100

The Storyline Connection

Most of the remaining images (eight of them if you started with ten) are used to construct the story in a sequence that tells the bulk of the story. They do not necessarily have to be ordered in a way that reflects the journalistic "inverted pyramid," where the most important images appear before the least important. All of the images you've selected for your photo essay should be important and essential if you edited them well.

Based on the type of story you're telling, the ordering may vary quite a bit. The main goal is to order them in a way that fluidly tells your story. You are attached to them in a different way than the audience is, so put yourself in their shoes for a moment. Make sure you are addressing the visual progression from their perspective.

In the example used above, you might actually build the boatmaker essay chronologically. After the opening image (which might be out of sequence with the rest), you might decide to follow with a variety of images that document the boat's construction chronologically. However, to keep the story visually interesting and inviting, you wouldn't choose images made from the same basic angle of the boat being built. Rather, you would use the range of angles and perspectives to capture the nuances of light, the sawdust, the feeling of the boat's ribbed skeleton, the tools being used, and maybe a shot of

An action shot of participants removing dirt from an excavation of the presidio's bastion. Medium shots like this proved useful, given the dig's crowded participation.

Canon 5D, 24mm, 1/80 sec., f/6.3, ISO 100

Tools of the trade: A detail shot helps further depict the field school's actions.

Canon 5D, 65mm, 1/125 sec., f/4, ISO 100

the builder taking a break from a day's hard work. All of these images can be captured chronologically and presented in the same way if you have enough visual variety among them.

An alternative way to order the images in the middle of the story is by conceptual value. Instead of compiling them in what amounts to a visual time line, the same images can be arranged in a way that stresses the significance of different areas of the story. The skeleton of the boat may be used to showcase the intricacy and beauty of the boat's design, the shop filled with glowing sawdust may depict the worker's environment, and the shot of the worker breaking for coffee may show the physical strain of the job or the pride that comes along with working with his hands.

Either way of ordering the images that make up the meat of the photo essay requires the photographer to think *interstitially*. Lead your audience on a dynamic journey, inclusive of all the ups, downs, and a climax, before ending

A portrait of the field school's principal investigator at the gate of the presidio provides a face of leadership.

Canon 5D, 47mm , 1/80 sec., f/4, ISO 100

Tighter medium shots of individuals participating in excavation visually connect with viewers of the essay.

Canon 5D, 93mm , 1/125 sec., f/4, ISO 100

the story. Ask yourself not only if one particular image should go after another (or perhaps be sized smaller than another on the same page), but also *why* the order must occur as so. Be very critical during this part of the process.

One of the best ways to get a hold on how to order your images, as I've stated before, is to look at other photographers' images, especially their photo essays. Start from the beginning and analyze how they progress. Do you think the ordering works? I f the idea was to tell a story somewhat linearly, what choices did the photographers make to ensure the story is both interesting and visually dynamic?

End Strong

Like the beginning, the ending serves an essential purpose—only this time it's to wrap the story up, at least to some degree. A strong image to conclude the story can be difficult to find or put a finger on. In the example above, a wide image of the finished boat in the shop or out on the water with fisherman on board might be a strong close, as would a tighter shot of a pair of work gloves and a smoothing plane lit warmly up against the side of the boat. In this case, the closing image indicates the conclusion of the story. At times you might want a closing image to provoke more questions, though, particularly in stories

Careful inspection and discovery of the site were facets of the dig and archeology in general I wanted to depict, including a tight shot of a participant sweeping over a section of the bastion.

Canon 5D, 88mm , 1/200 sec., f/6.3, ISO 100

Beyond digging, participants sifted the output in hopes of finding further evidence of historic human activity.

Canon 5D, 24mm , 1/320 sec., f/5.6, ISO 100

that have to deal with conflict or suffering, such as an image of a soldier's helmet lying by itself in a war zone.

Consult your research and shot list to see if you have already developed a vision of what will bring the story to some sort of closure. That term might sound like pop psychology, but it is a time for just that. It's your responsibility as the storyteller to put the story to bed. Always keep the audience in mind, and be intentional about the effects of your closing—do you want them to feel the story is complete, or do you want them to remain hanging on, waiting to see what happens next? Either way, choose a valuable, visually strong, and impactful image to end on.

The closing image is also a good opportunity to address thematic issues more directly as well. Although the rest of the images may contribute to a fairly abstract theme on which your story is constructed, the closing image allows you to more concretely tie the theme and the images together. The aforementioned closing of a soldier's helmet lying in a desolate, destroyed war zone powerfully connects confrontation and death to the physicality of the photograph itself. The gloves and tool on the boat reflect fulfillment and satisfaction, tradition and longevity. An ideal closing image is attractive and compelling and reflects both the activities in the story and the universality of the story itself.

The principal investigator consults with a participant on whether he has properly identified an artifact from the dig.

Canon 5D , 24mm, 1/1000 sec., f/4, ISO 10

A field school participant holds a newly discovered decorative artifact above its depiction. The image provides a sense of completeness for the essay.

Canon 5D, 24mm , 1/200 sec., f/5.6, ISO 100

ATTENTION, PLEASE

For each essay, prepare to produce or identify one image that stands out from the rest. This image, known as the *key* or *hook* shot, serves as the story's attention grabber. It should be the visually strongest, an image that constantly intrigues the audience. It's good enough to serve as a publication cover, an opener, or a stand-alone "advertisement" for the story.

No matter how the image is used, the key shot is an indicator of how interesting the story will be for others and gives a hint of what the story is about. As you shoot, you might come across a situation that you can imagine as your key shot. However, you're probably going to be so focused on shooting that you won't discover this specific image until you're editing. It's a valuable image to locate; don't hesitate to involve it in your story.

CAPTIONS You seldom see photo essays that lack some written text to go along with the images. One more way of telling a fuller story is to write a caption for each image. Captions help explain the image, highlight what might have come before or what will come after that 1/60th of a second in time, or go into more detail about the activities involved in a particular frame.

One or two sentences about each image will suffice—brevity is the key to keeping a viewing audience on track. If you are not too fond of words, then just keep in mind some simple tenets of writing when constructing captions—who, what, when, where, why, and how—and if you know someone who's a writer, offer to make a casual portrait of him if he'll help you out.

Even a portrait can serve as a key shot. To tie in the fact that the subject was the youngest person to direct the agricultural museum, placing her on a small John Deere lawnmower between two larger antique tractors provided a comical and intriguing entrance into the story.

Canon 5D Mk II, 28mm, 1/30 sec., f/4, ISO 1000

Cold nights, warm days, extremely rough roads, beautiful fall colors, and the tallest mountain in the state of Texas—all features of Guadalupe Mountains National Park. For the most part, they were also facets of a travel piece I was shooting on the park for a state travel publication several years back. I didn't shoot the cold nights aspect—I just lived that part.

The park is a big draw for outdoor recreationists from across the nation. Its hiking trails are extensive

Agave parryi **in the Guadalupe Mountains National Park provide color and detail for the story.**

Canon 5D, 57mm, .6 sec., f/22, ISO 100

and rigorous, and the Texas desert aura sits quietly on its peaks and the living dunes to the west of the mountain range. Its peaceful nature is countered only by the intimidating ridges and cliffs that loom over deep and steep valleys. Texas is not known for its extremely tall mountains (Guadalupe Peak sits just above 8,000 feet); however, this one has a rather distinctive southwestern feel and look to it.

After setting up camp in a central location, my job for the next five days was to actualize much of the research I had been conducting in regard to the mountain range, the park, and its history. The shooting went well, leading me down some interesting trails and roads, and I knew I wanted to photographically revisit or see certain areas for the first time. This is a highly photographed park, so I had in mind where other images were made and whether or not I needed or wanted to make any similar ones.

I covered the fall colors in McKittrick Canyon and spent an evening working the old Williams Ranch Road and the ranch house that sits at the foot of El Capitan, the most western peak of the Guadalupe range. I drove to Dell City, a small farming community covered in red in the fall from chili peppers produced in the fields, to gain access to the dunes for an evening. I covered as much as possible during those five days without sacrificing the quality of the images—you could spend a year in this area and not have enough material.

The last morning of my trip started out like all the rest—crawling out of a small tent when everyone else was still snoozing, gathering my gear, and jumping

Piles of autumn leaves, like those from the trees in the image that opens this chapter, line the trails in McKittrick Canyon.

Canon 1D Mk III, 58mm, 1/60 sec., f/4.5, ISO 200

in the pickup. I saved the last morning to photograph El Capitan, the most prominent feature of the park. Many people mistake El Capitan for the taller peak just behind it, but it's El Capitan that provides the park a recognizable face. The clouds that morning were sitting low on the mountain range, and I was afraid the sun was not going to be able to shine through as it rose above the horizon. A large boulder field stretches miles to the south of El Capitan, and I was headed there to set up my shots for the morning. This allowed me to compose the boulders in the foreground and compress El Capitan tightly in the frame.

When you're on a shoot, you just know when you have *the* shot. This was one of those moments. At the blue hour of dawn, the clouds were sitting low on El Capitan, and the sky was clearing to the north. With a couple cameras at the ready on tripods, all I needed was for the clouds to break for just a moment or two to light the mountain's facade. The sun then peeked through for about five minutes and lit El Capitan selectively.

The vantage point of the Guadalupe range from the living dunes near Dell City, Texas.
Canon 1D Mk III, 35mm, 1/80 sec., f/16, ISO 100

Shutters were tripped many times during that five minutes, and after the sun disappeared behind the clouds again, I hopped back in the vehicle and drove to another vantage point.

The sun shined on the rusty yellow cliffs again, and I made several more images. By the third or fourth time this occurred, I was shooting not only El Capitan but the surrounding environment as well. I had the good fortune of great, warm light and fantastic structure in the sky. After an hour or so of shooting, the sun said its final goodbye and went behind the cold front's veil for a few more hours.

Later, when I was editing the images, I spotted several worthy of flagging for a more specific look. I had no doubt the hook shot was in this morning's images, I just didn't know which one it was yet. After much deliberation, the one that hooked me, and ultimately led the story off, was one of the earliest, warmest-lit images that showcased the bulk of the cloud shelf and the domineering symbol of Guadalupe Mountains National Park. This was *the* shot for inviting viewers to dive more into the essay. It doesn't say everything that the combination of images in the essay tells as a whole, but it is a powerful indicator of what may be beyond the first magazine spread. ■

The story's hook shot: A golden El Capitan and the Guadalupe Mountains under a heavy blanket of morning clouds. The fact that this natural occurrence is not seen all that often in a photograph increased the image's appeal.

Canon 5D, 135mm, 1/250 sec., f/6.3, ISO 100

THE POWER OF THE DELETE BUTTON

Every photographer is bad about this. Every last one of us. I know many photographers who advise keeping every single shot you take. In my experience, though, this generates a heap of images that get in my way more than they help. I'm certainly not suggesting you get rid of all the images that don't make it to the final selection in your storytelling workflow—rather, I'm proposing that you…er, *we*—be judicious about whether we keep images that fall short of even deserving to be in a collection for your story.

Photographs with poor focus, weak composition, and other issues, compared with other, similar images that are in focus, have strong and leading composition, and stand a chance of being used in the current and future stories, will simply continue to pile up until they're a menace to your workflow and your overall storytelling abilities. Delete them.

Let's be honest: We make many more images worth deleting than worth keeping. Many of us get anxious about deleting anything. We have a connection with all of our images, right? We spent two weeks waking up at 4 a.m. to create a photo essay on the local fish market—a project that generated over 2,500 images—and we're supposed to just dump the bulk of them?

Keep in mind that your goal was to shoot the essay, not over 2,500 images. Sure, hold on to the images that would really work well for other stories or as stock. But trash the ones that don't meet your true standards, or your audience's. I promise it will increase your dedication toward your passion, and your professionalism to boot.

Why am I so adamant about this issue?

1. **Space is limited:** Workflow, remember, is a nuts-and-bolts type of concept. Part of it involves using digital media effectively. Deleting images that you won't use now or in the future frees up physical hard drive space for those that will contribute. Your hardware keeps going longer, your wallet stays heavier, and you won't all of a sudden run out of room for that 32GB of images you shot at the boardwalk this past Saturday.

 Even if purchasing newer and faster drives and other hardware is not that big of an issue to you, it still behooves you to delete those out-of-focus images. If you don't, then years later, when you're knee-deep in hard drives containing all the images you didn't delete, you'll waste valuable time with your incessant searching for that one important image among a multitude of nonkeepers.

2. **Insist on quality:** Consider this the self-help portion of your workflow. Deleting poor images is part of setting and following higher expectations

> Trash the images that don't meet your true standards, or your audience's.

for your images. Getting rid of those fuzzy images and frames you made in Paris with someone's arm peeking in next to the Eiffel Tower reminds you that you're seeking only quality. This may sound a bit snooty, but it shouldn't to those wanting to tell effective, interesting stories.

3. **Avoid clutter:** Deleting images you have no use for allows you to more deeply concentrate on what's important: telling your story. Get rid of images that would distract from rather than help a story line, and you'll find yourself continually developing a better, more thoughtful eye for shooting and editing.

One caveat, though: Do not, I repeat, *do not* delete the images you have flagged for the trash until you are finished editing and compiling your story. The last thing you need during this process is to mistakenly mark some images as nonkeepers that you will regret losing after emptying your trash can. Cleanup should be the last phase of your editing.

You might even find yourself catching up on image housekeeping months later. For this book, I've revisited old shoots and stories in my archive that I didn't clean up promptly—and I've spent a good chunk of time taking care of some of this janitorial business.

Do you dare delete images? Yes! However, only perform this function *after* you've completed your story.

TURNING WORKFLOW INTO THE NEXT STORY

The entire storytelling workflow is constructed in a way that lends itself to more stories. Not only does that mean more creative opportunities, but for those of us earning a living as photographers, it opens up job possibilities.

As those holding the reins to this process, we must remain flexible enough to see a new storyline emerging. Perhaps it's one related to the story we're currently telling, perhaps inspired by that story only in that it jogs another seemingly unrelated idea in our minds. Research opens up a multitude of doors where other stories may exist, and conversations and experiences with story characters and settings offer the same. The editing phase can be fruitful as well for generating story ideas.

Staying aware of new story when editing should not necessarily be a priority while working on the current story, but as someone who spends quality

This particular image did not see a place in my formal assignments on the Texas wine industry, but it gives rise to a few ideas I have for future stories about regional and global agriculturists.

Canon 5D Mk II, 200mm, 1/400 sec., f/5.6, ISO 100

This particular image overlooking the lower hills of the Guadalupe Mountains did not make the cut for the story discussed earlier. However, it is worth holding on to in case a magazine is telling a story about Texas deserts or the beautifully dressed West Texas skies.

Canon 1D Mk III, 28mm, 1/100 sec., f/8, ISO 100

time with your images, you may prick up your ears at other topics of interest emerging from your work. After you've made your deadline, it never hurts to put on another pot of coffee, go back into your images, and revisit some notable areas that you might have taken a few notes on.

In the story about the boat builder, for instance, maybe you have started to develop an interest in the types of woods used to construct the vessels. Your tight images of the unstained sides of the boat might just spark an idea for an essay on the life of the wood that goes into boatbuilding, a story on forest conservation, or a piece on the local facility that milled the wood before it was purchased by the boat builder.

A new story idea may be inspired by a single image in your current story's take, even one that you didn't end up using (another good reason not to delete any decent images until you're really finished). Or the idea may not occur to you until months after you've completed a particular photo essay. Revisiting your images is always a good idea to generate new story ideas.

Of course, you probably lack most of the images you would need to tell a different story. This is the rinse-and-repeat part of being a storyteller. With the close of one story, a new opportunity to turn a camera on a different subject or angle opens up. You start the workflow again in hopes of telling another intriguing story, whether for art or profit—or both.

The Wrap-Up

Quite a bit of work goes into making and telling a visual story. When done right, it may not look to others like you struggled at all to produce something visually attractive and engaging. Make no mistake, though, photographically showcasing a story takes time and involves copious amounts of research, planning, technical skill, style, and then even more time. For a lot of folks in the profession (and for many who are not), it also requires a fair amount of expense, depending on the size of the project.

In the end, though, it's all about what we do with a camera in hand. We tell stories.

A continuous stream of water running down the side of a mountain near South Fork, Colorado. Metaphorically speaking, story is much the same way: never ending and dynamic.
Canon 5D Mk II, 28mm, 5 sec., f/22, ISO 50

GROWTH THROUGH ASSESSMENT

At the close of a story, it only seems appropriate to spend some time reflecting on your work. I mentioned earlier that being reflective is part of being a storyteller, and it helps to review those questions that close out Chapter 2. At the same time, though, when you come to a thoughtful point *after* you've completed your storytelling workflow, you also need to complete an examination of your product. How do you feel about the story? Are you emotionally satisfied with the images that stitch together the story you started out telling about the natural history of the large trees that line regional waterways?

Sounds like a funny question, doesn't it? Emotionally satisfied? Believe it or not, though, your gut can tell you a lot about how the story turned out, and how *you* feel about your story has quite a bit to do with how others perceive its quality.

Consider this the quality assurance of your story. In order to take full advantage of it, use this quality assessment as a tool the entire way through the storytelling workflow. Doing so will ensure you feel more satisfied at the end of telling a story than not. Review the quality of your work, both technically and along story, continuously, and the story's wrap-up will be easy to face. You'll showcase your story knowing that you did everything possible to make it worth "reading."

No story is perfect. Each photographer can point out flaws in his own stories or highlight areas she wishes she had done differently. However, being reflective about your storytelling and photographic abilities is an important element of improving them. If such reflection earlier in the book came with asking yourself some questions regarding the value of the story and how it's being told, there's one more question (among others) that storytellers must pose before hanging their hat up on a story.

Being reflective about your storytelling and photographic abilities is an important element of improving them.

FINISHED, RIGHT?

At the moment, perhaps. Yet, as my university journalism professor once said, the story never really stops. Just because you finished documenting a certain facet of the natural ebb and flow of drought years and wet years in a land highly dependent upon agriculture, that doesn't mean the next drought will look the same as the last. Each day, month, year, decade, or century brings something new and different to the table, and even as we close the book on a particular story, opportunities for the next one spring forward. As a visual storyteller, you've positioned yourself to receive them.

An ominous thunderstorm rolls over wheat pastures near Shallowater, Texas, bringing not only a large amount of moisture but some rather interesting ambient light conditions at the close of the day (above).

Canon 5D Mk II, 17mm, 1/125 sec., f/5.6, ISO 400

Old cypress trees line a stretch of the Sabinal River in Utopia, Texas.

Canon 5D Mk II, 105mm, .6 sec., f/22, ISO 100

As discussed earlier in the book, your ventures into telling a story grant you unique access to other stories simply through engaging with those characters you meet in the first story. For example, an initial story on a month-long art education experience in the Texas Hill Country flowered into a growing series of stories on Texas-based artists, some locally known, others globally recognized. The original story provided me access to a handful of people (editors included) I could contact later about related story ideas and projects. Likewise, features I have shot on certain people or places have prompted me to revisit locations for either more storytelling or stock image material.

THE OPEN DOOR It's always a good idea to leave a shoot with the door cracked open, metaphorically speaking. Respectful, professional conversations with your subject or the people who provided you initial access to certain locations or story characters are a good way to keep a channel of communication open among all parties involved. You may get invited back for other photo shoots, or at the very least, have an opportunity to contact those people again if you're ever in need of their services, information related to their expertise, and so on.

Even finding out about and discussing a tangential issue or topic that the person on the other end of the lens is interested in may open up a new story line, one for which he might be willing to provide access. In a nutshell, the people you come across daily as a photographer might just be the keys to unlocking a new story or revisiting old ones.

KEEP YOUR RADAR UP

It only stands to reason that if story never stops, a part of it is still waiting to be told. To this end, it doesn't necessarily matter if you are "breaking" the story or if you jump into the larger narrative midstream; as long as you are tuned in to interesting activities, issues, phenomena, and anything else that you consider worthy of visually covering, you'll always be engaged with storytelling.

Professional or not, we're all given an opportunity when we take up photography to explore our world. As much as some individuals like to decry the way digital technology has increased the number of folks with a camera in their hands, we're still all part of a small community of people who create, document, and distribute pieces of natural, cultural, and social information in the form of story. It's our responsibility to contribute to this community, because the very fact that we bothered to learn how to use a camera in a way that produces story shows that we want to learn and communicate about the world we live in.

A barred owl leaves its perch in a frozen field in the Texas panhandle. This is the image that piqued my interest in wildlife conservation and management photography, and it was simply the result of exploring the area by vehicle in search of winter stock images.

Canon 5D, 200mm, 1/1600 sec., f/2.8, ISO 100

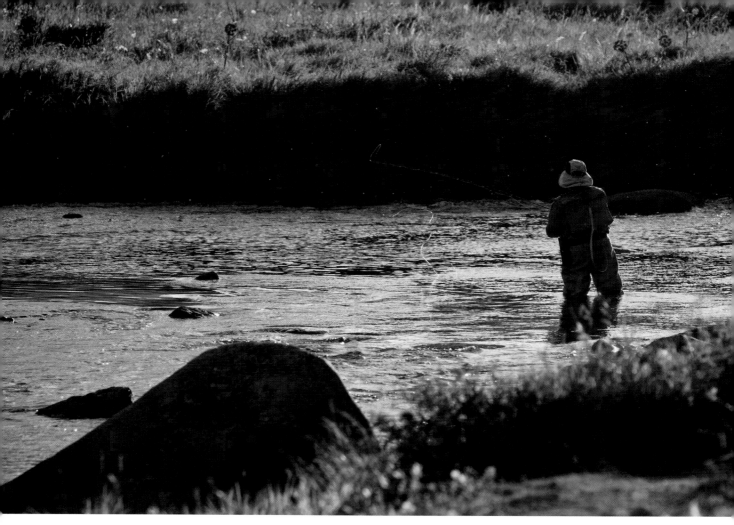

Keeping your eye tuned in to the mechanics of a shot is a good way to continually sharpen your technique, vision, and skills with the camera. Originally attracted to the backlight on the fly fisherman's form and the flies in the air, I quickly found some nice framing and composition to highlight his position in this Rocky Mountains river.

Canon 7D, 200mm, 1/640 sec., f/4, ISO 100

The Continuous Publisher

If there's any encouragement I want to give with the close of this book, it is to constantly seek and tell stories! Practically speaking, don't let those stories you visually collect go untold. Start a blog, self-publish a book (it's easier than it's ever been to do so nowadays), or start contributing to an online photography community. The point is, continue to "publish" your stories.

A photographer who is constantly telling stories, no matter which outlet she uses, is also constantly stimulated visually and along new story lines. Diversify your options for exhibiting your visual stories. You can publish a photo essay online through your own Web site or a Flickr or Google+ stream, or you can query a print publication about running your story, potentially reaching a targeted audience that shares similar interests.

Shoot stories that you know fit a particular kind of outlet best, and then shoot a story for another. A small multimedia photo documentary on my child's first year may not be all that interesting to any of the magazines I shoot for, but it could intrigue a parenting magazine, and it will be extremely interesting to those who read my wife's family- and friends–oriented blog. At the same time, a story about threatened North American wildlife species may be the perfect one to be told in coffee table book format through a conservation-driven publishing house.

Regardless, continually tell story. Just as simply shooting will help you become more familiar and competent with your camera, constantly coming up with and telling stories will hone your skill as a visual storyteller.

Remain Curious

Remaining curious about your world is a precursor to telling visual stories. Stay on the lookout for those elements that make for an interesting visual story (you'll get to a point where it becomes second nature). Take into consideration those elements of story that I highlighted in Chapter 5, and quickly assess whether a conversation you had with a colleague hints at a story worth training the camera toward.

At the same time, though, be curious about single images, abstract colors and form, unique light, and memorable faces and locations. You never know when those photographs and visual characteristics may either contribute to a story over time or inspire a completely different story with a new thematic structure.

KEEP A LIST **Some time ago, I learned that I can't remember everything. As hard as I try, I simply cannot do it. Since that pivotal moment, I've started carrying around a means of keeping track of story ideas, thoughts, interesting tidbits of conversation, and anything else that might spark my creative work. Whether it's my iPhone, a small, cheap notebook I can stuff in my back pocket, a formal journal, or just my hand, I keep something near so I can add to my list of story and shot ideas.**

Get in the routine of keeping a similar list.

More than likely, you'll be able to turn some of the ideas you keep on your list into outlines to flesh out once you start the storytelling workflow.

Don't forget to create what some photographers call "study pieces." Remain visually curious about light, lines, form, and shape.

Canon 5D Mk II, 95mm w/ extension tubes, 1/100 sec., f/9, ISO 160

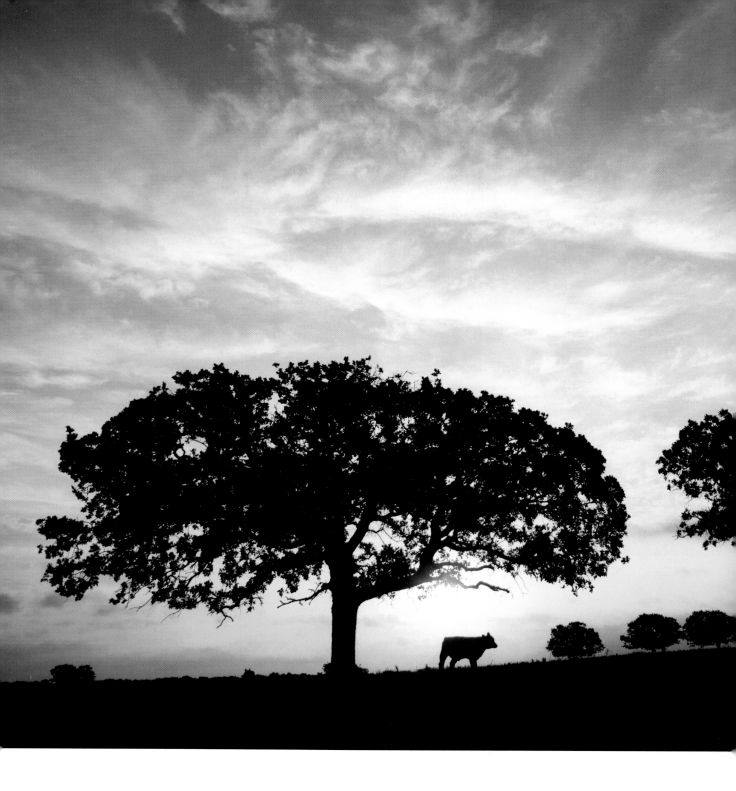

Even when you go into a part of a story with a set previsualization of what you are going to accomplish, be flexible. Don't let the previsualization preparation block your curiosity about what an image might look like if you tweak the setting on your flash or move your subject over to the crocodile wrapped around the door. Visual story can be told in a variety of ways; remain open enough to explore alternative frames.

I can't say it too many times: Curiosity is a good thing. Asking questions is a good thing. And answering your questions (or at least some of them) about your surroundings—the people, the places, and the events that unfold along the way—with your photography is a powerful way to tell story. Not only does it help you communicate your ideas and vision to others, it's almost guaranteed to make you more thoughtful about the world around you.

As sure as any new day starts, new story opportunities emerge. Be open to what you might be telling next.
Canon 1D Mk III, 24mm, 1/500 sec., f/5.6, ISO 100

Index